Indian Rock Art of the Columbia Plateau

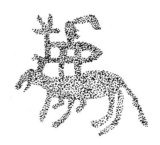

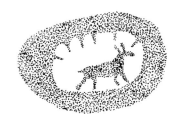

A Samuel and Althea Stroum Book

Indian Rock Art
of the Columbia Plateau

JAMES D. KEYSER

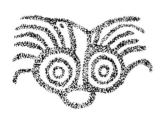

University of Washington Press *Seattle & London*

Douglas & McIntyre *Vancouver/Toronto*

This book is published with the assistance of a grant from the Stroum Book Fund, established through the generosity of Samuel and Althea Stroum.

University of Washington Press
P.O. Box 50096
Seattle, Washington 98145-5096
Douglas & McIntyre
1615 Venables Street
Vancouver, British Columbia V5L 2H1

The paper used in this publication meets the minimum requirements of American National Standard for Information Science—Permanence of Paper for Printed Library Materials, ANSI Z39.48–1984.

Library of Congress Cataloging-in-Publication Data
Keyser, James D.
Indian rock art of the Columbia Plateau / James D. Keyser.
p. cm.
Includes bibliographical references (p.) and index.
ISBN 0-295-97197-5 cl.
—ISBN 0-295-97160-6 pbk.
1. Indians of North America—Columbia Plateau—Art. 2. Rock paintings—Columbia Plateau. 3. Petroglyphs—Columbia Plateau.
4. Indians of North America—Columbia Plateau—Antiquities.
5. Columbia Plateau—Antiquities. I. Title.
E78.C63K49 1992
979.7—dc20 91-27353
 CIP

Canadian Cataloguing in Publication Data
Keyser, James D.
Indian rock art of the Columbia Plateau
Includes bibliographical references and index.
ISBN 1-55054-051-3 (Douglas & McIntyre).
—ISBN 0-295-97160-6 (University of Washington Press)
1. Indians of North America—Columbia Plateau—Art. 2. Rock paintings—Columbia Plateau. 3. Petroglyphs—Columbia Plateau.
4. Indians of North America—Columbia Plateau—Antiquities. 5. Columbia Plateau—Antiquities. I. Title.
E78.C63K49 1992a
709'.01'13089970797 C92-091306-7

Contents

Illustrations

Maps

Figures

Preface

I SAW MY FIRST INDIAN ROCK painting in western Montana when I was nine years old. My father had heard of the site several years before, and finally agreed to take an eager son who had just become fascinated with American Indians and their history. I still remember the experience: I marveled at the red painted deer that covered the rock wall and wondered what the nearby tally marks meant. To look at these pictures and to realize that they were painted before European Americans came to Montana was heady stuff for a boy who had just read about the Indian wars, Custer, Fort Fetterman, and the Wagon Box Fight.

During the next ten years, I visited several more sites in western and central Montana, usually on family outings. Then I entered college, and began studying archaeology, and found the library to be a treasure house of books and articles about rock art across the United States and around the world. I read everything I could find on the subject and scoured professional journals for the few articles concerning the rock art of my home state. In 1974, when I got the chance to do archaeological field work, I began my first rock art research project: recording the pictographs of western Montana, including the site that had sparked my interest fifteen years before. Imagine my joy upon learning that the site was even more impressive than I had remembered, and in finding two other sites nearby. That summer, a colleague and I visited most of western Montana's thirty sites.

As I did the research for a professional journal article about these paintings, I read or re-read dozens of the available publications on rock art. There were two basic sorts of publications. Most common were simple descriptive works with page after page illustrating various paintings and carvings, but without answers as to why or when the art was made. A few professional publications interpreted rock art, but for most people these explanations were obscured by clouds of jargon, statistical comparisons, and references to scholarly works not readily available outside of university research libraries. A few notable books, especially those by Campbell Grant (1967) or Selwyn Dewdney and Kenneth Kidd (1967), were different in providing plenty of good illustrations combined with readable, informative text. But these books had little or nothing about Columbia Plateau rock art, and Grant's national overview, *Rock Art of the American Indian*, didn't report even one of the sites I had just finished recording! In passing, I thought how sad it was that no book existed about these paintings—or about any of the many others that I had learned of in neighboring states and Canadian provinces—that not only pictured the art but also went much further to tell who made them, why, and when.

I finished the article on western Montana pictographs and moved on to other subjects in archaeology, including rock art in other areas. In the intervening fifteen years I have written many of those articles filled with jargon, charts, and statistics, attempting to describe this art to other professional colleagues and to discern the "who, why, when, and what" that would help explain it. I have had fun doing this, and I have traveled throughout the north-

ern Great Plains, the Columbia Plateau, and even to Europe to conduct my research. I have been fortunate in having had the opportunity to do much of this research in the course of jobs with universities and government agencies in both the United States and Canada.

Throughout my career, however, I have never forgotten my initial interest in rock art and my disappointment that so few publications had both good illustrations and answers to my many questions. Likewise, I have been conscious that much of my research has been funded by public support to preserve and study these prehistoric relics. In the past few years I have spoken to numerous public groups—from grade-school classes to historical societies—in an attempt to make more information about rock art available to the lay public, and thus to give something back to the people who ultimately support my research. This book is one more way that I can offer something about this subject to those who are interested. I hope it reaches everyone who has ever thought, "Why did they do these drawings? What do they mean?" Maybe some young person will read the book and find in its pages the same fascination that I found in that Montana pictograph thirty years ago.

Acknowledgments

Many people assisted in various ways with this book. Rick McClure, Carl Davis, Dan Leen, and Susan Carter all showed me sites and provided hard-to-find research source materials. McClure, Leen, Keo Boreson, and Greg Bettis gave photographs and drawings of many Columbia Plateau rock art sites. George Knight helped record and analyze western Montana pictographs during my first rock art research project. Dick Buscher, Greg Warren, and Don Oliver each gave support and counsel for my writing and illustrating the book. Paula Sindberg provided a place to live, a word processor, and sufficient moral support for me to take the time to write this book. To each of these people I give my heartfelt thanks; they all share in the success of this work.

To my parents, Dr. and Mrs. Raymond C. Keyser, I dedicate the book. Early on they recognized and fostered my interest in Indians and archaeology. Their support, and especially a trip to show a nine-year-old boy the Perma pictographs, is as much responsible for this book as anything else.

Indian Rock Art of the Columbia Plateau

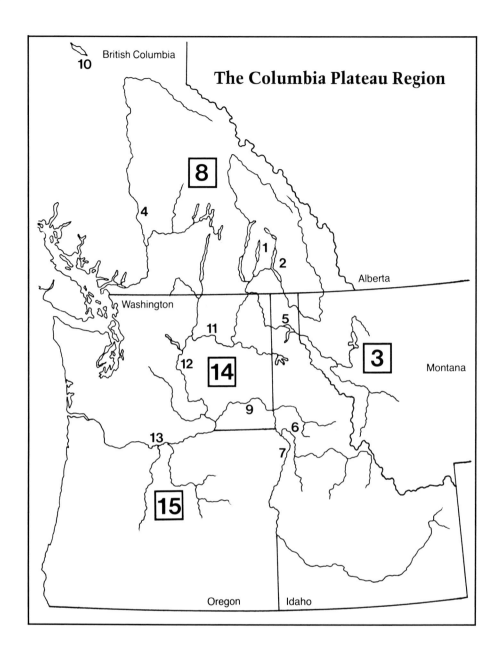

Map 1. The Columbia Plateau region, showing
locations of major rock art study projects. Larger
numbers indicate regional studies. 1, Bell 1979; 2,
Baravalle 1981; 3, Keyser and Knight 1976; 4,
Lundy 1979; 5, Boreson 1985; 6, Boreson 1984; 7,
Leen 1988; 8, Corner 1968; 9, Nesbitt 1968; 10,
Richards 1981; 11, Leen 1984; 12, Cain 1950; 13,
McClure 1984; 14, McClure 1978; 15, Loring and
Loring 1982.

Introduction

SCATTERED THROUGHOUT THE Pacific Northwest are hundreds of prehistoric rock paintings and carvings made by the Indians of this region prior to European American settlement of the area. These pictures, carved into basalts along the Columbia River and its tributaries, or painted on cliffs around the lakes and in the river valleys of western Montana, British Columbia, northern Idaho, and Washington, are an artistic record of Indian culture that spans thousands of years. Collectively called rock art by the scientists who study them, these drawings are most often carefully executed pictures of humans, animals, and spirit figures that were made as part of the rituals associated with religion, magic, and hunting.

Rock art in the Pacific Northwest was first noticed by early explorers. Before the turn of the century, government-sponsored expeditions searching for wagon and railroad routes through the region noted rock art at Lake Chelan, along the lower Columbia River near Umatilla, and in northern Idaho. Soon after, anthropologists and other scientists began studying some of these sites. James Teit, an ethnologist who recorded the cultures of Columbia Plateau Indian tribes in British Columbia and northern Washington between 1890 and 1920, interviewed natives who had painted some of these pictures and asked why they had done so (Teit 1928). Since then, his work has been a key to all serious rock art research in the region. Since 1950, numerous scientific articles and two small books about Columbia Plateau rock art have described and discussed the paintings and carvings of many areas in the

Pacific Northwest (Boreson 1976; Cain 1950; Corner 1968; Keyser and Knight 1976; Loring and Loring 1982; McClure 1978).

Despite this long history of scientific interest in Columbia Plateau rock art, the public remains relatively unaware of these paintings. Except for occasional newspaper or magazine articles, and limited interpretation of a few sites, little information on rock art has been made available to nonscientists. One result has been the spread of misinformation by sensationalist writers, who have suggested that these drawings are maps or "writing" left by Chinese, Norse, Celtic, or other pre-Columbian explorers.

More serious, however, is that current residents of and visitors to the Pacific Northwest miss the opportunity of understanding and appreciating rock art as a part of our region's rich cultural heritage. This has led to the defacement (and even the destruction) of some sites by unthinking vandals who obliterate the original art with spray-paint scrawls. Thus, my purpose in writing this book is to help interested persons understand the age, meaning, and function of this art. I hope that this will lead to public appreciation of and concern for these irreplaceable art treasures of our past.

What Is Rock Art?

Simply put, rock art can be defined as either engravings or paintings on nonportable stones (Grant 1967, 1983). Because it is the subject of scientific study, a set of specialized archaeological terms and a technical vocabulary convey exact nuances of meaning to professional

scholars. These terms can be confusing to the lay reader, and since the primary purpose of this book is to provide an overview of Columbia Plateau rock art and to describe in general its origin, function, and age, I have used a minimum of this professional jargon. Some terms cannot reasonably be avoided, however, due to the specialized nature of the subject matter. Thus, I define here six terms which may need clarification: petroglyph, pictograph, anthropomorph, zoomorph, rock art style, and rock art tradition. Each of these can also be found in the glossary, which contains a few other specialized terms used occasionally throughout the book.

Petroglyphs

Petroglyphs are rock engravings, made by a variety of techniques. In the Pacific Northwest, pecking was the most common method: the rock surface was repeatedly struck with a sharp piece of harder stone to produce a shallow pit that was then gradually enlarged to form the design. Some Columbia Plateau petroglyphs were also abraded or rubbed into the surface with a harder stone to create an artificially smoothed and flattened area contrasting with the naturally rough-textured rock. Pecked designs were sometimes further smoothed by abrading.

A few Pacific Northwest petroglyphs were made by scratching the rock with a sharp stone flake or piece of metal to produce a light-colored line on the dark surface. Some shallow scratches are now nearly invisible, having weathered over several hundred years. Others were deepened to form distinct incisions still readily apparent. A few petroglyphs show a combination of techniques; most common are animal figures with abraded bodies and scratched legs, horns, or antlers.

Columbia Plateau petroglyphs are most often made on basalt, a hard, dense volcanic stone. The weathered surface of basalt is a dark, reddish-brown to black patina, or "crust," several millimeters thick. Underneath this patina the stone is a lighter color, ranging from yellowish brown to dark grey. Prehistoric artists engraved deep enough to reveal this unweathered interior stone so that designs would stand out against the darker background. Reweathering of designs exposed in this way provides a clue to help in dating some petroglyphs.

Pictographs

Pictographs are rock paintings. On the Columbia Plateau these are most often in red, but white, black, yellow, and even blue-green pigments were sometimes used. Polychrome paintings are uncommon, but a few do occur throughout the region. Most frequent are the red and white polychromes of the lower Columbia River and Yakima valley.

Pigment was made from various minerals. Crushed iron oxides (hematite and limonite) yielded red—ranging from bright vermilion to a dull reddish brown—and yellow colors. Sometimes these ores were baked in a fire to intensify their redness. Certain clays yielded white pigment, and copper oxides blue green. Both charcoal and manganese oxide produced black. Early descriptions indicate that Indians mixed crushed mineral pigment with water or organic binding agents, such as blood, eggs, fat, plant juice, or urine, to make paint.

Pigment was most commonly applied by finger painting: finger-width lines compose the large majority of pictographs throughout the area. Some paintings, done with much finer lines, indicate the use of small brushes made from animal hair, a feather, or a frayed twig. Still others were drawn with lumps of raw pigment (much like chalk on a blackboard) or grease-paint "crayons." These pictographs have a characteristic fine-line appearance, but the pigment appears somewhat unevenly applied in comparison with the small brush paintings.

How this paint has survived on open ex-

posed cliff faces, where pictographs are usually found, has long been the subject of scientific debate. Early scholars, presuming that the paint would fade rapidly, argued that all of these paintings had been done during the last two hundred years. Several reported significant fading at some sites, and even suggested that none of these paintings would last beyond a few more years. Fortunately, they have been proven wrong: scientists have recently discovered evidence that the paintings are not disappearing, as originally thought. Photographs taken at several sites over spans of as much as seventy-five to one hundred years indicate that pronounced fading is not usually a problem. Often, "faded" pictographs are found to have been destroyed by road construction, inundated by reservoirs, or covered by road dust or lichen. When affected only by natural weathering, paintings at hundreds of sites remain as bright today as when they were first discovered.

Recent research by Canadian scientists (Taylor et al. 1974, 1975) has demonstrated why these rock art pigments are so durable. When freshly applied, the pigment actually stains the rock surface, seeping into microscopic pores by capillary action as natural weathering evaporates the water or organic binder with which the pigment was mixed. As a result, the pigment actually becomes part of the rock.

Mineral deposits coating many cliff surfaces provide a further "fixative" agent for these paintings. Varying types of rock contain calcium carbonates, aluminum silicates, or other water-soluble minerals. Rain water, washing over the surface of the stone or seeping through microscopic cracks and pores, leaches these naturally occurring minerals out of the rock. As the water evaporates on the cliff surface, it precipitates a thin film of mineral. This film is transparent unless it builds up too thickly in areas with extensive water seepage. In these instances the mineral deposit becomes an opaque whitish film that obscures some designs, the reason that some pictographs do actually fade from view. However, microscopic thin section studies show that, in most instances, staining, leaching, and precipitation have actually caused the prehistoric pigment to become a part of the rock surface, thereby protecting it from rapid weathering and preserving it for hundreds of years.

Anthropomorph, Zoomorph

Anthropomorph and zoomorph derive from the Greek words *morphe*, "form"; *anthropos*, "man"; and *zoon*, "animal." Thus, anthropomorphs have human form, zoomorphs have animal form. These words are often used instead of "human" and "animal" in the professional literature to communicate a specific meaning because scientists cannot be sure that the original artist intended a specific figure to represent an actual human (or animal), or merely the concept of humanness, or even the personification of a spirit or other nonliving thing. However, in this book, the terms "human," "human figure," "animal," and "animal figure" are more readily understood, and fine distinctions of meaning are not required.

On the other hand, I have used these two terms when it is obvious that the prehistoric artist did not intend to represent a real human or animal, yet used undeniably human or animal features in a design. Multiple-headed beasts, faces that combine some features of both humans and animals, or otherwise abstract designs incorporating clearly recognizable body parts are categorized as anthropomorphic or zoomorphic, depending on which features are primary. Thus, a grinning human face with a fish tail would be anthropomorphic, while a three-headed animal figure with hands in place of hooves or paws would be referred to as zoomorphic. For the most part, however, if a figure closely resembles a human or an animal (given stylistic conventions), I refer to it using the simpler terms.

tion, and (6) weathering (McClure 1979a, 1984).

Association with Dated Archaeological Deposits

Occasionally, sediment containing dated archaeological items will bury a rock art panel. This may occur in a rock shelter or on an open site where sediment builds up against the rock surface, or when a portion of a rock art panel falls from a vertical surface into an archaeological deposit below. Neither occurrence is especially common, since both require the propinquity of rock art and living areas, rapid deposition of sediment, or partial destruction of the site.

Two examples of buried rock art provide dating clues for the Columbia Plateau. In south-central Oregon, a deeply carved panel of abstract petroglyphs is partially covered by a deposit containing ash from the volcanic explosion of Mount Mazama that formed Crater Lake sixty-seven hundred years ago (Cannon and Ricks 1986). Thus this site demonstrates that Pacific Northwest Indians must have been making abstract petroglyphs before this early date. Of more direct relevance to Columbia Plateau rock art was the discovery—in Bernard Creek Rockshelter in Hells Canyon on the Snake River—of a spall, from the rock shelter wall, that bore traces of red pigment. The painted spall was found in a level that dated between six and seven thousand years ago (Randolph and Dahlstrom 1977). Although it could not be matched to any paintings still visible in the shelter, the fragment does demonstrate that Columbia Plateau Indians have painted pictographs for a very long time.

Association with Dated Portable Art

Many of the ancient Paleolithic paintings and carvings in the famous caves of France and Spain can be fairly securely dated because they closely resemble engraved designs on animal bone that have been found in dated archaeological deposits. In these cases, the portable art and the rock art are sufficiently similar in style and technique to infer that they are contemporaneous. Unfortunately, on the Columbia Plateau portable art is not often found in well-dated contexts, but a few examples are known. Probably the most definitive are near The Dalles, where a number of Tsagiglalal carvings have been found in cremation burials that date between A.D. 1700 and A.D. 1800, and almost identical Tsagiglalal petroglyphs occur on nearby cliffs. Certainly, given the stylistic complexity of this figure, both the portable and rock art examples must be of the same age.

Elsewhere at sites along the middle Columbia, archaeologists have recovered a few pieces of stone and bone sculptured in human and animal form. Some of the human forms show distinctly bared teeth; some humans and animals have ribs clearly shown. All examples with teeth or ribs date within the last twelve hundred years. In the same region are also occasional rock art portrayals of human and animal figures with teeth and ribs. McClure (1984) argues convincingly that these rock art depictions date to the same time period as the carved portable objects. Finally, at an occupation site in southern British Columbia, a small, cylindrical stone painted with red dots and lines was recovered from a context more than two thousand years old (Copp 1980). The designs would fit in any of the area's pictographs, indicating that simple geometric paintings are of considerable age in the region.

Portrayal of Datable Objects

Rock art from the northern Great Plains region of Alberta, Canada, Montana, and South Dakota shows thousands of historic items, including horses, guns, wagons, European Americans, and buildings. Since the dates at which these objects were brought to the area are known, the rock art is dated to the same time

period. Likewise, rock art on the north Pacific coast shows sailing ships that can be reliably dated to historic times.

On the Columbia Plateau, approximately thirty sites show examples of horses or mounted humans (Boreson 1976; McClure 1979a). The drawings include both pictographs and petroglyphs, and occur in all areas of the region. We can reliably date these depictions after about A.D. 1720, when horses were first introduced onto the Columbia Plateau by Indians who had obtained them from Spanish settlements in New Mexico (Haines 1938). A few sites also contain drawings of a gun, a European American, and brands that date to the historic period.

In addition to historic items shown in rock art, depicted atlatls (throwing sticks used to propel stone-tipped darts) and bows and arrows are reliable time markers. The bow and arrow was first introduced onto the Columbia Plateau between two and three thousand years ago; before that, hunting weaponry was the spear or atlatl and dart. Atlatls are shown occasionally in rock art throughout the western United States. On the Columbia Plateau, probable atlatl depictions occur at petroglyph sites near The Dalles and on the Snake River south of Lewiston, Idaho. These panels were probably carved before the Indians acquired the bow and arrow. On the other hand, bows and arrows are relatively common, both as petroglyphs and pictographs, throughout the Columbia Plateau, occurring at sites in British Columbia, Washington, Oregon, and Idaho. These designs must date within the last two thousand years.

Superimpositions

Occasionally one design will be carved or painted over another; thus superimposed, the overlapping figure must have been made more recently than the original. A series of superimpositions, involving stylistically distinct examples, can be useful in developing a general-ized chronology for a region's rock art, since the relative ages of each style can be shown. In some areas of the world (e.g., Valcamonica, Italy; Dinwoody, Wyoming; Coso Range, California), frequent superimpositions characterize rock art, and relative chronologies have been developed from detailed analysis of many instances of superimpositioning.

In Columbia Plateau rock art superimpositions are rare, although they occur occasionally in some parts of the region, most frequently along the middle and lower Columbia River. However, despite some tantalizing clues, we have not yet recognized a clear pattern of any specific design or style overlapping another. Instead, it appears that in this area a few superimpositions were done during approximately the past thousand years in a seemingly random pattern. Possibly further study will yield information that is of more value for turning these clues into a relative chronology.

Patination

Many petroglyphs along the middle Columbia River and the lower Snake River were made by pecking through the dark patina on the basalt bedrock characteristic of these areas. This patina, sometimes called *desert varnish*, is a brown to black stain that colors exposed rock surfaces. It occurs most often on stones in hot, arid portions of the world. Some scientists suggest that this patina forms due to chemical weathering and leaching of iron and manganese oxides from the stone, while others hypothesize that airborne microorganisms oxidize these minerals and concentrate them on the rock surface. In either case, the process is a slow one and desert varnish takes considerable time to develop.

When a petroglyph is pecked or carved through the patina on a rock surface, it exposes the lighter colored interior stone and creates a negative image, with the paler petroglyph showing on an otherwise dark background. If conditions for patina development still exist

after the petroglyph is made, the newly exposed surfaces gradually begin to acquire the desert varnish. After a long period the design will be repatinated; it will have essentially the same patina as the unaltered rock face. Although repatination of petroglyph designs does not provide an absolute age (since exposure, temperature, humidity, and other factors influence the rate of patina formation), petroglyphs repatinating differently on the same surface are useful for creating a relative chronology. In such cases, those that appear fresher are younger than those that have repatinated to an appearance closer to the original surface of the stone.

Differential patination has been used on petroglyphs near The Dalles and at Buffalo Eddy on the Snake River south of Lewiston, Idaho, to suggest relative chronologies. At The Dalles, petroglyphs in the pit and groove style invariably are heavily patinated and weathered. At two sites, these contrast with much fresher appearing designs pecked at a later time. The heavy repatination of all of these pit and groove petroglyphs is consistent with that noted in the Great Basin area of Utah, Nevada, and California. There the appearance of this art style has been dated between five and seven thousand years ago. While we cannot automatically assign an equally ancient age to the pit and groove petroglyphs at The Dalles, certainly they are the oldest in this locale.

At Buffalo Eddy, Nesbitt described two rock art styles (1968). A naturalistic style shows primarily mountain sheep, deer, and humans wearing horned headdresses, while a "graphic" style is composed of triangles, circles, dots, and lines arranged in geometric patterns. At Buffalo Eddy, the naturalistic petroglyphs are usually repatinated, some very heavily. In contrast, the graphic designs are reported as fresher looking and cut through the patina on the rock surface. In one instance graphic style designs may actually be superimposed on repatinated naturalistic designs. In this case, the naturalistic drawings of men and mountain sheep clearly seem older than the graphic geometric designs.

Weathering

Variations in the weathering of different designs are often used in conjunction with patination studies, but such variations can also be applied to pictographs, which are not affected by patination. Many Columbia Plateau pictographs show weathering differences: some designs at a site will be very "fresh" looking while others will appear somewhat faded or will be partially covered by mineral deposits. Since different artists likely used paints of slightly different composition and color, differential weathering of pictographs is not as reliable an indicator of the passage of time as is differential patination of petroglyphs, but it does serve to indicate that paintings were made at different times.

The lack of evidence of extensive pictograph weathering during the last century also provides a dating clue by suggesting that some of these paintings could be of considerable age. Photographs taken of the Painted Rocks pictograph site on Flathead Lake in western Montana show the paintings to appear as fresh today as they did in 1903. With such minimal weathering, these (and other similar) paintings could be as much as several centuries old.

A Word Regarding Interpretation

Scientifically accurate interpretations of Columbia Plateau rock art are notably scarce. The written material that presents a realistic idea of the richness of this art tradition (and of the cultures of the artists), along with reasonable explanations of some of the reasons why the art was created, consists of a small handful of professionally published journal articles and graduate student research papers. None of

these attempts to deal with more than a small part of the Columbia Plateau province, and very few are oriented toward helping the public understand and appreciate this rock art.

This lack of a comprehensive publication describing and interpreting rock art for the lay public is due primarily to scholars' reluctance to speculate in print about their subject beyond the limits of statistical confidence intervals, competing hypotheses, and regional style definitions. Thus, the only interpretation readily available to the public often consists of far-fetched "translations" of sites or designs— some of which even go so far as to attribute this art to ancient Chinese explorers, lost Celtic monks, or prehistoric spacemen! The result is a dearth of interesting, scientifically accurate information about rock art written for lay readers.

Elsewhere, other authors and I (Dewdney 1964; Hill and Hill 1974; Joyer 1990; Keyser 1990) have shown that rock art can be interpreted for the general public in a way that both educates and entertains, while still observing the basics of scientific accuracy. Throughout this book I continue this effort. In some cases this involves making leaps of faith (albeit minor ones) that a strict scientific treatment would not. For instance, paintings of horsemen or groups of men with bows and arrows found in the extreme eastern part of the Columbia Plateau (in British Columbia and central Idaho) cannot be positively identified as depicting successful raiding parties returning from the northern Plains. No site was so identified by any of the Kutenai, Nez Perce, or Flathead Indian informants used by early ethnographers in the area. These Indians did, however, recall such raids on Blackfeet, Crow, and Cheyenne villages, and among the Nez Perce there are

ledger drawings of such war parties. Informants also indicated that important events were sometimes pictured in rock art.

Therefore, putting these three things together—informant recollections of raiding parties, informant indications that important events were recorded in rock art, and the presence of rock art sites showing armed warriors or groups of horsemen—I feel comfortable speculating that some of these sites do, in fact, show war parties going to or returning from raids on Great Plains tribes. Similarly, the identification of bison hunt drawings, "twin" figures, "spirit beings," and vision quest pictographs is based on logical deductions drawn from ethnographic accounts, comparison with rock art in other areas (world-wide), and my own experience in nearly twenty years of rock art research. Obviously, in a courtroom much of this would be circumstantial evidence and hearsay, but this is usually the only sort of evidence available to archaeologists. It is exactly this circumstantial evidence that enables us to tell the stories about the people who made the artifacts or painted the pictographs!

This book is, therefore, my interpretation and retelling of some of the myriad fascinating stories with which archaeologists entertain one another around field campfires or in the bars at professional conferences. As such, some of these deductions are not "statistically significant," and some have alternate explanations in the form of "competing hypotheses." They are, however, good stories, based on the best available scientific information and thousands of hours of analysis, study, and thought. I hope they make you think about the subject, but more than that, I hope you enjoy reading them as much as I enjoyed writing them.

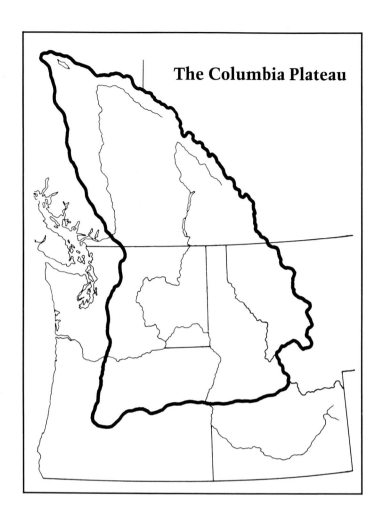

The Columbia Plateau

Map 2. *The geographical boundary of the Columbia Plateau, which consists of the drainages of the Fraser and Columbia rivers and the Hells Canyon portion of the Snake River.*

The Columbia Plateau and Its Artists

THE COLUMBIA PLATEAU EN-compasses the watershed of the Columbia River and its major tributaries (excluding the upper Snake River in southern Idaho) and the drainage of the Fraser River in south-central British Columbia (map 2). The region is bounded on the west by the Cascade Range, on the north by the divide between the Mackenzie and Fraser rivers, on the south by the northern Great Basin, and on the east by the Rocky Mountains. The plateau has a mild, dry continental climate with hot summers and cold winters. Temperature extremes range from −30 to 105 degrees Fahrenheit. Winters often have heavy snows, especially in the mountains; rain falls primarily in the spring and fall with occasional summer thunder-showers.

The northern Columbia Plateau is heavily forested with dense stands of fir and pine. Rushing streams and major rivers flow through narrow valleys that trend north to south. Numerous long, narrow, deep lakes (e.g., Flathead, Chelan, Priest, Kootenay, and Arrow) occupy glacially scoured portions of these valleys in western Montana, British Columbia, northern Idaho, and northern Washington. Mountain ranges throughout the area are often steep and severely sculpted by glacial erosion.

The central and southern portions of the region are an ancient basalt plateau formed by successive lava flows extruded from Miocene volcanos between 10 and 30 million years ago. In some places the basalts are more than ten thousand feet thick. Along the Columbia and Snake rivers successive layers form basalt rim-rocks that rise more than one thousand feet above the deeply cut rivers, forming Hells Canyon of the Snake River and the Columbia Gorge. Other major rivers in this part of the plateau, the Deschutes and John Day, also flow through deep, basalt-rimmed gorges. This part of the Columbia Plateau, more arid than the northern section, has typical vegetation of mixed short-grass and sagebrush prairie with scattered forests on uplands like the Wallowa mountains.

In the approximate center of the Columbia Plateau lie the channeled scablands ranging around Dry Falls near Coulee City. These pre-historic water courses, Hells Canyon on the Snake River, and the Columbia Gorge are all relict landscapes formed by immense floods from glacial lakes Missoula and Bonneville, which emptied during the melting and retreat of the Pleistocene glaciers twelve thousand to twenty thousand years ago (U.S. Geological Survey 1973).

Throughout the entire region, the most prominent topographic features are the steep sheer cliffs—basalt in the central plateau and granite, argillite, or metamorphic rocks in the surrounding mountains and foothills. On these cliffs, and in shallow rock shelters along lakeshores, streams, and ridge tops, are found more than 750 sites of the Columbia Plateau rock art tradition.

The Prehistoric Record
Clovis Culture

Archaeological evidence indicates that humans first came to the Columbia Plateau ap-

proximately twelve thousand years ago (10,000 B.C.). (See fig. 2.) These earliest immigrants, coming across the Bering land bridge from Asia and then moving south along the flanks of the Rocky Mountains or the Pacific coast, encountered a virgin land filled with herds of mammoth, mastodon, giant bison, ground sloths, and camels. They wandered from place to place, stopping to kill and butcher animals and camp in sheltered locations. Evidence of these early hunters—the characteristic *Clovis* fluted and lanceolate projectile points—has been found at a few sites scattered throughout the region: on the Snake River plain in Idaho, at the Dietz site in the northern Great Basin of central Oregon, at Wenatchee, and along the Columbia and Snake rivers, demonstrating that the hunters lived throughout the area. In the Pacific Northwest, the Manis Mastodon site near Sequim, Washington, on the Olympic Peninsula, is a kill and butchering site of these early people. Radiocarbon dates indicate that the mastodon dismembered here was killed more than eleven thousand years ago.

From these sites and others elsewhere in the West, we know that Clovis people were highly successful mammoth and mastodon hunters who had a variety of tools suited to performing the many different activities needed for living in this wild land. Dates for these sites are uniformly between ten thousand five hundred and twelve thousand years ago. Although their mammoth-hunting contemporaries in Europe and central Asia had a well developed artistic tradition that included both portable art and the world-famous cave paintings of France and Spain, the Clovis hunters apparently left no evidence in North America that they made rock art or portable sculptures.

Windust Phase

Following the Clovis hunters' initial immigration into the New World, a period of relative cultural stability lasted for almost three thousand years, although many of the large game animals, such as mammoth, camel, and giant bison, became extinct by ten thousand years ago. On the Columbia Plateau, projectile points show slight stylistic changes during this period. The characteristic Clovis fluted spear point gave way to a series of leaf-shaped and stemmed points called *Windust*. Named after a rock shelter in eastern Washington, where they were discovered, Windust points are radiocarbon dated to between approximately eight thousand and ten thousand five hundred years ago (8,500–6,000 B.C.). Living in the numerous rock shelters throughout the central Columbia Plateau, and in open campsites elsewhere, the Windust people, also nomadic hunters, preyed on deer, elk, birds, and small mammals. Salmon bones in the Five Mile Rapid site near The Dalles, dating about eighty-five hundred years ago, are evidence that salmon fishing was added near the end of this period.

Excavated materials from Windust Cave, Wildcat Canyon, Marmes Rockshelter, Lind Coulee, Five Mile Rapid, and other sites show that these early hunters had tool kits fully adapted to their seminomadic life style. Chipped stone tools included projectile points, knives, scrapers, choppers, and drills. Bone and antler artifacts included awls, eyed needles, fleshing tools, barbed points, beads, hammers, flakers, wedges, and atlatls.

Old Cordilleran Culture

After the Clovis and Windust period comes the *Old Cordilleran* culture (Cascade phase), dating from approximately eight thousand to sixty-five hundred years ago (6,000–4,500 B.C.) and demonstrating stylistic changes in artifact types. The characteristic bipointed Cascade spearpoint and edge-ground cobbles used for

2. A generalized chronology of cultures on the Columbia Plateau, with associated artifacts and rock art motifs.

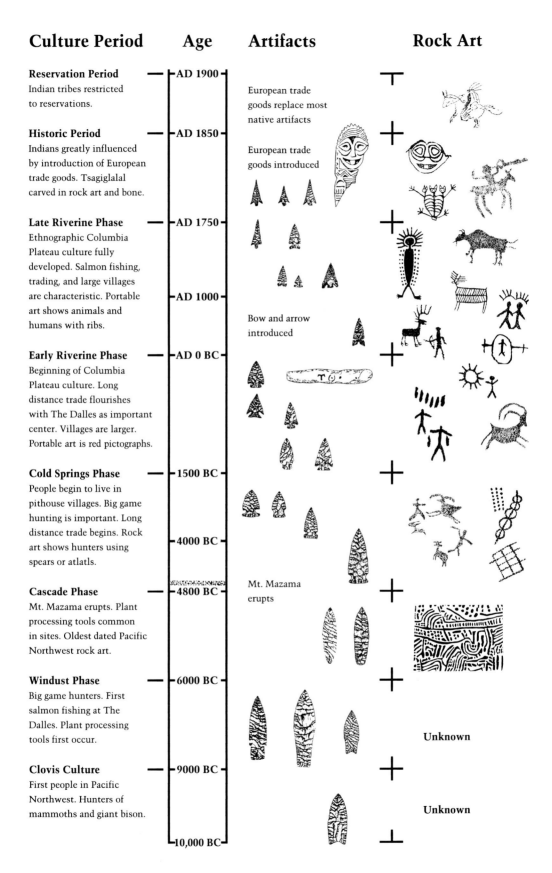

Culture Period | Age | Artifacts | Rock Art

Reservation Period
Indian tribes restricted
to reservations.

AD 1900

Historic Period
Indians greatly influenced
by introduction of European
trade goods. Tsagiglalal
carved in rock art and bone.

AD 1850

Late Riverine Phase
Ethnographic Columbia
Plateau culture fully
developed. Salmon fishing,
trading, and large villages
are characteristic. Portable
art shows animals and
humans with ribs.

AD 1750

AD 1000

Early Riverine Phase
Beginning of Columbia
Plateau culture. Long
distance trade flourishes
with The Dalles as important
center. Villages are larger.
Portable art is red pictographs.

AD 0 BC

Cold Springs Phase
People begin to live in
pithouse villages. Big game
hunting is important. Long
distance trade begins. Rock
art shows hunters using
spears or atlatls.

1500 BC

4000 BC

Cascade Phase
Mt. Mazama erupts. Plant
processing tools common
in sites. Oldest dated Pacific
Northwest rock art.

4800 BC

Windust Phase
Big game hunters. First
salmon fishing at The
Dalles. Plant processing
tools first occur.

6000 BC

Clovis Culture
First people in Pacific
Northwest. Hunters of
mammoths and giant bison.

9000 BC

10,000 BC

European trade
goods replace most
native artifacts

European trade
goods introduced

Bow and arrow
introduced

Mt. Mazama
erupts

Unknown

Unknown

food processing best identify this period. Other chipped stone and bone tools remained essentially the same as in the Windust period; hunting and fishing continued to be the primary mode of subsistence, although ground stone tools also indicate the use of plant foods. Old Cordilleran people hunted deer, elk, antelope, mountain sheep, and birds; took salmon and fresh-water mollusks from the rivers; and collected and processed berries and tuberous plants such as camas.

The Cascade phase provides the earliest reliable evidence for the presence of art on the Columbia Plateau. In Bernard Creek Rockshelter, along the Snake River in Hells Canyon, a pigment-covered spall from the roof was recovered from a level dating to this period, and in south-central Oregon a petroglyph with abstract line designs was found partially buried by a deposit containing ash laid down sixty-seven hundred years ago by the eruption of Mount Mazama (Cannon and Ricks 1986; Randolph and Dahlstrom 1977). These two occurrences clearly indicate that Old Cordilleran people made rock art in the Pacific Northwest.

Cold Springs Phase

Following the Old Cordilleran culture comes a three-thousand-year period of significant change on the Columbia Plateau that archaeologists have named the *Cold Springs phase*. The earliest Cold Springs phase sites immediately postdate the eruption of Mount Mazama. Archaeological evidence throughout the three-thousand-year span (4,500–1,500 B.C.) indicates that the western United States was somewhat hotter and drier than before or since. Archaeologists refer to this climatic maximum as the Altithermal period.

On the Columbia Plateau, the Cold Springs phase is marked by the appearance of various large, side-notched, projectile points and of microblades in the northern portion of the region. Both of these technological innovations facilitated hunting and butchering. Notched projectile points could be made smaller than lanceolate points, and thus could be more securely fastened to the short spears that were used with the atlatl, the throwing stick that greatly increased a hunter's power and range. Microblades produced significantly more usable cutting edge for each piece of stone that was flaked.

Archaeologists have characterized this period's cultural adaptation as one of increased trade and contact among local groups, with a corresponding elaboration of tools used for catching and storing fish, and gathering, processing, and storing wild roots and other plant foods. Sinkers, gorges, hooks, and fishing spears occur in Cold Springs sites, and for plant food processing the more efficient mortar and pestle largely replace the edge-ground cobble tools of the Old Cordilleran culture. Subterranean, rock-lined ovens for roasting camas were first used during this time. Recent archaeological excavations at several sites in the region have shown that people first began to live in pit house villages along major rivers during this period. Likely these villages, and the sedentism they imply, result from increased reliance on camas gathering and fishing as the major means of subsistence.

Although, for dating purposes, examples of portable art objects similar to rock art have yet to be found in Cold Springs phase sites, some of the petroglyphs in the region quite likely date to this period. Elsewhere in the western United States rock art flourished at this time. In the Coso Range of California, thousands of petroglyphs, dated between three thousand and five thousand years ago, show atlatl-using hunters and dogs chasing mountain sheep. Rock art of approximately the same age and similar style occurs throughout the Great Basin, even into south-central Oregon. On the Great Plains to the east, in Wyoming and South Dakota, petroglyphs showing hunting scenes with men pursuing bison and deer herds are called the early hunting style and are thought to be older than three thousand years.

Given the widespread occurrence throughout the western United States of pecked, hunting-style petroglyphs that were made more than three thousand years ago, it is likely that some of the mountain-sheep hunting scenes along the Columbia and Snake rivers also date to this period.

Early Riverine Phase

Beginning about thirty-five hundred years ago (1,500 B.C.) and lasting until the time of Christ is a period archaeologists call the *Early Riverine phase*. During this time, pit house villages became commonplace; roots, salmon, and shellfish were the primary food sources for Columbia Plateau groups. Increased use of adzes, whetstones, gouges, wedges, graving tools, and stone mauls used to make wood and bone items is evidence that wood and bone working became very important in Early Riverine villages. Corresponding to this technology is the occurrence in archaeological sites of portable art objects and the definition of localized art styles. A variety of large, corner-notched, and stemmed dart points dominate the chipped-stone tool assemblages from Early Riverine sites, indicating that hunting with spears and atlatls continued as an important activity.

Long-distance trade, begun in the earlier Cold Springs phase, became increasingly important during the Early Riverine period. Artifacts recovered from sites near The Dalles show that galena and slate were brought from west of the Cascades, obsidian was obtained from south-central Oregon, and nephrite for adze blades was brought from British Columbia. Apparently, even at this early date The Dalles area was an important trade center, as it was situated on the main access route between the Pacific Coast and the interior Columbia Plateau.

Because of the rise of wood, bone, and stone working during the Early Riverine phase, considerably more is known about the artistic traditions of these people than about those of ear-

lier plateau inhabitants. Artifacts recovered from cremation burials—excavated before inundation by The Dalles dam—included atlatl weights, beads, gorgets, pipes, and pendants, along with tools such as adzes, abraders, gravers, and mauls used in shaping wood. Portable art objects from sites of this period include sculpted mountain-sheep heads and a few other objects decorated with carved human and animal motifs. Although most known objects are from The Dalles area, one important painted item is a cylindrical stone with red designs, found at a site in southern British Columbia and dated to two thousand years ago (Copp 1980).

Given the artistic tradition evidenced by portable art from The Dalles, McClure (1984) suggests that some geometric petroglyphs, some of the mountain-sheep hunting scenes, and a few of the simpler human designs in The Dalles area date to this period. Some of the petroglyphs further upstream on the Columbia and Snake rivers are likely also this old. The painted stone from British Columbia hints that pictographs in that region may even date to the Early Riverine Phase.

Late Riverine Phase

The *Late Riverine phase* began approximately two thousand years ago and lasted until about A.D. 1720, when horses and Old World trade goods were introduced onto the Columbia Plateau. The Late Riverine period represents the material culture and life style of the ethnographically known Columbia Plateau Indians. Sites of this period are more common throughout the plateau than those of any other, and, using logical extensions and inferences from other ethnographically known cultures, we thus know more about these people's life styles than about those of earlier groups.

Archaeological sites include pit-house villages on most of the region's major rivers and lakes, and open campsites and rock shelters in the uplands and smaller stream valleys. Some

pit-house villages are quite large, with extensive artifact assemblages and storage pits that imply almost year-round occupation. Other settlements were smaller winter villages. Campsites demonstrate seasonal movements to exploit varied upland resources.

Artifacts from both villages and campsites include a wide variety of tools for fishing, hunting, gathering, and food processing, along with tools for working wood and bone and making decorative objects. The adoption of the bow and arrow, at the beginning of the Late Riverine period, with corresponding development of small-stemmed, side-, or corner-notched projectile points represents one major technological change. Exotic materials, such as shells, stone for arrowheads, and minerals, indicate an expanded trade network that undoubtedly also included perishable items—wood, hide, basketry, textiles, and feathers—that have not been preserved.

Accompanying increased sedentism and trade was a significant elaboration of art styles in places like The Dalles. Extensive working of bone and wood is indicated by a diverse assemblage of carving, cutting, and chopping tools and by carved items, often decorated or sculpted, such as bone harpoons, hairpins, pendants, awls, needles, beads, and dice. Stone items, including bowls, mortars, pestles, pendants, pipes, and incised pebbles, were shaped or figured with animal and human designs. Although The Dalles, because of its importance as a trade center and the presence there of a cremation burial complex, has produced the majority of these art objects, sites farther up the Columbia River and occasionally throughout the Columbia Plateau also yield numerous examples.

Soon after A.D. 1700, the historic period begins with the appearance of Old World trade goods in the cultures of the Columbia Plateau. The horse, introduced into the area about A.D. 1720 (map 3), and increasing contact with Old World traders and settlers substantially changed the social and economic patterns of the Late Riverine phase and ultimately destroyed this cultural pattern through decimation of the Indian populations by disease and the relocation of most survivors to reservations. In some respects, social change was greater on the eastern periphery of the plateau, where, for example, the Nez Perce and Flathead adopted many attributes of the Great Plains equestrian bison-hunting culture. Tipis, buffalo hunts, ceremonies, and warfare patterns were borrowed wholesale from neighboring northwestern Plains tribes such as the Blackfeet and Crow. Elsewhere on the Columbia Plateau, the horse culture made less impact, change was slower, and some groups in northern Washington and British Columbia were relatively unaffected until disease and European American settlement took their toll.

Columbia Plateau Culture

We can generally describe the life style of Columbia Plateau Indians in the early historic period if we keep in mind that specific details of customs, ceremonies, and socioeconomic systems varied from group to group (Teit 1928; Ray 1939). However, all Columbia Plateau groups shared basic themes of religion, methods of subsistence, and economics that were more similar to each other than to groups in any neighboring area.

Language and Government

Representatives of five language families inhabited the Columbia Plateau (map 4). North of the Columbia River, in Washington, interior British Columbia, northern Idaho, and western Montana, were groups who spoke Salishan languages: the Flathead, Coeur d'Alene, Kalispel, Sanpoil, Wenatchee, Okanagan, Thompson, Shuswap, and others. In far southeastern British Columbia, extreme northern Idaho, and northwestern Montana lived the upper and

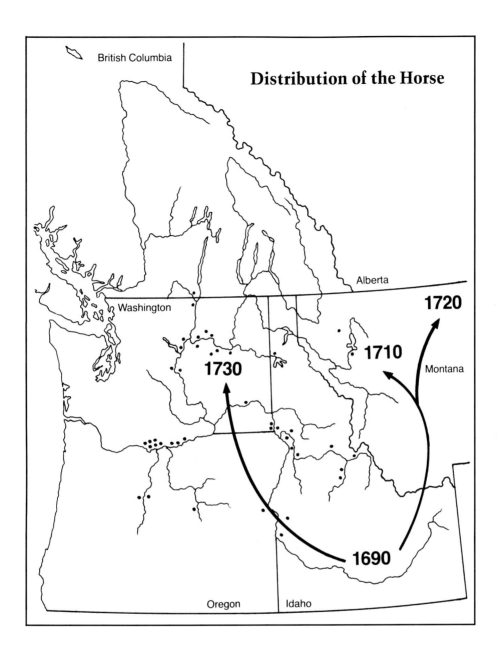

Distribution of the Horse

British Columbia

Alberta

Washington

1720

1710

Montana

1730

1690

Oregon Idaho

*Map 3. The introduction of horses on the Columbia
Plateau, and distribution of the horse motif in
Plateau rock art. Each dot indicates a site with a
horse shown. Dates indicate arrival of horses in
various areas of the region; arrows show probable
routes of diffusion. Sources for this map are
Boreson (1976), Haines (1938), Keyser and Knight
(1976), Leen (1984 and 1988), and McClure
(1979a and 1984).*

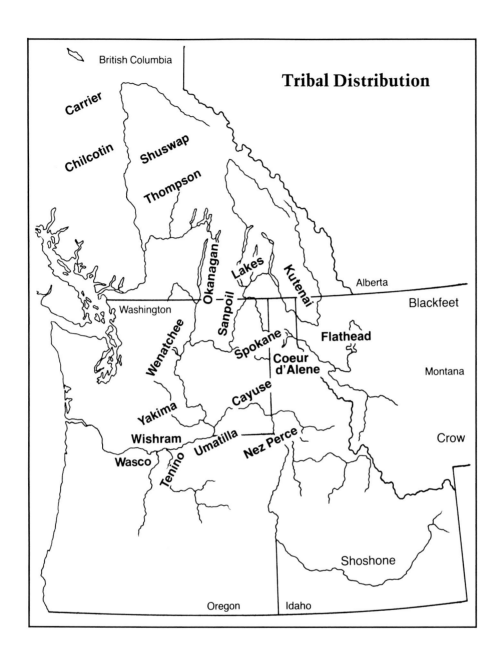

Tribal Distribution

British Columbia

Carrier

Chilcotin

Shuswap

Thompson

Okanagan

Lakes

Kutenai

Alberta

Blackfeet

Washington

Sanpoil

Spokane

Flathead

Coeur
d'Alene

Montana

Wenatchee

Yakima

Cayuse

Nez Perce

Crow

Wishram

Umatilla

Tenino

Wasco

Shoshone

Oregon

Idaho

*Map 4. Distribution of Indian tribes on the
Columbia Plateau. Shoshone, Crow, and Blackfeet
are Great Basin and Plains groups living on the
southern and eastern edges of the region.*

lower Kutenai who spoke the Kutenai language. Far to the north, in the upper Fraser River drainage, were the Athapaskan-speaking Chilcotin and Carrier groups.

In the central and southern portions of the Columbia Plateau, in a broad band extending from central Idaho across southern Washington and northern Oregon, most groups were Sahaptian speakers. Among these were the Nez Perce, Umatilla, Tenino, and Yakima. At The Dalles lived the Wishram and Wasco, the only interior representatives of the Chinookan language family. These two groups are important primarily because of their strategic location at the major fishing and trading center of the area and the spread of Chinook Jargon—a widely understood trader's language—throughout the Columbia Plateau and adjacent regions.

Columbia Plateau "tribes" lived in autonomous villages (or bands in areas like western Montana, where partially sedentary villages were uncommon) to whom members gave their allegiance and from whom they received their identity. Villages or bands had chiefs who "governed" through charisma and group consensus rather than through true political power. Chiefs were always men, though a few important women exercised some charismatic leadership. Band chief was a more-or-less hereditary position, usually passed from father to son, or uncle to nephew. People were free to change village membership within their tribe, and even to neighboring tribes, and did so frequently either through marriage or simply from the desire to change situation. Villages controlled local hunting and gathering areas and fishing places, but trespass by other groups was frequent and was not usually considered a serious offense.

Government was by informal council, not a permanent body of people but an open meeting where anyone could attend and speak. Some bands had a casual caucus of elders who presided over council meetings. Intergroup disputes were solved by the chief's mediation or

by movement of one of the protagonists to another group. The councils selected important individuals to lead various activities, usually because of their superior skill and possession of appropriate guardian spirits. Thus, an older woman was put in charge of the major springtime root-gathering expedition, and a man was named as hunt chief—sometimes a different person for each species of big-game animal hunted. Expedition leaders were also named for berry picking, salmon fishing, warfare, and even other tasks. Leaders coordinated the expedition and directed the activities of the participants, and were responsible for conducting the ceremonies designed to insure the venture's success and for distributing the catch or harvest. Often these two aspects were joined through celebrations: during the First Fruits or First Salmon ceremonies, families in a band would be allotted their share of the products obtained.

Economy and Subsistence

Trade was a key element of the Columbia Plateau economy; it served both to bring in items not obtainable locally and also to redistribute food products to areas of seasonal scarcity. Most trading centers were on rivers, often at major falls with important fisheries. Kettle Falls in northeastern Washington was a significant center for groups to the north in British Columbia and east in Idaho and Montana. Okanagan Falls served the same purpose for groups in southern British Columbia and north-central Washington.

The largest and best known of these trading centers, however, was The Dalles at the east end of the Columbia Gorge. The Dalles attracted people from throughout the Columbia Plateau, up and down the Northwest Coast, and the northern Great Basin. Historic records indicate that travellers came here from as far away as the southern coast of Alaska, northern California, and the Mandan villages on the upper Missouri River in North Dakota. Not only

important regionally, The Dalles was one of the major trading centers in all of North America. Items that changed hands here included slaves, obsidian, nephrite for bead and adze manufacture, dentalium and other shells from the Pacific Coast, buffalo hides and skin bags from the Plains, fish oil, carved wooden and bone objects, horses, furs, feathers, woven blankets, baskets, metal utensils, and specialty food items. Because of its importance for trade, The Dalles area was heavily populated. In fact, for the five hundred years before A.D. 1800, major villages at The Dalles were the primary settlements between the Missouri River and the north Pacific coast that approached the status of permanent towns.

The subsistence economy of almost all Columbia Plateau tribes was based primarily on salmon fishing, though gathering of wild roots, nuts, and berries and hunting of various large and small game animals were also very important. Villages had between 50 and 100 inhabitants; a few of the larger contained as many as 200 individuals. At key fishing and trading centers, such as Kettle Falls and The Dalles, as many as 400 to 500 people would congregate for short-term "trade fairs."

Villages, located along the larger rivers and lakes, usually had a number of permanent pit houses. These semisubterranean structures, often as large as twenty to thirty feet across, were constructed by digging a shallow circular or rectangular pit, erecting a beam framework, and covering it with planks, mats, or brush and, finally a thick layer of earth. Entrance was via a ladder through a hole in the roof that also served as a smoke hole for the central fireplace. In some areas houses were constructed above ground and covered with planks, bark, or mats. In most of the region these were summer houses, made during hunting or berrying trips, but in the northeastern Columbia Plateau such structures were used throughout the year.

The Indians occupied villages primarily during the winter and the salmon fishing season, but old or injured people might remain year-round. In the spring, by late March or April, small groups of several families each would move out from the villages to gather roots. Women gathered camas, bitterroot, wild onions, and lilies, the primary root crops, with digging sticks and baskets and roasted them in large, underground, stone-lined ovens. After roasting, the roots were mashed, formed into cakes, and dried for storage as winter food.

Fishing began at the beginning of May. Salmon, steelhead, sturgeon, and smaller fish were caught—salmon and steelhead with spears, dip nets, and a variety of traps and wires; sturgeon and smaller fish with hook and line. An important communal religious ritual, the First Salmon ceremony celebrated the staple food of so many Plateau tribes. This ceremony and all other aspects of the fishing season were supervised by the *salmon chief*, who was responsible for controlling the fishing and distributing the catch. Often the salmon chief was a shaman, or someone who had the salmon as his guardian spirit. During the fishing season, which lasted until October, fish were dried and smoked or processed for oil. Most of the catch was stored to provide food for the winter. The Flathead, some of the Kutenai, and the northern Okanagan, who were without dependable salmon runs, hunted in summer or traveled to places such as Okanagan Falls or Kettle Falls to fish.

By September, some of the men in all parts of the region had quit fishing and had journeyed to the uplands to hunt. Indians hunted deer, elk, and mountain sheep throughout the Columbia Plateau; caribou, bear, moose, and mountain goats in the northern forests and mountains; and antelope and occasionally bison on the open basalt plateau. Small game was hunted year-round throughout the region and waterfowl were taken during spring and fall migrations. Hunting involved both individual and communal methods. Individuals stalked game, sometimes wearing disguises to aid in their approach. In communal hunts, groups of "drivers" herded animals—most

commonly deer, elk, mountain sheep, and mountain goats—into wooden corrals or woven nets, or to natural areas such as canyons or ridges where archers were stationed. A skilled man having an appropriate guardian-spirit helper was named hunt chief; he controlled the operation and attendant ceremonies and distribution of the catch.

Meat from the hunt, dried or smoked, was frequently ground and mixed with fat and berries to make pemmican, which could be stored. During the hunting season, women picked serviceberries, huckleberries, strawberries, wild cherries, and many other kinds of wild fruits for drying or for combining with meat or salmon in pemmican. Hide bags and bark baskets were used to transport and store berries.

During the historic period, after the introduction of the horse, groups from eastern Columbia Plateau tribes made summer buffalo-hunting expeditions to the northwestern Plains. Such trips probably had been made occasionally before the horse arrived, but the adoption of horse culture enabled the Indians to make them an annual event. The Indians also often conducted war parties and horse raids on these hunting trips. The horse became so important to these eastern tribes that they adopted many other traits of Plains culture, including the tipi, parfleche storage bags and other gear, and the Plains system of warfare and coup counting. Some bands of the Nez Perce, Cayuse, Flathead, and Kutenai were so strongly influenced by these traits that in many respects they resemble Plains tribes more closely than they do their Columbia Plateau relatives. Throughout most of the western and northern Columbia Plateau, however, horse culture made little impact until after the advent of reservations.

Social and Religious Life

At the onset of winter, groups returned to their villages, by now well stocked with meat, fish, berries, and roots. Winter was a time of minimal subsistence efforts, apart from hunting. Primary winter activities were dances, shamanistic rituals, and ceremonies. Neighboring villages often coordinated these so that all members could participate in a series of events at different sites. These ceremonies alleviated the boredom of long periods of forced inactivity, helped to dissipate tensions built up over the year, and strengthened intergroup contacts and alliances.

Groups on the Columbia Plateau were patrilineal and patrilocal; that is, descent was traced through the male, and married couples lived in the man's house, often in association with his brothers or uncles. Tasks were divided fairly strictly along sexual lines, with warfare, hunting, and fishing being men's province, and plant gathering and processing of foodstuffs women's responsibility. Both sexes participated in ceremonies, gambling games, and religious rituals. Many Columbia Plateau groups had slaves, captured directly from other tribes in warfare or obtained through trade (these slaves were almost always initially war captives). Women slaves often married and integrated into the group.

Columbia Plateau religion centered around public ceremonies such as the previously mentioned First Fruits and First Salmon rites. These appeased the spirits that the Indians believed inhabited all things, and thereby ensured world renewal. Ceremonies and wintertime dances and rituals brought people together to validate the group's place in the natural world. However, the most important aspect of religion for an individual was the concept of a guardian spirit. Verne Ray, an ethnologist who specialized in Columbia Plateau Indian cultures, has written, "Perhaps nowhere in America did the guardian spirit concept play so great a role as among the Salishan groups of the Plateau" (1939). There, a person needed a spirit helper to survive, and many people had multiple guardian spirits, each of which aided in a different part of life.

Both men and women sought guardian spirit helpers through the *vision quest*. Initially, this ritual came at puberty as part of the rites of passage that marked the transition from childhood to adulthood. For girls, the quest coincided with the onset of menstruation; for boys it occurred in the early teen-age years. To obtain a guardian, the supplicant would go to a secluded place, often one where such spirits were known to reside. There the person contacted the spirits by keeping a vigil of one to three days, during which time he or she fasted, prayed, and performed a variety of tasks designed to demonstrate worthiness. Sweat baths were taken in conjunction with the ceremony, and women in some groups rubbed or whipped themselves with fir branches. Often a supplicant built a small circular stone structure or cairn at the vision quest site.

Spirits were the soullike aspect attributed to nearly all natural things: animals, birds, insects, plants, celestial bodies, and some inanimate objects such as rocks and mythical beings. During a successful vision quest, a spirit appeared to the supplicant in a dream or vision. The spirit would assure the seeker of its aid in such activities as warfare, hunting, love, and healing. The spirit would provide rituals, songs, and dances that could be used to invoke its assistance in times of need. Pictographs were often painted afterward to commemorate these visions (Cline et al. 1938; Malouf and White 1953). Thus, many Columbia Plateau rock art sites represent these images of forgotten dreams.

Western Montana:
The Eastern Columbia Plateau

WESTERN MONTANA EN-compasses the Columbia River drainage that lies west of the continental divide. This area is one of broad, north-south trending river valleys separated by steep, rugged, heavily forested mountain ranges. Larger valleys are open, grassland parks. The Clark Fork of the Columbia River and its primary tributaries, the Flathead and Bitterroot rivers, drain most of the well-watered region. The northwestern corner of the state is part of the watershed of the Kootenai River, another major tributary of the Columbia. Flathead Lake, the largest natural fresh-water body in the western United States, is a small remnant of glacial Lake Missoula, which emptied at the end of the Pleistocene epoch approximately fifteen thousand years ago.

Western Montana's rock art was first studied in 1903 by John Morton Elrod, a biology professor from the University of Montana, who described the Painted Rocks site, almost directly across Flathead Lake from the biological sta-

tion where he worked during the summer (Elrod 1908). About fifty years later, Carling Malouf, a University of Montana anthropologist, studied this and other sites in the area and collected data from Indian informants on the origin and function of these paintings (Malouf and White 1952, 1953). Not until 1976, however, was all of the region's known rock art summarized and professionally reported (Keyser and Knight 1976). During the past decade a few additional sites have been found and described.

The Rock Art

Scattered throughout western Montana, and at a few sites just east of the continental divide in the Rocky Mountain foothills, are approximately thirty-five pictograph sites of the Columbia Plateau rock art tradition. Almost all of these are red, though yellow or black pigments were used for one or two figures at six sites. The only polychrome paintings are red and yellow figures at one site in the Bitterroot valley and another by Flathead Lake. The region's single petroglyph is a large geometric abstract lightly abraded over red pictographs at a site on the lower Flathead River (fig. 3).

Only three western Montana sites have large concentrations of pictographs with as many as fifty separate figures. These obviously repre-

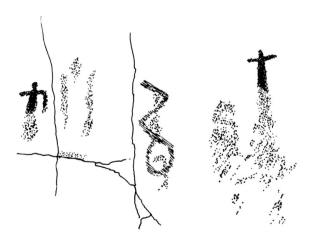

3. The only petroglyph found so far in western Montana is this zigzag and circle abstract (hatchured design in center of illustration) lightly abraded over red paint smears (stippling) associated with stickmen.

sent repeated visits by numerous artists. Most sites have fewer than twenty designs and are likely the product of a handful of artists, each of whom visited the site once or twice. Several sites have simply a few figures drawn in a structured composition by a single painter.

Site preservation in western Montana is relatively good. In contrast to those in the middle Columbia River region, few sites have been damaged or destroyed by dam construction or road building. Vandalism, in the form of scratched or painted names and initials, is usually relatively minor, although it occurs at most sites.

Pictograph sites cluster in several areas of western Montana, notably near Kila in the Flathead valley, around Flathead Lake, near Perma on the lower Flathead River, and in the upper Bitterroot valley. At Painted Rocks, two large sites are at opposite ends of a high, sheer cliff on the west shore of Flathead Lake. These show painted deer and bison, tally marks, and geometric figures. At Kila, five separate sites are painted on the small broken cliffs along the north side of the Ashley Creek valley (fig. 4; fig. 5). These have paintings of bison, a horse, other animals, humans, men in canoes, abstracts, a "sunburst," and tally marks. The two larger sites, protected by highway department

fences, offer the casual visitor an opportunity to view excellent examples of rock art. These pictograph clusters, and others, clearly indicate that some locations were favored places for painting. The sites here document repeated visits by numerous artists, who conducted rituals and painted the multitude of interesting figures.

Designs in western Montana rock art fall into four major categories: human figures, animal figures, tally marks, and geometric motifs (fig. 6).

Human Figures

Paintings of humans occur at more than 75 percent of western Montana sites (fig. 7). The great majority of these are simple stick figures, although a few block-body and outline forms also occur. Phallic representations identify some as men, and breasts identify a woman in a hunting scene in the Bitterroot valley (fig. 8). Hands and feet appear on a few figures, but the rayed arc headdress so common on the western Columbia Plateau is not found here. Action oc-

4. Stickman and animal painted at a site near Kila in western Montana. Compare these figures to those of the Long Lake pictographs in fig. 46.

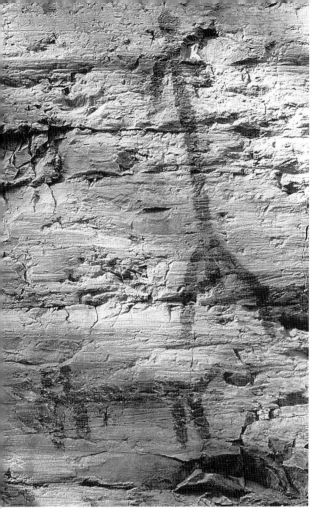

a shield bearer is a red and yellow polychrome, another is painted entirely in yellow. These shield figures are similar to those found throughout the northwestern Plains and in a few southern Idaho sites.

Another specialized human representation is people in canoes, shown at one site near Kila (fig. 10). Here, several human figures are arranged as if they were standing on a horizontal line. Nearly identical depictions were used in the rock art of the Great Lakes region to represent people in canoes, and such water transport was common throughout the Columbia Plateau.

Animal Figures

Animal pictographs are more numerous than human figures, although they are found at slightly fewer sites. Generally they are simple, solid-colored, block-body or stick figure forms,

5. The Kila pictographs show several instances of stickmen associated with animal figures. This association appears to represent vision quest symbolism in Columbia Plateau rock art.

curs rarely, most notably as a horse and rider or a hunting scene with humans and a dog chasing an animal. In many instances a human figure is closely associated with an animal or geometric design in a structured, static composition.

One specialized type of human figure occurs at two sites in the southern Bitterroot valley. These shield-bearing warriors hold large circular shields in front of their bodies so that only heads and legs are visible (fig. 9). Several wear horned headdresses, and one carries a weapon projecting from behind the shield. At one site,

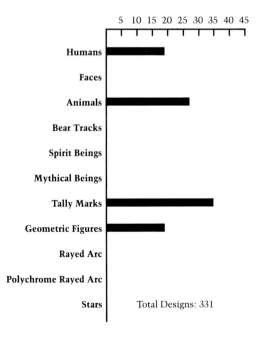

Western Montana Percent

6. Percentages of motifs in western Montana rock art.

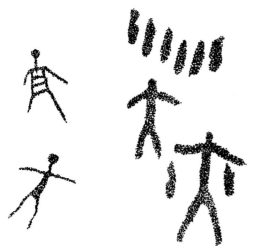

7. *Simple stick figure humans are the most common pictograph designs in western Montana. Many have associated tally marks.*

8. *This Bitterroot valley pictograph shows a communal hunt with a woman and a dog participating as "drivers" to direct the game toward the waiting hunter.*

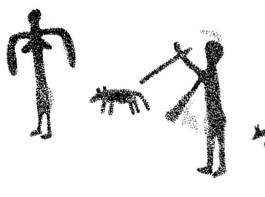

9. *Shield-bearing warriors found at two Bitterroot valley sites indicate Plains or Great Basin influences. Hatchured areas are yellow pigment; figure at far left is polychrome.*

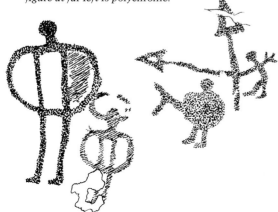

representing large mammals. A few, shown upside down or in a vertical position rather than the normal horizontal orientation, may show dead animals to indicate hunting activities (fig. 11). Herds of deer or bison at three sites further suggest a hunting emphasis for some of this art. Fewer than 25 percent of the animal figures in western Montana have sufficient anatomical detail for identification of species, but bison, deer, mountain sheep, horses, a dog, a bird, and a turtle are known (fig. 12). Bison are usually shown as bulky, hump-backed animals, but two painted at a site near Kila show horns, hump, ears, tail, tongue, and hooves. These are the most detailed, finely painted animal figures in the region (fig. 13).

Deer and elk, the most common big game animals in western Montana, can be identified at three sites (since the animals are similar and the medium imprecise, I make no attempt to differentiate these species unless there is a compelling reason to do so). Deer at two sites have well-defined antlers, now partially obscured by natural mineral deposits. The other occurrence is a herd of deer painted at a site near Perma (fig. 14). Although none of the animals has antlers, their positioning gives an extremely realistic impression of a nursery herd composed of does and fawns. A strikingly similar scene is painted at a site on Kootenay Lake, 175 miles away in southeastern British Columbia (fig. 29).

The dog, shown with characteristic upraised tail, is part of a hunting scene that resembles others found throughout the Columbia Plateau (fig. 8). Two mountain sheep are back-to-back figures with the identifying swept-back horn shape. The bird and turtle, both somewhat abstract, are painted together at a small site consisting of only five figures (fig. 15).

Horses are shown at two sites. One is being led by one human and ridden by another. The other horse is finely drawn, with flowing mane and tail and C-shaped hoof, in a style resembling that used to draw horses at northwestern Plains sites several hundred miles to the east.

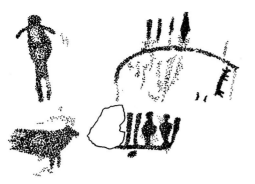

10. This crowded panel at Kila shows a human, animals, people in a canoe, and a geometric design. Note the small animal at the extreme right, painted in a "killed" posture.

11. This upside-down bison painted at Kila may represent a dead animal. The details (including C-shaped hooves) on this figure are similar to those on the other bison from this site (fig. 13).

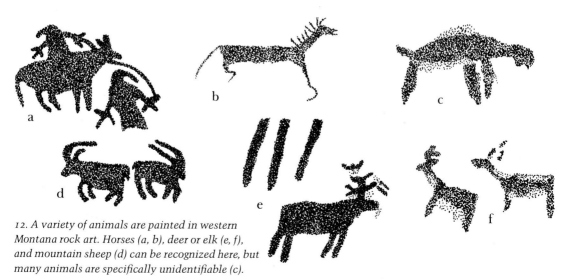

12. A variety of animals are painted in western Montana rock art. Horses (a, b), deer or elk (e, f), and mountain sheep (d) can be recognized here, but many animals are specifically unidentifiable (c).

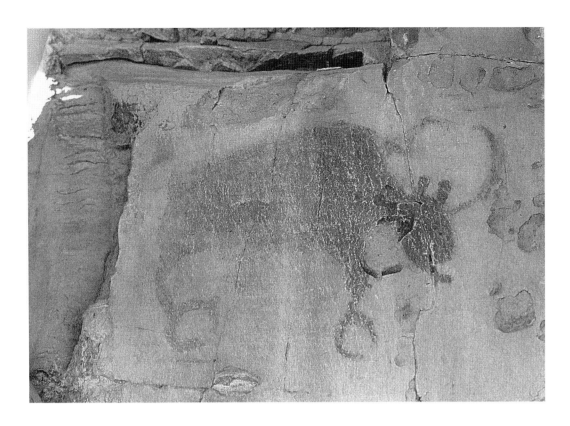

13. *This bison at the Kila pictographs is the most finely drawn animal in western Montana rock art. Note the intricate detail of hooves, horns, hump, ears, tail, and tongue.*

14. *A very realistic deer herd is painted at one Flathead River site. Compare this to the herd shown in fig. 29.*

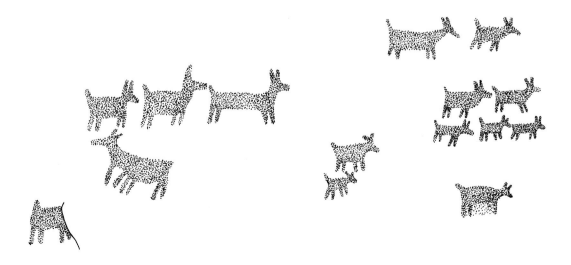

15. Western Montana pictographs (above) showing a bird, turtle, and other figures in somewhat abstract form.

16. Stickmen and tally marks characterize the pictographs of western Montana.

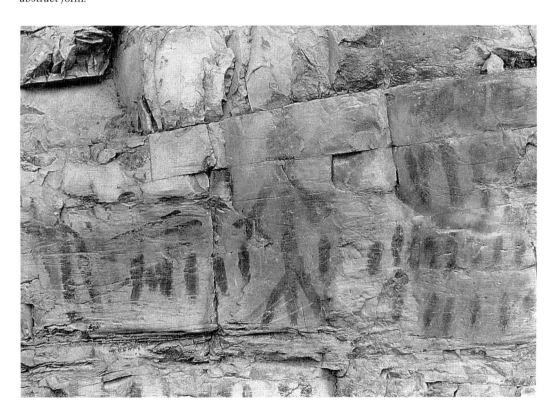

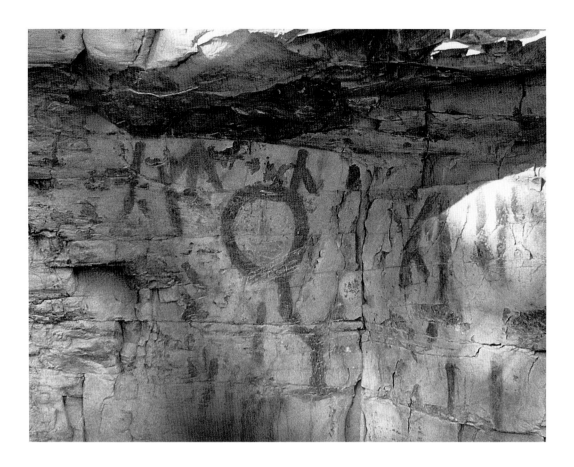

17. Tally marks are often associated with geometric figures in western Montana pictographs.

18. Various geometric designs are painted in western Montana rock art. The upper right figure may represent people in a canoe.

Tally Marks

Tally marks—horizontally oriented series of short, evenly spaced, vertical lines—are the most common design element in western Montana rock art (figs. 16,17). They occur in series of from two to more than twenty marks, with usually several series at a single site, though some have more than a dozen series totalling as many as 100 strokes. Although varying in size and spacing from one group to another, marks in any particular series are almost always well painted and consistent in length, thickness, and spacing.

Tallies have been interpreted variously as counts of days, people, animals, or other objects, but probably some also are mnemonic devices for recalling the steps necessary to complete a religious ritual or ceremony (similar to the function of rosary beads). Their number, placement, and consistently good execution indicate that they were a very important part of this area's rock art.

Geometric Figures

For descriptive convenience, a large group of various designs—rayed and simple circles, ribbed and "rake" figures, zigzag lines, crosses, dots, and complex abstract drawings—is classified as geometric. Generally, geometric figures are well-drawn, apparently intentional designs, not merely "doodles." Their execution and similarity of form throughout the Columbia Plateau suggest that many of them may have had true symbolic meaning for their creators (fig. 18).

Circles, rayed circles, dots, and crosses are most common. Some undoubtedly represent the sun, moon, stars, and meteorites, all of which were important in the cosmology of Columbia Plateau tribes. Groups of dots or circles in various arrangements are found at numerous sites, often associated with human or animal figures. Rakes, ribbed figures, and zigzags, probably symbolic, occur in fewer numbers.

Many sites also include geometric abstracts. Most are simple, like circles with trailing lines, but others are quite complex figures composed of "spoked" or concentric circles, rectangles, and appended lines. A circle with one or two trailing lines occurs at several sites, and may have had a standard symbolism.

Interpretations

Western Montana rock art appears to represent two separate traditions, each reflecting a different cultural influence. Two sites near the headwaters of the Bitterroot River show shield-bearing warrior figures whose style resembles rock art of the northwestern Plains and the Snake River plain of southern Idaho more than rock art on the Columbia Plateau (fig. 9). Shield-bearing warriors are quite common in Plains and northern Great Basin rock art, where they have been attributed to Shoshonean-speaking artists. Shoshones sometimes lived in the upper Bitterroot valley and in territory to the south and east, it therefore seems likely that they painted these warrior figures, which thus relate more closely to rock art of south-central Montana or southern Idaho.

The other pictographs in western Montana belong to the Columbia Plateau rock art tradition. Many are located in relatively inaccessible places, either high on cliff faces or on lakeshore cliffs or islands reached only by water. The drawings are not closely associated with major villages or occupation sites. Simple animal shapes significantly outnumber humans, which are usually drawn as stick figures or block-body forms. Often animals, humans, and geometric designs are closely associated in structured relationships (fig. 19).

Typical designs found at these sites resemble those painted elsewhere on the Columbia Plateau more than they do rock art of any other adjacent area. For example, the bison at Kila are stylistically similar to bison painted at sites on the Columbia and Snake rivers in Washington and Idaho. The deer herd at Perma

19. *Animals are often associated with geometric designs. At this Flathead Lake site a group of painted ovals surrounds an unidentified animal.*

animal figures shown with little anatomical detail, contrasts markedly to northwestern Plains art, in which humans and animals often show eyes, ribs, hands, feet, hooves, and heartlines. A study of the rock art at Writing-On-Stone (Keyser 1977), just east of the Rocky Mountains, shows that northwestern Plains human figures are of several characteristic types categorized by body styles, and that more than 90 percent of the animals have anatomical detail sufficient to identify species. Furthermore, typical northwestern Plains designs, such as V-neck humans, shield-bearing warriors, guns, tipis, and battles, are rare or absent in Columbia Plateau paintings. Conversely, tally marks, sunbursts, and stick figure humans, common on the Plateau, are very rare in northern Plains rock art.

is almost identical in both style and composition to one depicted in southeastern British Columbia. The hunting scene resembles others in central Idaho, Washington, and British Columbia. Sunbursts, simple circles, ribbed figures, zigzag lines, and crosses are all common elsewhere in Columbia Plateau rock art (fig. 20). As one might expect, pictographs in the northern part of the area show closest stylistic similarity to those in British Columbia, northern Idaho, and northeastern Washington, while those in the southern Bitterroot valley appear more similar to ones in central Idaho and Hells Canyon.

Tally marks are equally characteristic of Columbia Plateau rock art and are the most common design element in western Montana pictographs, occurring at more than 75 percent of the sites, often in large numbers (fig. 16). Sites in central Idaho, northeastern Washington, and southeastern British Columbia also have tally marks in similar quantities.

Western Montana rock art is clearly distinct from that of the northwestern Plains, just east across the continental divide. The general Columbia Plateau style, of simple human and

20. *The sunburst is a common design in western Montana rock art. This pictograph is painted near Kalispell.*

The extreme stylistic distinctions between Columbia Plateau and northwestern Plains rock art make it easy to identify the few Plateau-style sites that occur along the eastern flanks of the Rocky Mountains. From southwestern Alberta to the Missouri River headwaters just east of the continental divide in southwestern Montana, a few sites in isolated foothill locations show simple red pictographs of stick figure humans, tally marks, sunbursts, and animals. About ten of these sites have been described and reported (Keyser 1978, 1979, 1981); a few others are known but as yet unrecorded. Bands of Kutenai and Flathead Indians, living just east of the continental divide in late prehistoric times, were probably the artists responsible for these Columbia Plateau style pictographs.

Western Montana pictographs apparently relate to both vision questing and hunting magic. Among plateau tribes, a person seeking supernatural power would go to a secluded place to pray for intercession by a guardian spirit, which revealed itself through a "vision" in the form of an animal, celestial object, or mythical being (Teit 1928; Cline et al. 1938). Afterward, the supplicant painted a pictograph to commemorate the experience. Sometimes special events important in a person's life were also recorded as rock paintings.

Many western Montana pictographs record vision quests (Keyser and Knight 1976). These sites occur in relatively inaccessible, isolated areas like those chosen for vision quests. The predominant designs show humans, animals, sun symbols, dots, crosses, and geometric abstracts. The frequent, intimate association of human figures with animals or abstract designs apparently represents pictographically the appearance of a guardian spirit, as an animal or object, to the vision seeker (fig. 21).

Western Montana pictographs also pertain to hunting. The most obvious example, a well-illustrated scene in the Bitterroot valley, shows all the components of a Columbia Plateau hunt: a hunter spears the quarry, and a woman and dog help to drive the animal to the desired location where the hunter makes the kill (fig. 8). Other animals painted at several sites are recognizable as bison, deer, or mountain sheep—the major game animals of the region. Some are shown as herds, others are painted in upside-down postures indicating death (fig. 11).

21. Vision quest symbolism shows associations between humans, animals, and geometric designs.

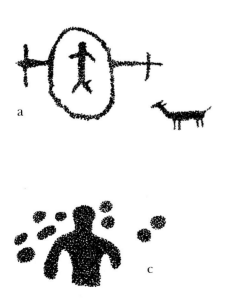

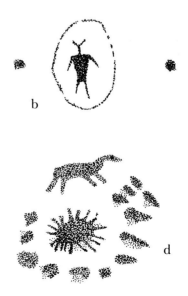

Game animal pictographs and the hunting scene probably represent "hunting magic," conducted either before the hunt to control the animals or afterward to propitiate their spirits. As did many hunting groups around the world, Columbia Plateau tribes thought that animals had spirits controlling their behavior. Certain rituals could appeal to these spirits, convincing them to allow the animals to be killed for the good of the human group. Related ceremonies, conducted after a successful hunt, "thanked" the animal spirits for their cooperation. These ceremonies were the prerogative and responsibility of the hunt chief selected because he possessed a guardian spirit that provided "power" over certain animals or fish. Thus, hunting-related pictographs are likely to be the result of such ceremonies led by the hunt chief either before or after a hunt.

The exact age of most western Montana pictographs cannot be reliably determined. Sites at Kila and at the south end of Flathead Lake include horses, dating them to the historic period after A.D. 1700. However, most sites contain no historic items, and thus probably date to prehistoric times. The hunting scene from the Bitterroot Valley shows a man with a spear, but many other Columbia Plateau hunt pictographs show archers using bows and arrows, which were introduced into the region between two and three thousand years ago. The Bitterroot valley hunting scene is painted on a hard, dense, rock surface and is somewhat protected by an opaque mineral deposit precipitated on the figures, making them very durable. Pictographs in other areas of the world (e.g., Spain, Africa, and Australia) are known to have survived at similar open sites for more than five thousand years. The fact that pictographs can last this long, coupled with the apparent durability of this particular site, makes it possible that this painting could predate the introduction of the bow and arrow, and thus be older than two thousand years.

Other paintings in western Montana could also be of considerable age. Several larger sites have many designs that show noticeable differences in weathering, fading, and obscuring by mineral precipitates and lichens. At Painted Rocks, a large chip bearing the forequarters of a painted animal flaked away, and a later artist painted dots and a line on the fresh surface. A site near Perma has the region's only petroglyph superimposed on a "wash" of red paint associated with a human figure. While instances of weathering or superimposition do not provide a specific date, they do indicate that the practice of making rock art lasted for a considerable period of time. Elsewhere on the Columbia Plateau, pictograph fragments recovered from dated archaeological contexts indicate that rock art in the region has been made for the past six thousand years. The evidence of weathering on western Montana pictographs suggests significant age for some of these designs, since photographs of two Flathead Lake sites clearly show that weathering of these paintings has been negligible in the last fifty to eighty years. Taken together, these clues suggest that most of the paintings in western Montana were painted during the past two to three thousand years, with the most recent dating to the historic period between A.D. 1700 and A.D. 1900.

Images of Forgotten Dreams

AMONG THE SALISH AND Kutenai tribes of the Columbia Plateau, the guardian spirit quest played a major role, for in this way a person acquired a spirit helper to insure success in life. In this ritual, a man or woman sought to obtain a guardian spirit by retreating to a secluded, sacred place to fast and pray. During this vigil, the supplicant hoped that a spirit would appear in a dream or vision, and would provide sacred items, songs, and rituals that the individual could use in his daily life. Spirits of animals, birds, mythical beings, and the sun and stars served as guardians to assist in hunting, fishing, love, warfare, and gambling.

Lasso Stasso, an elderly Flathead Lake Kutenai, described firsthand his vision quest experiences, which occurred about 1900 (Malouf and White 1952): "When I was about age 13, I went up on top of Chief Rock, near Dayton. . . . Up there is a little circle of stones where we would lay. All kinds of spirits dwell up there, like birds, animals, rocks, everything. Coyote spoke to me up there one night. . . . He also gave me a song. Deer gave me the power to hunt successfully, while fawn still later gave me gambling power. . . . Fawn came when I was 14 or 15. They all gave me good songs to use. . . . It is the song that does it. The power is in the song."

To commemorate a successful vision, the supplicant would finger-paint pictographs of the guardian spirit or other dream subjects at the site (fig. 22). Often both pictographs and a rock structure, like the "little circle of stones" mentioned by Lasso Stasso, are found together. There is even a pictograph associ-

22. *Vision quest rock art from the Columbia Plateau: a, Hells Canyon; b, western Montana; c, southern British Columbia; d, Spokane River, central Columbia Plateau.*

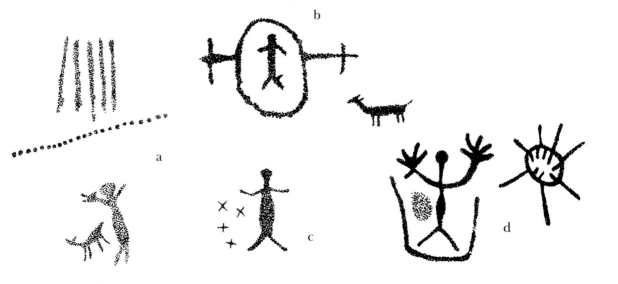

ated with Chief Rock, where Stasso sought his visions.

The linking of pictographs with vision quests was so strong in the northern Columbia Plateau that the presence of paintings was thought to indicate a very sacred place, where powerful spirits dwelt. Supplicants often sought visions at such pictographs and then added their own paintings. Baptiste Mathias, another elderly Kutenai, attributed pictographs at Painted Rocks on Flathead Lake to spirit beings, who painted there long ago so that people would go to that place to obtain spirit power (Malouf and White 1953). Successful vision seekers then painted "signatures" on the rock to record their own visions.

Among the Okanagan Indians, rock paintings were very propitious places for adolescents to seek and acquire a guardian spirit. Paintings made to commemorate successful experiences assisted the vision seeker later in life when he employed his spirit power (Cline et al. 1938). Undoubtedly, this is how sites like Kila and Painted Rocks in western Montana (fig. 22 b), Long Lake near Spokane (fig. 22 d), and Seton Creek, Cayuse Creek, and Pavillion Lake in British Columbia (fig. 22 c), grew to be the major concentrations of rock art we see today.

The modern observer finds in the vision quest pictographs more than mere representation. In one painting (fig. 22 e), a man with upraised hands beseeches, "Oh Sun, take pity on me and help me to be strong!" Another man lies in a circle of stones as his guardian spirit animal approaches (fig. 22,b). Today, countless generations later, these ancient paintings still evoke the mystical relationship between man and guardian and speak eloquently of the power of these images of forgotten dreams.

British Columbia

SOUTHEASTERN BRITISH CO-lumbia makes up more than 40 percent of the Columbia Plateau. This large region, consisting of the Fraser and upper Columbia River drainages, is roughly triangular, with its northern terminus at Stuart Lake and its three sides defined by the Fraser River drainage to the west, the continental divide along the Rocky Mountain crest to the east, and the United States–Canada border on the south. Interior British Columbia is characterized by numerous glacially scoured, south-trending river valleys, most of which have long narrow, deep lakes formed behind glacial moraines. The largest of these lakes are Kootenay, Upper and Lower Arrow, Slocan, Okanagan, and Adams. These lakes, the Columbia and Fraser rivers, and their many tributaries, including the Thompson, Kootenay, Okanagan, and Similkameen rivers, provide the area an abundance of fresh water. Only small semiarid areas occur, most notably in the lower Okanagan and Thompson valleys. Most of the area is heavily forested, and the valleys tend to be narrower than those farther south on the Columbia Plateau. Steep, rugged mountain ranges, whose summits often rise above the timber line, separate the valleys from one another.

Southeastern British Columbia was the heartland of the Interior Salish Indians, whose major tribes included the Shuswap, Lillooet, Thompson, Lakes, and Okanagan. To the far north lived the Athapaskan-speaking Carrier tribe, and the southeastern corner of the area was the homeland of the Kutenai.

Interior British Columbia has had a long history of rock art research. Beginning in the 1890s, ethnographers James Teit (1928) and Father A. G. Morice noted pictographs of the Salish and Carrier tribes and collected information about them from the Indians of that era. Despite occasional inconsistencies in the data (e.g., an unmistakable bear identified as a caribou), these accounts are invaluable sources of information and form the basis for much of today's interpretation of Columbia Plateau rock art. During the first half of the twentieth century, several archaeologists reported various interior British Columbia sites. However, not until 1968 was the bulk of the region's numerous pictographs fully described and summarized by John Corner, an amateur rock art researcher who travelled extensively to locate and record more than 100 sites (Corner 1968). Since its publication, Corner's book has been a key resource for my research and for that of every other person who has studied Columbia Plateau rock art. Following 1968, major studies have reported on additional pictographs at Stuart, Slocan, and Kootenay lakes, and interior British Columbia petroglyphs—primarily located along the middle Fraser River—have been summarized (Baravalle 1981; Bell 1979; Lundy 1979; Richards 1981). Although much research remains to be done, southeastern British Columbia is still one of the best-known rock art areas of the Columbia Plateau.

The Rock Art

More than 150 rock art sites have been located along the lakeshores and in the river valleys of interior British Columbia. Additionally,

because the territory is so large and remote, and because recent surveys have located many new sites, many more likely await discovery. Known sites are primarily pictographs; fewer than a dozen are petroglyphs. Pictographs are scattered from Stuart Lake in the far northwest to the international boundary, but major clusters of sites occur in the Similkameen valley and along Kootenay, Shuswap, and Okanagan lakes. As in western Montana, the high mountain valleys in western Alberta, along the eastern flank of the Rocky Mountains, also hold a few pictographs executed in the Columbia Plateau manner. In style, location, and subject matter these sites are nearly identical to interior British Columbia pictographs and thus are included in this discussion. Petroglyphs occur primarily along the middle Fraser River; the others are in the north Thompson River drainage and near Cranbrook in extreme southeastern British Columbia.

Overwhelmingly, pictographs are red—only five sites have a few black paintings, and one or two show small designs of yellow or white pigment. The only polychrome figure in the region is a bird painted with fine black and red lines at a site on Lower Arrow Lake. Red is clearly the dominant color, with more than 99 percent of the paintings executed in various shades ranging from orange-red to reddish brown. Most paintings are composed of finger-width lines, though some show much finer lines that could only have been applied by a brush, feather, or frayed stick. Deposits of both hematite (red ochre) and limonite (yellow ochre) occur in the province; several show evidence that Indians used them as a paint source. Interior petroglyphs are cupules and pecked naturalistic forms showing many typical Columbia Plateau motifs, such as animals, stick figure humans, and bear tracks.

Of the 150 known pictographs, almost 20 percent are large sites with more than 50 individual paintings. The four largest all have more than 100 individual designs, and the Seton Creek site in the middle Fraser River is the largest pictograph grouping on the Columbia Plateau, with more than 300 individual designs. Obviously these panels were visited repeatedly by numerous native artists, each of whom added a few figures. Through time the collections gradually grew into the large murals we see today. Smaller sites in the region range from single figures, or small composed groups of designs painted by an individual artist, to groups of 15 to 20 paintings that likely represent the work of no more than a handful of painters, each of whom visited the site once or twice.

A notable concentration of paintings occurs in the Similkameen valley along the highway from Hedly to Princeton, where twenty-two separate sites are found in a twenty-mile section of river valley. These pictographs are painted on granite boulders or on the large slump blocks that have come to rest on the flood plain at the base of the mountains forming the valley sides. Although paintings at many of these sites are single figures and none has more than fifteen designs, this is the densest concentration of sites in the province.

In general, the size of the sites and their concentration in different areas throughout the province give the impression that rock art was very important in the Interior Salish Indian culture, and that sites or areas were routinely visited by artists who attached great significance to their endeavors. British Columbia pictographs appear to be relatively well preserved, though there are instances of vandalism. In other places, lichens, water seepage, mineral deposits, or exfoliation of some granite surfaces have obliterated parts of some designs.

Designs characteristic of interior British Columbia rock art fall into five major categories: humans, spirit figures, animals, geometric designs, and tally marks (fig. 23).

Human Figures

Human figures, the most numerous design in British Columbia rock art, are found at more

British Columbia

Percent

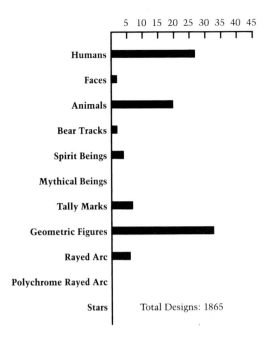

23. *Percentages of motifs in interior British Columbia rock art.*

two-horn headdresses; others are shown with multiple rays projecting from their heads, or have rayed arc designs immediately above the head. One stick figure, known to have been painted after 1890, wears a wide-brimmed hat identifying the person as Caucasian (Corner 1968).

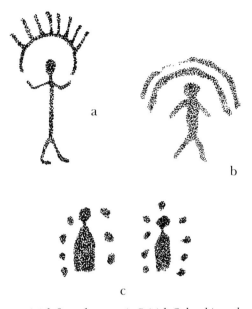

24. *Stick figure humans in British Columbia rock art often have associated geometric designs. Note rayed arcs (a, b, d) and vision quest symbolism (c, f). Compare c to figure 21 c.*

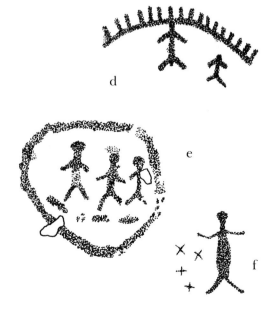

than 80 percent of the sites, usually as stick figures or simple block-body or outline forms (fig. 24). Heads are dots or open circles; a few figures have three- or five-fingered hands. Occasionally, the open-circle heads have simple facial features, such as eyes and mouth. Phallic representations denote some figures as male, but the sex of most cannot be determined. Despite the absence of clearly identifiable females, a significant portion of the figures probably show women, since girls reportedly painted many of the pictographs during their puberty rites. A few hunting and fishing scenes portray action, as do a pair of horseback riders and several bent-legged humans who appear to be running, sitting, or falling. At several sites a human and an animal figure are shown in close association, and one human hand print is known.

Humans in British Columbia pictographs wear a variety of headgear. Some have one- or

Human figures use or carry several kinds of objects: spears, bows and arrows, "fir branches," and unidentifiable items. No shield-bearing warrior motif occurs. In a few instances, men appear in canoes; at a site in the lower Fraser River watershed less than 200 miles from the coast, two humans ride in a seagoing canoe. Some hunting scenes show communal game drives, while other pictographs have individual archers shooting single animals. One large site in the Okanagan valley portrays a communal hunt, with herds of deer and mountain sheep pursued by men and a dog. Several animals in this scene are pierced with spears or arrows. A painting at Kootenay Lake shows a man spearing a sturgeon (fig. 25).

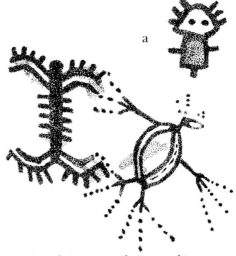

26. Spirit beings are anthropomorphic or zoomorphic figures with stylized or exaggerated characteristics. These include "blind" eyes, extra, deformed, or missing appendages, exaggerated mouths, and interior body decoration. Note relationship in i between small stickman and the spirit being.

Spirit Figures

Scattered throughout the rock art of interior British Columbia are many well-executed, highly stylized, anthropomorphic or zoomorphic figures that do not appear to represent actual humans or animals. These designs, each of which has some human or animal characteristics, are bizarre, often abbreviated, and easily differentiated from either human or animal portrayals by their extreme stylization and abstraction (fig. 26). For instance, "mask" or "face" figures have exaggerated teeth, eyebrows, or other facial features. No two of these spirit figures are markedly similar, in notable contrast to the repetitive sameness of many of the other forms characteristic of this art. This suggests to me that they represent each artist's highly individual perception of his guardian spirit (fig. 27). Lending support to their identification as spirit beings are the incorporation of zigzag "power" lines or dots into some figures and the symbolic association of a small stick figure human with one spirit pictograph (fig. 26 i).

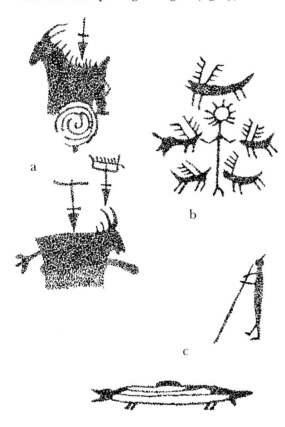

25. Hunting is a common theme in British Columbia pictographs. The human surrounded by deer may represent a shaman with special power over these animals. The mountain goats (a) are found infrequently in Columbia Plateau rock art, and the man spearfishing a sturgeon (c) is unique.

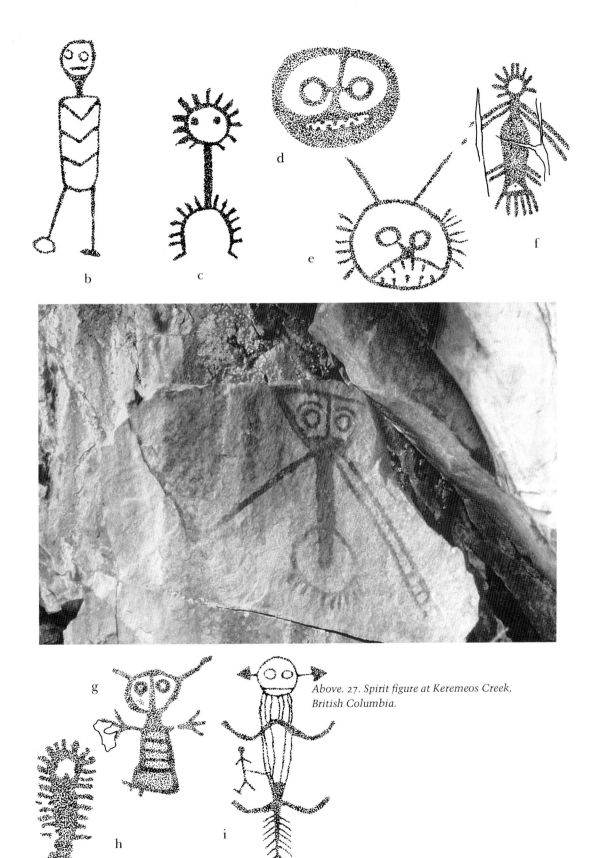

b

c

d

e

f

g

h

i

Above. 27. Spirit figure at Keremeos Creek, British Columbia.

Animal Figures

More than 400 animals appear in interior British Columbia rock art, nearly as large a number as that for human figures, but at many fewer sites. The great majority are four-legged mammals, but birds, fish, insects, and amphibians or reptiles are also depicted (fig. 28). Identifiable species include mountain sheep, mountain goats, deer, moose, birds, bison, horse, dog, bear, porcupine, sturgeon, and possibly toads, turtles, and lizards. Other identifications—beaver, caribou, cattle, rabbit, lynx, and snake—are highly speculative and unsupportable by objective criteria, so will not be repeated here.

Animals are usually shown in side profile, but birds are often frontal, spread-eagle representations, and insects, amphibians, and reptiles are drawn as if one were looking down on them from above. Most animals are solid-colored, block-body figures, but stick figures and outlined forms also occur. Outlined animal figures showing ribs are relatively common at several western sites and may represent a distinctive, localized substyle of animal depiction. Herds, shown at eleven sites, range from three to more than fifteen animals. In several pictographs, hunters pursue these herds, but others have no associated humans.

Mountain sheep and deer are the most common animal species in provincial rock art. Sheep show the characteristic swept-back horns; deer (or elk) have branching antlers. Both animals also occur at Fraser River petroglyph sites. One deer herd near Kootenay Lake, an impressively lifelike portrayal of travelling does and fawns, is strikingly similar to one in western Montana (fig. 29). A few unmistakable mountain goats are painted at two sites as stout, blocky animals, each with a pair of short, erect, slightly curved horns and short "guard hairs" along their backs. These are the only positively identified mountain goats in Columbia Plateau rock art. A group of animals at Kootenay Lake, identified by John Corner

28. Animals play a major role in British Columbia pictographs: a, b, birds; c, deer; d, bison; e, f, toads, frogs, turtle.

(1968) as mountain goats because of their "characteristic hump-shouldered posture," has been described by Baravalle (1981) as cattle (this seems doubtful); as good a case could be made for their being bison. These divergent opinions clearly illustrate the hazards of identifying species in the absence of distinctive anatomical detail.

Single moose, identified by bulky shape, antlers, and pendulous "bell" beneath the throat, occur at two sites; a hunter with bow and arrow is shooting one. Two bison at one site on Lower Arrow Lake have humped backs, horns, and hooves, and are similar to bison shown occasionally at rock art sites throughout the Columbia Plateau. Another bison appears at Zephyr Creek in the Alberta Rockies. Two horses with riders are painted in the Similkameen valley. Neither animal is particularly distinctive and could not be identified were it not for the rider. Single dogs are recognizable at two sites because of short bodies and tails arched over their backs. One also has short erect ears, and the other accompanies hunters. Corner's other identifications of dogs and coyotes lack substantiating detail. A porcupine is known by its short legs, humped posture, and erect dorsal quills.

Birds, more common in this area of the Columbia Plateau than in any other, include long-legged wading birds (herons or cranes), a possible pelican, a possible duck, and more than fifteen spread-eagled "thunderbirds." One thunderbird petroglyph is pecked on the Lone Cabin Creek boulder (figs. 30, 31). The thunderbirds are highly stylized; their claws and beaks are delineated and their bodies often decorated with dots, lines, or "ribs." Some undoubtedly represent mythical or spirit figures, while others may simply be depictions of hawks, eagles, or owls.

Seven sites have paintings of fish, mostly salmon or trout. One appears at the Zephyr Creek site in the Alberta Rockies just east of the continental divide. Four fish at a Kootenay Lake site are fine-lined, detailed paintings of

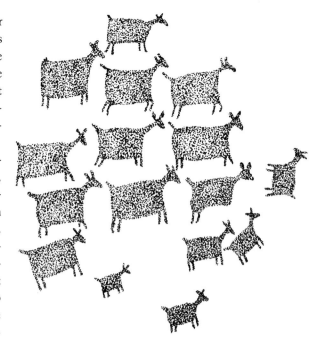

29. This deer herd painted at Kootenay Lake closely resembles one on the lower Flathead River, 175 miles south in Montana (see fig. 14).

30. The Lone Cabin Creek petroglyphs show typical Columbia Plateau motifs. In 1926 this boulder was moved from the Fraser River to Stanley Park in Vancouver, British Columbia.

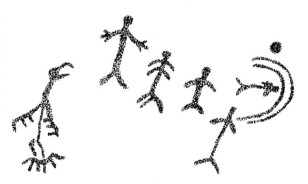

sturgeon, one of which a human is spearing. One other fish, near Stuart Lake, attacks a swimming human. Quite probably this represents a pictographic portrayal of the "water monster" myth prevalent throughout the northern Columbia Plateau.

Paintings or carvings of their characteristic clawed tracks denote bears. Usually these

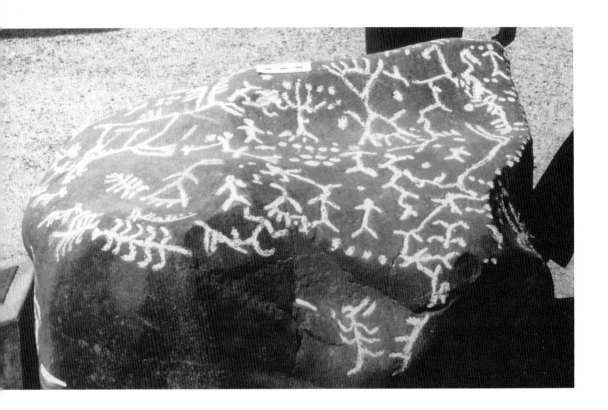

31. *The Lone Cabin Creek boulder, Stanley Park, Vancouver, British Columbia.*

tracks are isolated U or V shapes with claws at the wide end, but one bear at Stuart Lake has bear tracks for each paw. Sometimes two bear tracks will be back to back, forming a "bow tie" design. Bear tracks occur at nearly twenty sites, including the Cranbrook petroglyph in the southeastern corner of the province. As large, powerful animals, bears had especially strong spirit force for Columbia Plateau Indians.

We cannot easily describe one other category of zoomorphic representations: the figures identified variously as turtles, toads, lizards, insects, and water mammals. More than forty such figures are found, all shown as though the viewer were seeing them from above. Anatomical details are rare, and where they do occur they are often exaggerated to the point of hindering rather than helping identification of the animal. Quite probably

some of these figures were meant to represent each of the species listed above, but definite assignment is usually impossible. All of these kinds of animals have special features (such as beavers' and muskrats' ability to live almost entirely in the water, or the speed of lizards, dragonflies, or water bugs) that led Indians to attribute special powers to the animals, and to accord these creatures special places in their myths and cosmology. Probably many figures in this category represent spirit beings whose powers were being petitioned by the painter, and some are probably equivalent to guardian spirit figures.

Geometric Designs

Geometric designs encompass rayed arcs, rayed circles, crosses, chevrons, zigzags, dots, rakes and ladders, line abstracts, and the simple, linear, fir branch design. Some of these drawings, such as zigzags, crosses, rayed circles, and dots, likely represent the sun, stars,

meteorites, and other celestial phenomena. Many other well-executed figures obviously had symbolic meaning to the artists, and James Teit's informants interpreted various examples as rivers, trails, lakes, mountains, huts, and other geographical features or constructions (1928). Most meanings were probably highly individualistic, however, and it is unlikely that all examples of a particular design meant the same thing to all artists.

Two geometric designs occur with such frequency and consistent stylization that they deserve special mention. The rayed arc is found throughout the western Columbia Plateau from central British Columbia southward along the middle Columbia River to The Dalles. Most commonly the design is an upward-arching arc, with upward-projecting rays. Sometimes the arcs are "stacked" in pairs or triplets. Rarely, the rays depend from the arc's underside. Often a rayed arc is situated just above a human figure's head, and in a few instances an arc, with eyes and nose added, actually forms the head or face of a figure.

The stylization of the rayed arc motif and its similarity over thousands of square miles eloquently argue that it had its own symbolic meaning. Some early Indian informants said that arcs represented unfinished basketry, painted by young women who were required to weave baskets in their puberty rituals to demonstrate their worthiness as future wives (Teit 1928). This explanation may serve for some depictions, but many others, especially those associated with human figures as "headdresses," likely meant something else—probably an "aura" of the power central to British Columbian Indian religion. Whatever its actual meaning, the rayed arc design is a familiar motif on the western Columbia Plateau.

The second particularly important geometric motif is the fir branch symbol, identified and interpreted as such by many of Teit's Salishan informants (1928). This design ranges in execution from a simple chevron to a four-limbed stick figure that resembles a very simple human without head, hands, or feet. Approximately 200 of these symbols can be identified in published drawings of interior British Columbia pictographs, but only occasional examples are found elsewhere on the Columbia Plateau. Both men and women used fir branches in puberty rites and vision quests or for rubbing or whipping themselves after a sweat bath purification ritual. At other times young women plucked fir needles to demonstrate their manual dexterity to the guardian spirit whose help they sought. Human figures hold these fir branch designs in paintings at a few sites, and an Indian informant identified a pictograph at Mara Lake as a young woman in a hut, holding the branches as part of her puberty ritual. The strength and consistency of informant designations of this symbol suggest that many do represent the fir branch, though others probably were intended to be simple stick figure humans.

Tally Marks

Although not as common as in western Montana or central Idaho, tally marks occur at more than thirty sites in British Columbia and at the few sites in Alberta's Rocky Mountains. Most sites have fewer than five groups of tallies, although one site on Lower Arrow Lake has more than ten. Tally marks in British Columbia are well-executed, ordered designs, like those in other areas.

Interpretations

The rock art of interior British Columbia is a remarkably homogeneous group of paintings and carvings scattered across a broad region of many thousand square miles. Within this area occur the northern extensions of two broad stylistic zones, which McClure defined primarily by the frequency of the rayed arc motif and its association with human figures (McClure 1980). My research shows that several other motifs (e.g., birds, spirit figures, tally

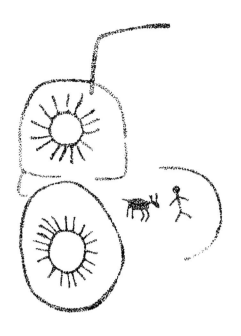

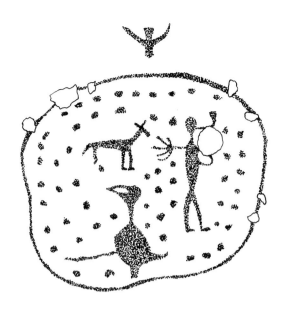

32. *Vision quest symbolism in Columbia Plateau rock art often involves figures painted inside circles or ovals. The pipe-smoking man associated with bird and animal is typical of vision quest pictographs.*

marks) are concentrated in one or the other of these zones, further strengthening McClure's original definition.

The western style zone (from Upper and Lower Arrow lakes to the west) contains almost all of the rayed arcs in British Columbia. As well, identifiable spirit figures and birds occur much more frequently here than in the eastern part of the province. Of the thirty-nine sites with spirit beings, thirty-three are on or west of Arrow lakes, and several western sites have multiple spirit figures, some of which are quite complex. The few spirit figures in the eastern style zone are less complex than those characteristic of the west. Birds are also concentrated in the western style zone; only a single example, at Zephyr Creek in western Alberta, is recorded in the eastern zone.

In interior British Columbia, the eastern style zone, lying east of the two Arrow lakes, shows a higher proportion of sites with tally marks, corresponding to the generally greater use of this motif in western Montana, Idaho, and those few sites in the eastern foothills of the Rocky Mountains. Rarity of birds, spirit figures, and rayed arcs, plus smaller size and simpler design, characterize eastern style zone sites, in contrast to those typical of the western zone. Only three eastern sites have more than thirty figures, and most are small groups of humans and animals, occasionally with associated geometric designs. Overall, these sites appear less "cluttered" and somewhat more structured as individual groupings of paintings than do the western style zone sites.

One petroglyph site does not fit well with the rock art elsewhere in the province. Located on a horizontal bedrock outcrop in the Kootenay River valley, the Cranbrook petroglyphs show numerous pecked and abraded tracks, including those of two-toed ungulates (bison, deer), bears, canines (dog, wolf, coyote), rabbits, and others (Cornford and Cassidy 1980). Other than bear tracks, paw- or hoofprints are very rare in Columbia Plateau rock art: two pecked, ungulate hoofprints near The Dalles are the only other occurrence of the motif on the Columbia Plateau, though such tracks are common on the northwestern Plains of Montana, Saskatchewan, and South Dakota.

The Cranbrook petroglyphs may likely be more closely related in origin and style to these Plains sites than to those elsewhere in British Columbia.

The rock art of interior British Columbia apparently functioned primarily to record an individual's supernatural experience, which could be a vision quest ordeal, an important dream, or hunting magic. Early Indian informants reported that both adolescents and adults made pictographic accounts of events connected with their puberty rites, of notable dreams, and of the things that they desired to obtain through supernatural intercession (Teit 1928). Vision quest supplicants would depict what they had experienced and what sort of spirit helper they had obtained. Many of the highly stylized anthropomorphic and zoomorphic figures probably represent these guardian spirit beings (fig. 26). Viewing them, we are looking through the artist's eyes to see how he pictured his spirit helper (fig. 32).

Other paintings probably represent supplicants' desires. Thus, a man might paint pictures of big game or of animals such as lizards (noted for their swiftness) to gain the power or skills needed for successful hunting. Likewise, a person who wanted to become a warrior might paint a bear or an eagle as a way of requesting their supernatural aid. Women painted images of fir branches and other objects connected with their vision quests and puberty rituals (fig. 33). One key aspect of many of these paintings is that they were more than merely records: the very act of painting them was thought to help transmit the supernatural power from the object to the artist.

A few paintings likely represent events important to individuals or to the tribe. The large group of bowmen at a site on Columbia Lake has been interpreted as a war party, and the location of this site in the eastern part of the Plateau—nearer the northern Plains—supports this. Occasionally Salishan tribes organized expeditions to the northwestern Plains to raid the Blackfeet, Cree, and Crow, often in retalia-

tion for raids these Plains tribes made onto the Plateau, and a successful foray would very likely have been recorded. Hunting expeditions to the Plains were likely also depicted, and the bison at Lower Arrow Lake and Zephyr Creek probably show such hunts. Humans in a seagoing canoe at one site probably portray a person's visit to the coast, and the horsemen and Caucasians at other sites may also represent records of important events.

The age of interior British Columbia rock art apparently spans hundreds of years, if not several thousand. The oldest pictograph in the region is a red painting of lines and dots on a cylindrical stone recovered from a site in the southern Okanagan valley (Copp 1980). This

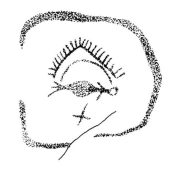

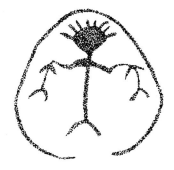

33. Early Indian informants identified figures like these as pictures of women during their guardian spirit quest. The rayed arc in the upper painting represented a basketry fragment; the objects held by the person in the lower right design were fir branches used in ritual bathing. Lines partially enclosing figures represented caves or constructed shelters.

pictograph, which would not be out of place at any rock art site in the province, dates to approximately two thousand years ago. No other pictograph in the region is known to be this old, but informants consistently report that rock art clearly visible today was already there up to 150 years ago (Teit 1928). Likewise, many sites contain paintings with different shades of color due to weathering or mineral deposition, indicating that the art was done at different times. Since very few of these sites have been painted in the past one hundred years, their current condition suggests that even the freshest could be several hundred years old. Taken together, all of these factors suggest that interior British Columbia rock art was painted and

carved during the last two to three thousand years, much of it undoubtedly within the past few hundred years.

The most recent rock art in interior British Columbia was painted after the beginning of the historic period, and a few pictographs may even date to the turn of this century. In the late 1800s, some Indian informants reported that they themselves had painted some sites, and the horses at Hedly Cave could not be older than approximately A. D. 1750, when these animals were introduced into the northern Columbia Plateau. For another site, John Corner (1968) presents convincing evidence that the Caucasian wearing a brimmed hat was painted after James Teit sketched the site in the 1890s.

34. *Basalt cobble found at archaeological site in southern Okanagan valley of British Columbia. Stippling shows pictographs of lines and dots on background of red paint smears. Object is almost 60 cm long and dates to between 1800 and 2000 years ago. (Figure modified from Copp 1980.)*

Rayed Arcs: A Distinctive Motif

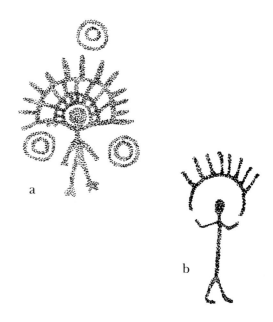

SIMPLE STICK FIGURE HU-
mans, with a dot or open circle for the
head, downward-pointing legs, and arms
arranged in various positions, are a hallmark
of Columbia Plateau style rock art (fig. 34).
Sometimes hands and feet are shown, and a
few figures are phallic. Often a stickman is
joined with an animal or a geometric design.

In a recent stylistic analysis, McClure
(1980) studied stick figure humans from vari-
ous parts of the Columbia Plateau and found
that an associated rayed arc motif character-
izes pictographs of humans in western Colum-
bia Plateau rock art. This association plays
out in three variations on a single theme:
most commonly a rayed arc is placed just
above a human's head. Some figures have rays
projecting directly from the head (fig. 35).
A third form, restricted primarily to sites
around Yakima and along the lower Columbia
River, shows a rayed arc partially surrounding
dots that represent a stylized human face with
eyes, nose, and mouth (fig. 36). Many of these
are red and white polychrome paintings.

Stick figures with a rayed arc or rayed head
are distributed fairly consistently south to
north throughout the western Columbia Pla-
teau, from The Dalles up the Columbia River
watershed and into western British Columbia
as far north as Pavilion and Shuswap lakes,
near Kamloops. They are commonly found as
far east as Slocan Lake in British Columbia
and near Spokane, Washington. Within this
area, slightly more than 25 percent of identi-
fied human figures have rayed arcs. Addition-
ally, rayed arcs without humans are a com-
mon motif at many sites in this same area.

*35. Humans with rayed arcs: a, lower Columbia
petroglyph; b,c, British Columbia pictographs; d,
mid–Columbia River petroglyph; e, mid–Columbia
pictograph.*

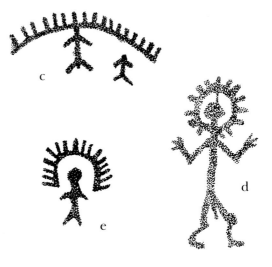

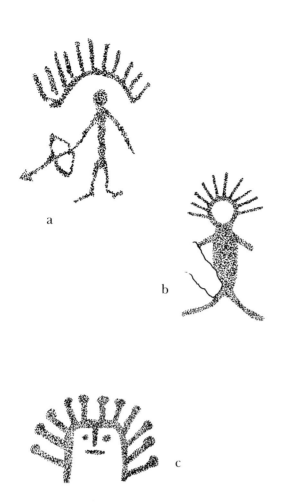

a

b

c

36. Humans with rayed arcs: a, lower Columbia petroglyph; b, pictograph of human with rayed head, Yakima, Washington; c, lower Columbia arc face petroglyph.

In contrast, rayed arcs are nearly absent in the rock art of the eastern half of the Columbia Plateau. Fewer than a dozen examples are known, and several of these are at sites on Kootenay Lake not far from their primary area of concentration. No example occurs among western Montana pictographs, and only a few humans with rayed heads are found in the rock art of central Idaho and Hells Canyon. According to McClure's analysis, less than 2 percent of the human figures on the eastern Columbia Plateau were accompanied by rayed arcs.

We do not yet understand the full meaning of this distribution. McClure used it to differentiate eastern and western style zones within the greater Columbia Plateau region, and suggested that other designs might follow this division. Recent research has shown that several motifs, including tally marks, faces or masks, birds, and spirit beings also are more or less restricted to one or the other of these style zones. The rock art's age and function, however, appear generally to be very similar in both zones, probably reflecting strong cultural similarities among the various Columbia Plateau Indian tribes who painted and carved it. Obviously, we need more detailed analysis of rock art from all parts of the Plateau before we can fully understand the importance of these two broad style zones.

The Central Columbia Plateau

OR MY PURPOSES, I DEFINE the central Columbia Plateau as north-central and northeastern Washington and the panhandle of Idaho north of Lake Coeur d'Alene. Roughly bounded by the crest of the Cascade Mountains to the northwest, the Canadian border on the north, and the Idaho-Montana border on the east, the central Plateau includes the entire watershed of the Columbia River in Washington state above Priest Rapids. Thus, the area's southern boundary is a wide, shallow V that follows the drainage divides between the Yakima and Columbia rivers on the southwest and the Columbia and Snake rivers on the southeast.

The central Columbia Plateau is a region of diverse environments. The Columbia River, inscribing a reverse S curve from northeastern Washington to Priest Rapids, divides the Plateau approximately in half. Northwest and north of the river is primarily forest land: thick coniferous forests grow on the east slopes of the North Cascades and in the Selkirk and Purcell mountains of north Idaho and far northeastern Washington. Between these two extremes, sparser forests cover the Okanogan highlands and the territory surrounding Spokane. To the south and west of the Columbia River lie the channeled scablands, an extensive basalt plateau scoured clean and incised with deep coulees by Pleistocene floods of glacial Lake Missoula (U.S. Geological Survey 1973). The scablands are rocky, arid semidesert, which supported only short-grass and sagebrush prairie prior to the advent of wheat farming. The lower Okanogan valley, although lying just north of the Columbia River, has an arid climate more like that of the channeled scablands.

The forested terrain of the central Plateau is well watered by several major tributaries of the Columbia River, including the Pend Oreille, Spokane, Sanpoil, Okanogan, Methow, and Wenatchee rivers. Priest Lake, Lake Pend Oreille, and Lake Chelan are large, deep, glacial lakes dammed by terminal moraines. The channeled scablands, situated in the rain shadow of the North Cascades, are poorly watered, with only small streams and marshy, pothole lakes.

Throughout this region, humans have dammed most of the major waterways in the past seventy-five years. Eleven dams impound water on the Columbia, Spokane, and Pend Oreille rivers; Lake Chelan and Lake Pend Oreille each have had their levels artificially raised. In the channeled scablands, dams at Grand Coulee, Coulee City, Moses Lake, and elsewhere have created large reservoirs on this arid plateau. These dams have had a devastating effect on rock art, because so many pictographs and petroglyphs are located along rivers and lakeshores. No fewer than forty-five known sites have been destroyed or damaged by dam construction and rising reservoirs (McClure 1978). Undoubtedly, other rock art disappeared beneath the waters behind Rock Island and Grand Coulee dams, which were constructed before anyone had made concerted effort to locate or document prehistoric paintings and carvings.

Given the destruction of so many sites, rock art research on the central Plateau owes much to the diligence of interested amateurs who, in

the absence of professional concern, recorded and even preserved parts of many sites prior to their destruction. Early explorers looking for road routes through the Pacific Northwest made the first rock art records in the region. Between 1850 and 1890, they noted sites on the Columbia River, on Lake Chelan, and near Post Falls, Idaho. One important panel, now beneath the waters of Lake Chelan, is known only from photographs taken by one of these explorers. An early professional study described the Lake Pend Oreille petroglyphs in 1893 (Boreson 1985), but until 1945 professional interest in these sites was limited. Fortunately, members of several amateur archaeological societies took an interest in the area's rock art and attempted to record many sites through photographs and drawings. Foremost among these, Harold Cundy of Wenatchee spent ten years prior to World War II visiting and recording dozens of sites in north-central Washington. For many of these petroglyphs and pictographs, Cundy's records provide the only information collected before they were destroyed.

Beginning after World War II, professional archaeologists reawakened to the value of the area's rock art (Boreson 1976, 1985; Cain 1950; Leen 1984; McClure 1978, 1981). Thomas Cain published the initial research in a short monograph describing forty sites in central Washington, many of them along the middle Columbia River. Although admittedly a pioneering effort, this work suffers considerably from errors in text, faulty illustrations, and overly speculative interpretations. However, Cain's monograph is the only known record of a few sites, and it provides much-needed information on many others long since destroyed. Between 1950 and 1975, archaeologists catalogued many individual rock art sites in the region, but no large-scale effort synthesized and analyzed this information until 1977, when Richard McClure assembled existing data on all known Washington rock art sites and tried to visit most of those that still existed (1978). Working from state site records, archives, amateurs' notes, and informant reports, McClure summarized information from more than 200 sites, including many that he found during his own field work. Since this publication, McClure has remained active in regional rock art research, conducting small-scale field projects and writing a series of articles about the art styles, distributions of motifs, and chronology of central Columbia Plateau rock art. Other major studies in the past decade include Dan Leen's recording of sites for the Chief Joseph Dam salvage project (1984) and Keo Boreson's recording of the Lake Pend Oreille petroglyphs (1985).

The Rock Art

The more than 130 rock art sites in northeastern Washington and northern Idaho are found from Lake Pend Oreille to the eastern slopes of the Cascade Range and from the Canadian border on the north to Priest Rapids Dam on the Columbia River twenty miles south of Vantage. Slightly more than two-thirds are located along the Columbia River and its two major tributaries, the Okanogan and Spokane rivers; the others are scattered along streams and lakeshores in upland locations in the Cascades, Okanogan highlands, and channeled scablands. These rock art panels fall into a southern group of 40 sites along the mid-Columbia River from Priest Rapids to Wenatchee, and a northern group composed of the remaining 93 sites, found north of an imaginary line drawn from Wenatchee to Spokane.

The mid-Columbia River sites are predominantly petroglyphs, most of which are pecked or abraded figures. Several of these sites are quite extensive; eight have more than 50 figures, and the three largest each have more than 300 individual designs. These figures are carved and painted on the columnar basalts that flank both sides of the river, or on boulders on major islands.

Small pictographs are most usual at the

northern sites; petroglyphs occur primarily in small clusters at Kettle Falls and Lake Pend Oreille. Northern Pictograph sites usually contain between 5 and 20 figures; fewer than half a dozen have more than 50 figures, and the largest has only about 100 paintings. Most of these pictographs are painted in various shades of red, but the use of other colors is more common here than at sites farther north or east. Sixteen sites have occasional figures painted in black, yellow, white, blue-green, and brown, in that order of frequency. Two-thirds of these are clustered between the towns of Grand Coulee, Chelan, and Omak. A few of these designs are true polychromes, usually arcs with alternating red and white rays.

Within the area, sites cluster at Priest Rapids, Vantage, and Kettle Falls on the Columbia River, south of Tonasket on the Okanogan River, and on the north shore of Lake Pend Oreille. Within a few miles of Vantage, one pictograph and five petroglyph sites were recorded before the Wanapum Dam flooded that stretch of Columbia River (Cain 1950). Four of these were quite large, and one had more than 250 separate carvings and paintings. Designs included all the motifs common to northeastern Washington: humans and animals, hunting scenes, rayed arcs, spoked and concentric circles, twin figures, mountain sheep and deer, and a variety of geometric forms. In number and variety of figures, the Vantage locale had one of the largest concentrations of rock art on the Columbia Plateau, rivalling such areas as The Dalles further downstream and Buffalo Eddy on the Snake River.

A unique concentration of bear-paw petroglyphs (fig. 37) occurs at seven sites on the north shore of Lake Pend Oreille (Boreson 1985). The designs, pecked on argillite outcrops along the shore and on small islands, include about 150 bear paws, more than 70 arcs and ovals, and a few curvilinear abstracts. These sites have closest affinity to the Cranbrook petroglyphs just across the border in British Columbia, and to a large panel of

37. A panel of bear-paw petroglyphs on Lake Pend Oreille in Idaho.

pecked bear paws near John Day Dam on the lower Columbia River.

Pictographs on the central Plateau tend not to cluster, as do petroglyphs; however, along a short stretch of the Okanogan River just south of Tonasket six pictograph sites have been recorded. These small, well-executed sites each contain between five and twenty paintings. This clustering is similar to that observed in interior British Columbia and in western Montana. Each of these clusters, along with others seen elsewhere on the Plateau, documents that, once begun, many rock art sites became important places to which the Indians would return through many generations to add more paintings or carvings.

Site preservation is generally poor on the central Columbia Plateau, largely because so many dams have been constructed on the Columbia and its tributaries. Nearly fifty sites have been damaged or destroyed by inundation or by the building of dams, roads, or railroads. Although parts of some of these sites were salvaged and are now displayed in museums or

visitor centers at the dams, most of the scientific information that could have been gleaned from them has been irretrievably lost. Lost also is the opportunity for the public to visit and enjoy them.

Sites in the area also suffer other damage. Vandals using paint, chalk, or gunfire have defaced several. Relic collectors, who chip off figures for private collections, have stolen other panels. Natural weathering has affected a few sites through mineral deposition and exfoliation. Thus, a prehistoric art resource, once very rich, has been reduced by as much as half, primarily by modern construction and the thoughtless actions of a few vandals, making the remaining sites an even more important part of our cultural heritage.

Designs in central Columbia Plateau rock art can be grouped into six descriptive categories: humans, animals, bear tracks, rayed arcs or circles, tally marks, and geometric designs (fig. 38).

Central Columbia Plateau Percent

38. *Percentages of motifs in central Columbia Plateau rock art.*

Human Figures

Simple stick figure humans predominate in the rock art of the central Columbia Plateau; more than 75 percent are of this type. Others include a variety of block-body and outlined forms. In all, more than 400 human figures have been identified, and some sort of human is illustrated at more than two-thirds of the sites (fig. 39). Dots or open circles indicate human heads; only very rarely are facial features shown. Three- or five-fingered hands appear on a few figures, and phallic images designate some as males. Although no female figures can be positively identified, some pairs of twin figures show one as obviously male and the other not (fig. 40). Possibly the nonphallic figures represent women. Though action is uncommon, a few figures shoot a bow and arrow, usually in hunting scenes, or ride a horse.

Humans and animals are closely associated symbolically, although less frequently than in western Montana rock art. More common are pairs or groups of humans, including the twin figures found at several sites (McClure 1981). Stylized, exaggerated anthropomorphs like the spirit figures in interior British Columbia rock art are rare; only three examples are found, in Okanogan valley pictographs. A few humans wear a bison-horn or feather headdress. Almost 25 percent of human figures in central Columbia Plateau rock art have either a rayed arc above, or rays projecting directly from, their heads (fig. 41). In a few cases, two humans are under the same arc, or a bird or animal appears under a rayed arc. These depictions' number and stylistic consistency throughout the region strongly suggest that this design had inherent symbolic meaning.

Human faces are drawn at six sites. Two examples north of Vantage are formed by a rayed arc partially enclosing dots placed just beneath it to give the impression of eyes and mouth. The other instances are merely circles or ovals with facial features indicated. None of these is as stylized as the face or mask figures found to

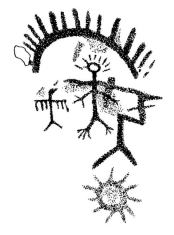
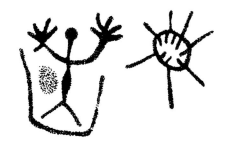

39. *Human figures are common in central Columbia Plateau pictographs. The bird, men, rayed arcs, and sun suggest vision quest symbolism.*

40. *The twins petroglyph from the Vantage site is now on display at the Ginkgo Petrified Forest State Park Museum at Vantage, Washington.*

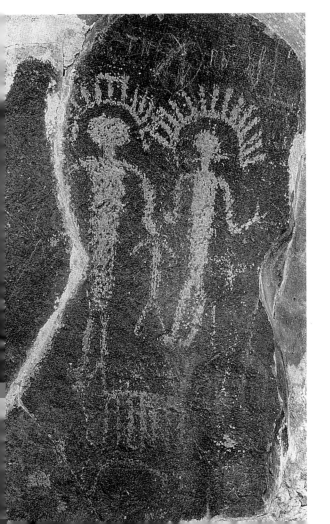

the north in interior British Columbia or to the south at The Dalles. Humans are also denoted by a few painted hand prints.

Animals

Central Columbia Plateau rock art pictures animals less frequently than humans, and at fewer sites (fig. 42). Less than 60 percent of the recorded sites contain the total of almost 250 individual figures. Animals are usually simple block-body, four-legged figures, although a few birds, fish, insects, and amphibians or reptiles are drawn. Approximately 50 percent of the portrayals are detailed enough anatomically for specific identification, but the great majority of these are found in mid-Columbia River petroglyphs. Herds are rare, although found occasionally in both pictographs and petroglyphs. Hunting scenes occur frequently, however, usually with an individual bowman shooting an animal. One scene shows a communal game drive, at a site on Lake Chelan. Recognizable animals include mountain sheep, deer, birds, fish, bison, a bear, horses, and representations that probably depict insects, toads, turtles, lizards, or even water mammals such as beaver or muskrat.

Mountain sheep, identified by the characteristic horn shape, are the animal most common in central Plateau rock art, occurring most often as petroglyphs. At a site on Lake Chelan, a lone hunter is pursuing one herd (fig. 43). In the

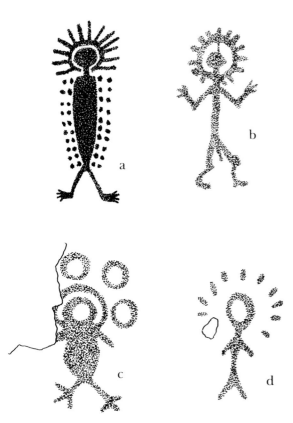

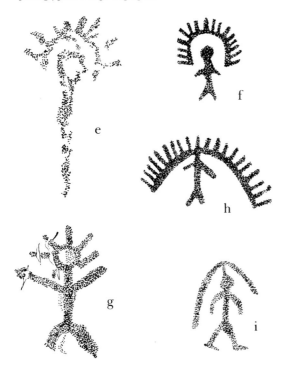

41. Humans with rayed arcs or rayed heads are a common central Columbia Plateau motif; a and b, petroglyphs; c-i, pictographs.

mid-Columbia region, several sites show mountain sheep with horns in front view, rather than in the more usual swept-back profile (fig. 44). Similar portrayals occur occasionally in lower Columbia River rock art, and more frequently in Great Basin petroglyphs. We cannot positively identify any mountain goats in this area, despite their presence in interior British Columbia rock art. Branching antlers denote deer or elk at ten sites. Usually these creatures figure in hunting scenes with archers.

About a dozen birds are painted at pictograph sites in the northern part of the area; no bird petroglyphs occur. Most birds are spread-eagled, one is surmounted by a rayed arc, and another in the Methow valley has zigzag power lines radiating from its head. The two examples of fish both appear to represent salmon or steelhead. The scarcity of fish portrayals is striking, given that this region is the heartland of the Columbia Plateau, where salmon fishing played the major role in the Indians' subsistence economy.

Three bison painted at Buffalo Cave, southeast of Wenatchee, have characteristic hump and horns. They could represent bison seen in the channeled scablands or Palouse, since in prehistoric times these animals did inhabit these parts of the Plateau in small numbers. More likely, however, the bison commemorate hunting trips to the northern Plains, which Columbia Plateau tribes undertook occasionally. The single bear appears at a site in the Okanogan highlands.

Horses are painted at eleven sites and pecked at one other (fig. 45). Four painted examples have the characteristic elongated body, long neck, and flowing tail, but no rider. One wears a saddle. The remaining horses, all ridden, range from nondescript quadrupeds, unrecognizable without the mounted human, to a very stylized depiction showing an obvious horse whose rider wears a flowing, feathered bonnet.

Nine of the twelve sites with horse designs

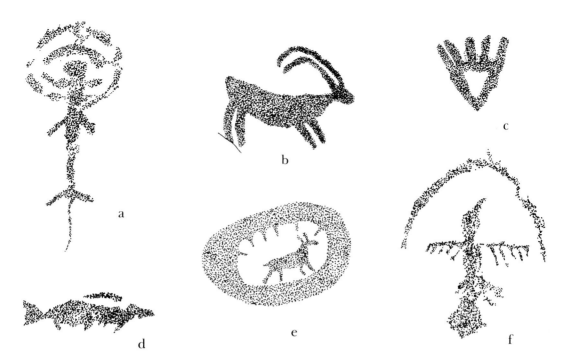

a

b

c

d

e

f

42. Animals in central Columbia Plateau rock art.
Petroglyph: b, mountain sheep. Pictographs: a,
lizard; c, bear track; d, fish; e, quadruped; f, bird.

43. A lone hunter pursues a band of mountain
sheep or mountain goats at this pictograph site
on Lake Chelan in north-central Washington.

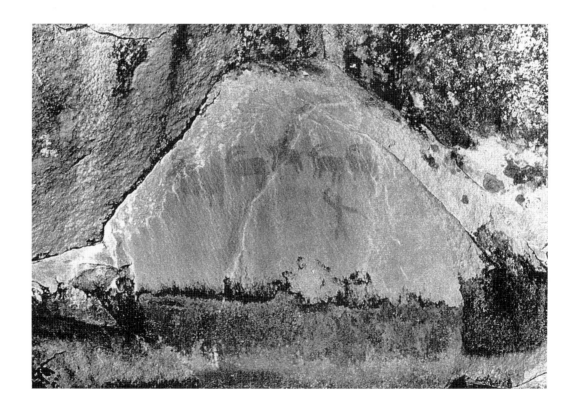

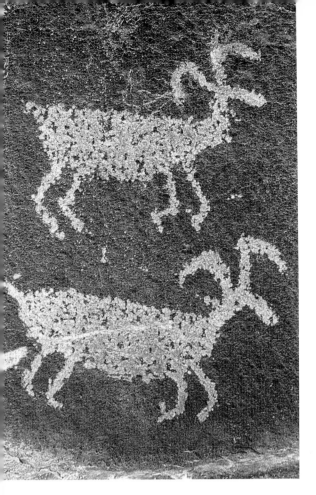

period after 1885 (McClure 1979a). Three other horses nearby resemble the dated one stylistically and are different from other typical painted animal figures, suggesting that they may be equally recent. This apparent florescence of the painting of horses may have resulted from the resettlement of members of the Nez Perce tribe on the Colville reservation following Chief Joseph's war (1877). The Nez Perce, Cayuse, and Umatilla were the Columbia Plateau tribes most influenced by the northern Plains horse culture and adopted the Plains practice of depicting horses frequently in art.

Approximately twenty indeterminable figures may represent insects, lizards, turtles, frogs, salamanders, or lacustrine mammals such as beaver. Most of these are pictographs shown in plan view, as if looking down on them from above. Their simplicity of form, stylization, and lack of defining anatomical detail precludes positive designation in most instances. A few otherwise unidentifiable animals, most often pictographs, have exaggerated anatomical features resembling no known spe-

44. Mountain sheep, like these petroglyphs pecked at Vantage, Washington, are sometimes shown with horns in front view.

45. Rock art horses, relatively more common here than elsewhere on the plateau, indicate the importance of this animal on the central Columbia Plateau; a, d, e, pictographs; b, c, mid-Columbia petroglyphs.

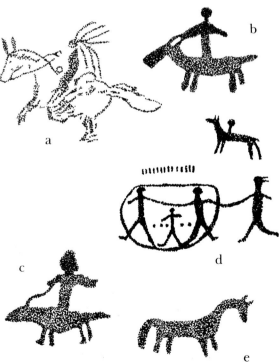

are situated on or near the Columbia River between the Methow and Spokane rivers. This open basalt terrain is the portion of the central Columbia Plateau most suited to the Indians' adoption of an equestrian culture. Today the Colville Indian Reservation lies just north of the central Plateau. One site near Grand Coulee Dam portrays a somewhat lifelike, riderless horse, which an informant's report dated to the

cies. Two of these are painted with elongated snouts and some have multiple-toed feet instead of hooves. At one site (destroyed prior to accurate recording) these creatures may have stood for dogs; others could be depictions of mythical animals or monsters.

Bear Tracks

Bear tracks warrant a separate description because so many of them are concentrated at six petroglyph sites on Lake Pend Oreille (fig. 37). Here more than 150 pecked bear-paw designs have been recorded, often in groups of 10 or more. The largest two panels have 28 and 47 examples each. The tracks are closed U or V shapes, with claws shown at the wide end and lines sometimes crossing the paw print. Many are linked with pecked circles and ovals. All designs are shallowly pecked into shoreline argillite outcrops along Lake Pend Oreille and on two small near-shore islands. We do not know the reason for this concentration of bear paws; the only similar concentration of this motif on the Plateau is at two petroglyph sites on the lower Columbia River near John Day Dam. The only other bear tracks recorded in the central Columbia Plateau area are two paw prints painted at a site on the Okanogan River.

Rayed Arcs and Circles

After humans and animals, the most common design in the region's rock art is the arc or circle with rays, recorded as pictographs and petroglyphs at sixty-three sites, all in Washington. They appear to be slightly more common at sites on the mid-Columbia River. Often they are connected with human portrayals, as a rayed arc situated just above a figure's head, an arc headdress, or rays projecting directly from the head. A few animals also have rayed arcs in close proximity. When not found with humans, the motif occurs as single, double, and even triple rayed arcs nested inside one another. Rayed circles also appear as isolated ex-

amples. Of the sixty-three sites with rayed arcs, almost half show two or three different forms, and some sites have more than ten individual examples.

The meaning of these designs is unclear. Some authors (Cain 1950; Corner 1968) have assumed that they represent the sun; undoubtedly some, especially the rayed circles, do. The sun had especially strong guardian spirit power for some Columbia Plateau tribes (Keyser and Knight 1976). On the other hand, early Indian informants identified some rayed arcs as basketry fragments, which functioned in women's puberty rite vision quests (Corner 1968; Teit 1928). Neither of these concepts explains the rayed heads or rayed arc headdresses very well, however. Based on their number, association with other figures, and stylistic consistency throughout the western Columbia Plateau, many of these designs, I suggest, may have been intended to represent symbolically the concept of supernatural power, which a human could gain through the vision quest and allied rituals. This explanation fits with the direct association noted so often between these rayed symbols and humans or animals.

Tally Marks

Fourteen central Columbia Plateau sites have recorded tally marks—horizontally oriented series of short, evenly spaced, vertical lines. They only occur as pictographs, and most sites have more than a single group, six groups of tallies at the most. We do not know precisely how tally marks functioned, but we can speculate that they probably served as counts of objects or as mnemonic devices to assist in remembering rituals. It is tempting to infer that those associated with the game-drive pictograph on Lake Chelan count either the number of hunters or animals killed, or both.

Geometric Figures

Many geometric figures appear in the rock art of the central Columbia Plateau. The records

of forty known sites mention examples of various geometric motifs, and others probably exist, since these figures have not often been photographed or described by casual rock art researchers. The most common are zigzag lines, rakes showing a horizontal line with several shorter dependent lines, crosses, circles or dots (often in groups), and line abstracts. A geometric figure will frequently be associated with a human or animal, presumably to convey some sort of symbolism. We know that dots, zigzags, circles, and crosses were used in Columbia Plateau pictography to represent celestial bodies, the sun, moon, and stars. One specialized geometric figure resembles a stick figure human without head, hands, or feet; early Indian informants identified this as a fir branch used in puberty rituals and quite common in paintings at some interior British Columbia sites. A few fir branch designs are painted at four sites in northeastern Washington.

Geometric figures ranging from simple circles or ovals to complex line abstracts are used at several sites to enclose single or grouped images (fig. 46). Usually such a circular design serves to integrate a composition and segregate it from others on the panel. Most of these circles are pictographs, although they do occur as petroglyphs in a few instances. Similar compositions are recorded throughout the northern and western portions of the Columbia Plateau.

Interpretations

Most rock art on the central Columbia Plateau belongs stylistically to the western Plateau style, as defined by McClure (1980). The exceptions are a few pictographs near Spokane and in north Idaho at Post Falls and Priest Lake, which represent the eastern Plateau style. These eastern sites have simple stick figure humans associated with animals, geometric designs, and tally marks. Rayed arcs occur infrequently. These sites more resemble in style those in western Montana and southeastern

British Columbia than those to the west on the central Plateau.

Within the western style zone, two broad patterns can be identified. To the north lies a group of more than eighty sites, most of which contain red pictographs. These are primarily small groups of humans, animals, and rayed arcs or other geometric designs painted on low cliffs and boulders or in shallow rock shelters. Sites typically contain fewer than 20 paintings; only one has as many as 100 figures. Other than birds and horses, few of the animals can be specifically identified, and the humans are most often simple stick figures. Tally marks and horses are relatively common.

To the south, along the mid-Columbia River between Priest Rapids and Wenatchee, is a group of forty sites, primarily petroglyphs. Although the subject matter is generally similar to that of the northern pictographs, differences in emphasis create a distinctive aspect to this art. These sites tend to be much larger: murals at Priest Rapids, Vantage, and Rock Island each contained more than 300 individual designs, and several others have as many as 50 to 100 figures. Although, as in the north, humans usually appear as stick figures, more frequently they are shown associated with the rayed arc, and 16 examples of twin figures are recorded at six sites. Humans represented only by faces or masks are more common. Animals occur slightly more frequently, and more often these can be identified as to species. Several sites portray mountain sheep and deer herds. Other than in the fairly common hunting scenes (fig. 47), however, few petroglyphs have a human closely associated with an animal figure. Geometric figures are less usual, and tally marks are absent. In general, this mid-Columbia rock art seems slightly more "descriptive" than do the pictographs of the northern area. Although undoubtedly made for Indians' religious purposes, the hunting scenes, animal herds, and twin figures are a little more recognizable and "familiar" to the modern observer than are the symbolic depictions and geomet-

46. *Pictographs enclosed in circles are a common vision quest theme in Columbia Plateau rock art. These pictographs at Long Lake, near Spokane, Washington, show an encircled animal near a stickman and several other designs in a larger circle to the left.*

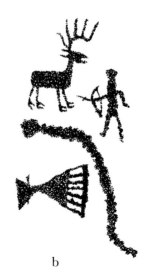

47. *Hunting scene petroglyphs are common in central Columbia Plateau art. These scenes are found at sites along the middle Columbia River. The lighter bowman, a, appears to be a later artist's addition.*

b

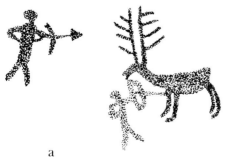

a

ric designs characteristic of the northern pictographs.

The bear-paw petroglyphs at Lake Pend Oreille and the cupule petroglyphs at several Kettle Falls sites fit neither northern nor southern pattern. Cupule petroglyphs appear at a few sites scattered throughout the Columbia Plateau, from the Fraser River in the north to The Dalles and Hells Canyon in the south. These petroglyphs may represent a rock art tradition older than the Columbia Plateau style (as they appear to do in parts of the Great Basin), or they may be contemporaneous with, but made for a different purpose than, the naturalistic drawings of the Plateau style art.

The bear tracks on Lake Pend Oreille are also significantly different from the central Plateau panels of naturalistic pictographs and petroglyphs. These bear-paw designs occur in large groups associated only with pecked circles or ovals. Hoof- or pawprint images occur occasionally on the Columbia Plateau, but much more commonly on the northwestern Plains—almost always as petroglyphs. Elsewhere on the Plateau, large concentrations of bear paws are pecked at two sites near John Day Dam, and tracks and hoofprints of several species are pecked at the Cranbrook petroglyphs in British Columbia. To the east, sites containing hoofprint art are frequent on the Plains in Montana, Saskatchewan, and South Dakota. As with cupules, we know very little about the reasons behind these bear-track and hoofprint petroglyphs, but their purpose probably differed significantly from that of the more common naturalistic art.

Like that of other Columbia Plateau areas, central Plateau rock art appears to have functioned in a religious context. Many of the northern pictographs apparently record vision quests, in which adolescents and adults sought supernatural power through a ritual of isolation, fasting, and prayer. According to Salishan Indian informants from the region, pictographs commemorated the successful acquisition of a spirit helper, the rites associated with the vi-

sion, and the symbolic relationship between human and guardian (Cline et al. 1938; Malouf and White 1953). In fact, Indians thought that the act of painting assisted the transfer of the spiritual power. Typical vision quest motifs are tally marks and symbolic groupings of animals or geometric designs; often the group will be contained within a circle. Sites in the mid–Columbia River region probably also served religious purposes, although these petroglyphs and pictographs appear a little less "symbolic." Drawings typically show humans with rayed heads or rayed arcs above their heads. Twin figures depicted at several sites probably represent deities of some sort connected with the supernatural power ascribed to human twins. Deer and mountain sheep frequently appear both singly and in groups and often in hunting scenes, usually with a single bowman.

Missing from these mid-Columbia sites are the symbolic groupings of humans associated with an animal or abstract figure, the animals or humans drawn inside a circle, and groups of tally marks. Mid-Columbia rock art seems to be slightly more "documentary" than the northern pictographs, as if the artist were more interested in recording his possession of spirit power or hunting prowess than the mystical association between himself and his spirit helper. Thus, the rayed arcs, especially those linked with humans, could almost be imagined as "self-portraits" of persons with power. The hunting scenes might record either a man's accomplishments or his supplications to the spirit world for future success. In either case the emphasis is on the possession and use of power, rather than on the ritual of obtaining it.

The slightly different religious focus of mid-Columbia rock art might result from its being more closely related to shamanism than to vision quest practices. Shamans were religious specialists who controlled power and made it serve them. A shaman obtained power through the vision quest, as did everyone else, but, in contrast to others who held this spiritual power only for personal reasons, the shaman

became a public religious practitioner who used his power to affect others. Thus, Indians thought that shamans could cure or cause illness, divine the future, control weather, and control fish and game animals. A shaman also instructed people in religious rituals and ceremonies and sometimes acted as hunt chief because of his power over animals. An evil shaman could cast spells to curse another individual or group with disease or bad luck in hunting or fishing. Every village had at least one shaman to insure the community's success and well-being. The fact that mid-Columbia rock art appears more to illustrate the possession, use, and control of power than the mechanism by which power was obtained suggests that shamans may have produced much of this art as part of their rituals, ceremonies, and instruction.

We do not know the age of most central Columbia Plateau rock art. As in other parts of the Plateau, some of the pictographs could be two thousand or more years old, but most were likely painted in the past one thousand years. Bows and arrows depicted at sites on Lake Chelan and in the Okanogan valley must have been painted in the last two thousand years, since this weapon did not come into the region before the time of Christ. The numerous horses date to the historic period after A.D. 1720, when this animal was introduced onto the Plateau from the southwest (Haines 1938). At least one site in Grand Coulee showed a horse associated with various cattle brands. Before 1950, an aged Indian informant explained that these were brands of the region's pioneer cattlemen, painted there by local Indians to help them identify owners when they were

48. Scratched and abraded petroglyphs of deer from Vantage, Washington. These are on display at Gingko Petrified Forest State Park. Note vandals' initials.

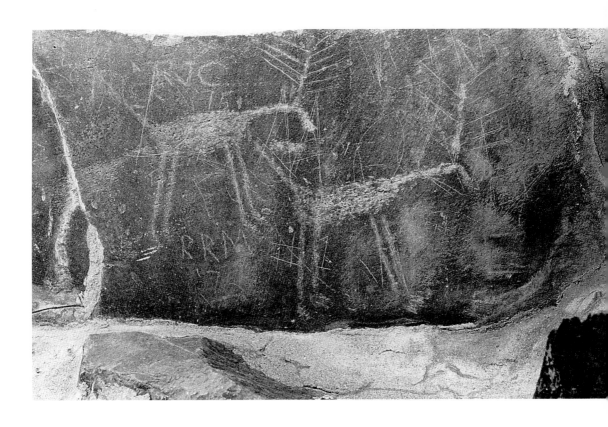

hired to round up strays. This explanation fixes the time of these pictographs, including the horse, to the period between 1880 and 1900 (McClure 1979a). Horses at a few other nearby sites, stylistically similar to this particular example, thus may also date to the last half of the nineteenth century.

As one would expect from the similarity of style and subject matter, the mid–Columbia River petroglyphs appear to be contemporaneous with the northern pictographs. One petroglyph site near Wenatchee shows an object that has been identified as an atlatl. If correct, this probably dates the drawing to more than two thousand years ago. Other petroglyphs in the same area clearly show hunters using bows and arrows, which must have been carved within the past two thousand years. Three horses with riders, pecked at Rock Island, indicate that some petroglyphs were made in the historic period after A.D. 1720.

Early photographs of several mid-Columbia sites show superimpositions of some figures and differences in weathering or repatination of others. Furthermore, some of the petroglyphs on display at Priest Rapids Dam and Ginkgo Petrified Forest State Park at Vantage show distinctly different types of petroglyphs (fig. 48). Some figures are deeply pecked and much worn, others are shallowly pecked, and still others are scratched and abraded. The deep, well-worn figures appear to be older than the others, and scratched designs will occasionally be superimposed on pecked ones.

Certainly the rock art at these sites contained some significant clues as to relative ages, but most of the designs are now destroyed or inundated. Salvaged examples have been removed from their original positions, which were crucial for evaluating patination and weathering. Had these central Columbia Plateau sites, prior to their destruction, been the subject of a comprehensive chronological study, such as that done by McClure for The Dalles–Deschutes area rock art, we would likely have had a much better sense of their antiquity. Possibly, additional study of the remaining sites, of the salvaged portions, and of the existing photographic records might yield some information of this sort. Unfortunately, so much of the record has been destroyed that further research is difficult.

Twins: The Duality of Life

MANY COLUMBIA PLAteau tribes viewed the birth of twins as a very special occasion, though not an especially propitious one, for twins were thought of as animal-like and were felt to have special shamanistic powers inherent in their duality. Some Northwest Coast tribes thought of twins as "salmon people" who had special influence over the fish runs. Other, interior groups felt that shamans caused twin births and thus guided the children toward becoming shamans. As with all shamanistic power, however, that of twins could be either good or bad, depending on how it was used and controlled.

To protect themselves, parents of twins observed restrictions and taboos to counteract the distinctive powers of their offspring.

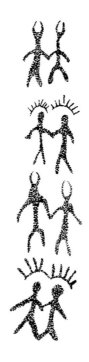

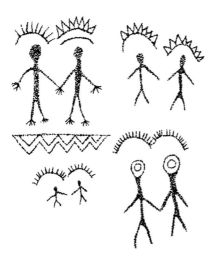

49. *Painted twins at a site near The Dalles, Oregon.*

Sometimes they lived apart from the rest of the group and performed special twin ceremonies at regular intervals. So strong was their respect for twins' powers that early Indian informants were reluctant even to discuss the subject for fear that bad luck would follow.

Beliefs about twins are only one part of the duality characteristic of Columbia Plateau cosmology. Folk tales also tell of the "transformers," a pair of culture heroes who figure prominently in some Salishan world creation myths. Though not twins, these men possessed extraordinary supernatural power and at the beginning of the world had taught people many aspects of Salishan culture and life style. Among their powers was the ability to turn evil persons to stone. At the end of the world, the transformers were to return as judges for eternity. The Indians' belief that twins possessed extraordinary power may well be linked to the same concept of duality that the transformers represent.

Rock art along the middle and lower Columbia River includes a significant number of painted and carved twin figures that denote the supernatural aspects of twins or the transformer culture heroes (McClure 1981). These figures, shown holding hands or jointly holding an object between them, wear elaborate headdresses or are surmounted by rayed arcs. In some pairs one figure is obviously male and the other is not, suggesting a male-female duality. One pair share a leg and an arm in a depiction that may represent siamese twins. One site near The Dalles has eight pairs of painted twins (fig. 49), and four sites between Wenatchee and Vantage had three or four pairs each. Away from the Columbia River, the motif occurs only at two sites on the Snake River near Lewiston, Idaho (fig. 50), and possibly one faded pictograph on the Wenatchee River near Leavenworth.

What these twin figures specifically meant to the artists who painted or carved them is lost in the mists of time, but undoubtedly they were made for supernatural purposes. The rock art in this part of the Columbia Plateau is linked closely with shamanism, and it would have been within the realm of shamans to guide the lives of twins and to control their special powers, in order both to harness the positive aspects of these powers and to protect the people of the tribe from the dangers of such awesome supernatural influence.

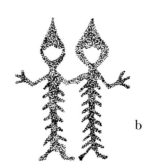

50. Twin figures in Columbia Plateau rock art: a–c, mid-Columbia pictographs; d, Snake River petroglyph near Buffalo Eddy. On polychrome figures (a, c) hatchured areas are white pigment.

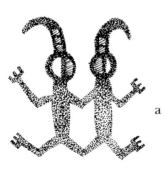

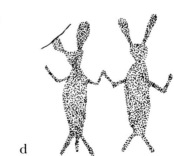

a

b

c

d

The Magic of the Hunt

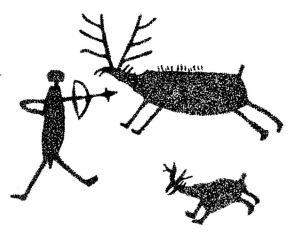

BIG-GAME HUNTING WAS a key means of subsistence for Columbia Plateau tribes. Deer, elk, moose, caribou, mountain sheep, antelope, and mountain goats were major food animals for tribes in various parts of the region. Hunting parties also traveled to the northwestern Plains to kill bison.

But hunting is a chancy pursuit, even for the best-prepared woodsman. Bad weather or lack of forage can scatter herds or leave an area without game, and even a small mistake such as a snapped twig or momentary inattention can cause an animal to bolt or an arrow to miss its mark. Given the unpredictability of the hunt, Columbia Plateau hunters had strong religious rituals designed to insure its success. Individuals had spirit helpers specifically responsible for aiding in the hunt, and communal efforts required the leadership and direction of a hunt chief who combined expert knowledge with appropriate guardian spirit help. Sweat baths and purification ceremonies were a part of the prehunt ritual, and hunters appealed to game animal spirits to foster an attitude of cooperation so they would allow themselves to be harvested. Ceremonies following a successful hunt were designed to appease and thank these spirits.

Given this close association between hunting and the supernatural, we may easily suppose that the magic of rock art would play some part. Evidence from many sites across the region indicates that it did. Herds of game are commonly shown, and individual animals are pierced with spears or arrows. Bowmen shoot deer or mountain sheep (fig. 51), Snake

51. A bowman shoots an elk in this mid-Columbia petroglyph.

River pictographs show horsemen shooting bison, and one painting at Kootenay Lake, British Columbia, even shows a man spearing a sturgeon (fig. 52). Most spectacular, though, are the scenes showing communal hunts, for they bring to life the hunting culture and associated rituals of these tribes.

Communal hunts were complex affairs involving the efforts of men, women, and dogs. Often they required the construction of nets, traps, or drive-lane fences. A story told to James Teit (1928) by an Okanagan informant clearly illustrates the method used for a winter mountain sheep hunt: "A great many [people] came . . . and proceeded to the hunting ground. Many women joined the party to act as drivers, and all were provided with snowshoes. . . . the hunting chief took off his cap, made of the skin of a ewe's head, and waving it toward the . . . sheep, prayed to them. . . .

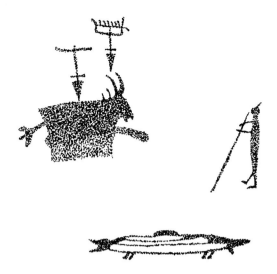

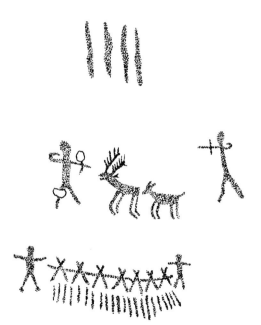

of hunters surrounding their quarry. The region's most detailed scene, though, is a Lake Chelan pictograph (now inundated), in which drivers stationed along a wooden pole fence direct deer to waiting bowmen (fig. 53).

These scenes, and many others, were made as part of the pre- and posthunt rituals conducted by hunt chiefs and shamans to bring luck or to offer thanks for success. Across unknown hundreds of years, they still speak to us of the magic of the hunt.

52. Hunting-related pictographs in British Columbia include a mountain goat pierced with arrows and a spear fisherman hunting sturgeon.

53. Communal hunt pictograph on Lake Chelan shows bowmen, drivers, and constructed fence.

He then sent many men around to sit at the heads of two gulches on top of the mountain and shoot the sheep with arrows as they came up. The men picked were the best shots. . . . A woman [with] . . . shamanistic powers . . . approached the sheep . . . gave a sharp call . . . and [her] dog rushed off and drove the sheep fiercely. . . . the men in waiting killed a great number." Similar drives were directed at deer, though fences of poles were often constructed to channel the animals to the hunters, and drivers were stationed along the fence to control the animals.

Columbia Plateau pictographs clearly show communal hunts. A scene in western Montana portrays a woman and dog driving an animal to a spear-wielding hunter (fig. 8), and a painting on Slocan Lake depicts a group

The Lower Columbia

THE LOWER COLUMBIA AREA of the Plateau consists of the river's watershed between Priest Rapids and The Dalles, excluding the Snake River. In addition to the main channel of the Columbia River, with its multitude of rock art sites, the region includes the basins of the Yakima, John Day, and Deschutes rivers, in each of which rock art sites are plentiful. Geographically, the area is bounded by the Cascade Range on the west, the Yakima-Columbia divide to the north, the Snake River drainage to the east, and the northern Great Basin on the south.

Lower Columbia terrain is arid, forested only on the eastern flanks of the Cascades and atop low mountain ranges such as the Ochoco Mountains and Horse Heaven Hills. Major rivers provide most of the region's water, serving to concentrate prehistoric occupation in villages along the Deschutes, Columbia, and Yakima. No large lakes, so typical of the northern Columbia Plateau, occur. The lower Yakima valley, below Selah Canyon, is a wide, flat, alluvial plain flanked by lofty arid ridges. The John Day and Deschutes rivers drain the high, dry, lava plateau of north-central Oregon, but are deeply entrenched in narrow canyons for most of their lower reaches. The lower Columbia River, which flows through a picturesque, basalt-rimmed gorge more than one thousand feet deep, is well known to most travelers through the area, thanks to Interstate 84 and the Columbia River Scenic Highway, which parallel the river on the Oregon and Washington sides.

As in the central Columbia Plateau, dams along this stretch of the Columbia River have drowned more than half of the known rock art. At least forty-five sites were completely or partially destroyed when The Dalles, John Day, and McNary dams were completed and their reservoirs filled between 1955 and 1968, and it is likely that other, smaller sites were obliterated before they were found and recorded. Despite this wholesale destruction, we have reasonably good records of most sites, due to early scientific interest in the area and the efforts of dedicated amateur researchers who photographed and made rubbings or tracings of many designs before they were lost. In addition, parts of a few sites were salvaged and are now on public display in several places.

Although Lewis and Clark, traversing this terrain in 1805–1806, made no mention of any lower Columbia rock art sites (probably because they portaged around the major rapids where the biggest concentrations occurred), other early explorers, such as the Wilkes expedition of 1841 (McClure 1984), did document some of the area's rock art. Later, around the turn of the century, early photographers, including Edward S. Curtis, took pictures of a few sites, and a German company made and sold postcards showing rock art near The Dalles.

Professional interest in this rock art began between 1910 and 1940, when archaeologists from the Smithsonian Institution and from the University of California at Berkeley did limited field work in the Yakima and Columbia river valleys. Dr. L. S. Cressman of the University of Oregon also recorded some northern Oregon rock art sites at this time. During the two decades of dam building on the lower Colum-

bia (1950–1970), professional archaeologists from the Smithsonian Institution River Basin Surveys, the U.S. National Park Service, and the University of Oregon Museum recorded rock art from The Dalles to Pasco, responding to its imminent destruction, but most of this work remains only partially published. One study team made rubbings of many of the figures at Petroglyph Canyon, one of the area's most extensive sites.

Avocational rock art researchers, including some professional artists, also took an interest in the area and photographed and copied many designs. The work of these amateurs continues today with the recording efforts of Greg Bettis and the recent publication by Malcolm and Louise Loring of descriptions of more than 120 sites along the Columbia River and throughout northern Oregon (Bettis 1986; Loring and Loring 1982).

Since 1975, renewed professional interest has focussed on rock art near The Dalles. Books by Beth and Ray Hill (1974) and John Woodward (1982) illustrate some of the more well-known sites, but the primary work has been by Richard McClure. Between 1978 and 1983, McClure visited all remaining Columbia River sites and compiled an interpretive synthesis in a volume on Washington's rock art, as well as a master's thesis for Washington State University on the rock art chronology of The Dalles–Deschutes area (McClure 1978, 1979a, 1984).

Definition of rock art styles in this part of the Columbia Plateau, and determination of their relative ages, is much easier than in other sections of the region, due largely to McClure's work. His master's thesis is the most detailed interpretive treatment of the subject for anywhere on the Columbia Plateau. Malcolm and Louise Loring, whose work has detailed drawings of more than three thousand designs, have provided additional assistance in style definition (Loring and Loring 1982).

The Rock Art

More than 160 rock art sites are found in the lower Columbia area. Almost 90 of these are along the Columbia River between The Dalles and Pasco, Washington, but other large concentrations occur along the middle and lower Deschutes River, and scattered sites are found in the Yakima and John Day river drainages. These sites compose four separate rock art styles, each somewhat distinct from the others despite their general similarities as part of the Columbia Plateau rock art tradition. These are the Yakima polychrome style, the Long Narrows style, the north Oregon rectilinear style, and the central Columbia Plateau style.

The Yakima polychrome style consists primarily (more than 90 percent at many sites) of red and white polychrome pictographs of arc faces, rayed arcs, and rayed circles (fig. 54). Stickmen with rayed heads and a few abstract red and white human figures are also observed. At many sites some rayed motifs are painted in single colors (either red or white) and sometimes the characteristic rayed-arc faces and elaborate, concentric, rayed circles are inscribed as petroglyphs. More than half of the fifty known locations of this style show the use of white pigment. Yakima polychrome sites occur in the Yakima and Little Klickitat river valleys, and along the entire length of the lower Columbia River. South of the Columbia, only one site, on the lower Deschutes River, has the characteristic arc faces.

The central Columbia Plateau style, described in detail in the preceding chapter, includes both pictographs and petroglyphs like those found throughout western interior British Columbia and the central Columbia Plateau. In the lower Columbia area, as in these other parts of the region, characteristic motifs are stick figure humans, simple rayed arcs and rayed circles, and block-body animal figures. Animals are mainly simple, spread-eagled thunderbirds, mountain sheep, and deer; many humans have rayed heads or a rayed arc head-

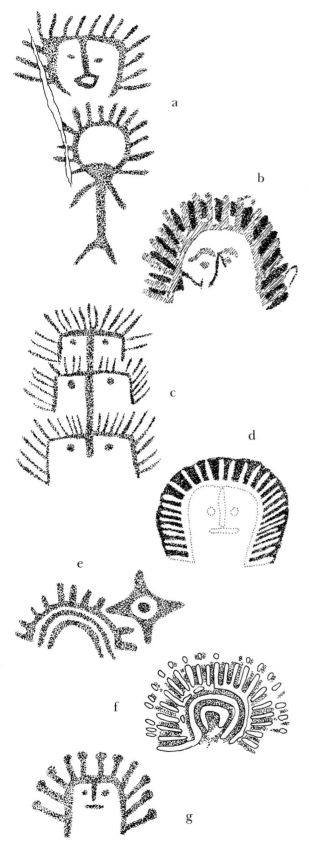

dress. The common hunting scenes sometimes involve large herds of mountain sheep. Horses with riders appear at eleven sites.

The Long Narrows style (also called Columbia River conventionalized [Lundy 1974] and The Dalles style [Hill and Hill 1974]) occurs as both petroglyphs and pictographs primarily along the Columbia River but also at a few northern Oregon sites (Wellman 1979). On the Columbia River, occasional examples appear as far upriver as Umatilla, but most sites lie between The Dalles and the mouth of the John Day River. In northern Oregon, Long Narrows art is found only at sites on the lower stretches of the Deschutes and John Day rivers. Characteristic motifs .are grinning faces; curvilinear abstracts; elaborate, concentric, spoked or rayed circles; and abstract human and animal forms with eyes, ribs, and internal organs depicted. Many of these zoomorphic or anthropomorphic figures apparently represent mythical beings or water monsters. Faces, often wearing hats, have broad grinning mouths, ears, and concentric-circle eyes. The most famous of these is Tsagiglalal.

The north Oregon rectilinear style occurs primarily as red pictographs of simple stick figure humans and animals, lizards, tally marks, and numerous rectilinear abstracts. In this latter category are rectangles, ribbed figures, grids, zigzags, crosses, circles, chevrons, rakes, and ladder figures, often combined with one another to form elaborate mazes. These rectilinear abstracts make up more than 50 percent of the paintings at sites of this style in northern Oregon's Deschutes and John Day river basins (fig. 55).

Sites cluster densely in several favorable locales in the lower Columbia area (map 5; Lor-

54. *Yakima polychrome style motifs include arc faces, rayed arcs, and four-pointed stars: a, red pictograph; b, d, f, red and white polychromes; c, e, g, petroglyphs. White pigment is indicated on polychrome figures by hatchured areas (b) and outlined areas (d, f).*

55. *Complex geometric abstract pictographs characterize north Oregon rectilinear style rock art.*

Lower Columbia

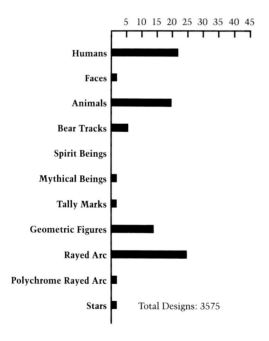

56. *Percentages of motifs in lower Columbia River rock art.*

ing and Loring 1982; McClure 1978, 1984). Many of these are now inundated by The Dalles and John Day dams, or were destroyed by associated construction activities, but a few still exist out of reach of the reservoir waters or in protected areas such as Miller Island and Horsethief Lake State Park.

Each of these clusters of sites originally had examples of the Yakima polychrome, central Columbia Plateau, and Long Narrows styles, although many are now lost. Certain sites consisted only of single drawings or small groups of figures; others, such as Petroglyph Canyon and John Day Bar, each contained hundreds of figures, and some were the largest in the lower Columbia region. The John Day Lock petroglyph, one site that still exists, has nearly 200 bear tracks—the predominant motif recorded there—and nearly 500 separate designs were noted at Petroglyph Canyon before it was inundated.

Sites also cluster in the Deschutes River drainage, although not as densely as along the Columbia River. Ten sites have been recorded below Sherar's Bridge, and another cluster of ten sites occurs around the confluence of the Deschutes and Crooked rivers (Bettis 1986). These sites tend to be smaller than the Columbia River sites; the largest have fewer than 100 individual glyphs.

Rock art preservation is poor in much of the lower Columbia area, due to the destruction of so many sites by dam building and road construction. Other sites have suffered vandalism and defacement by paint, chalk, and scratched initials. Although a few panels are fading from natural weathering, this loss is relatively minor compared to the destruction wrought by modern humans. Thus, as in the central Columbia Plateau, a once rich prehistoric art heritage has been significantly reduced in the past fifty years, making the surviving examples an even more precious resource.

Motifs recorded at lower Columbia rock art sites are divided into ten descriptive categories: humans, faces, mythical beings, animals,

Long Narrows Style

Yakima Polychrome Style

Central Columbia Plateau Style

North Oregon Rectilinear Style

Map 5. Sites of rock art styles in the lower Columbia region.

bear tracks, rayed arcs and circles, polychrome rayed figures, stars, linear geometrics, and tally marks (fig. 56).

Human Figures

Human figures occur at slightly more than two-thirds of the lower Columbia sites. Simple stick figure humans predominate, making up about 70 percent of the more than 900 recorded examples. The preponderance of stick figure humans varies considerably by style, however. Fewer than ten are associated with Yakima polychrome motifs, but 235 of the 250 recorded humans in northern Oregon sites are of this type (fig. 57). Along the Columbia River, 75 percent of human figures are stickmen, but most of these appear to be part of the simple scenes characteristic of rock art in the central Columbia Plateau style.

Other human representations include a few block-body figures, many faces, and a group of abstract anthropomorphic forms that may represent spirits or mythical beings. Both the faces and mythical beings are of sufficient stylistic importance to warrant separate discussion below. The block-body figures are often only variations of the general stickman theme, with oval, rectangular, or triangular bodies and slightly exaggerated features of head, face, or limbs. A few of these portrayals have ribs and other internal organs shown, consonant with the Long Narrows style. Humans are also indicated by hand prints at six sites and a single footprint at another.

57. Simple human figures and rectangular geometrics characterize the north Oregon rectilinear style. These are part of the Tumalo pictographs near Bend, Oregon.

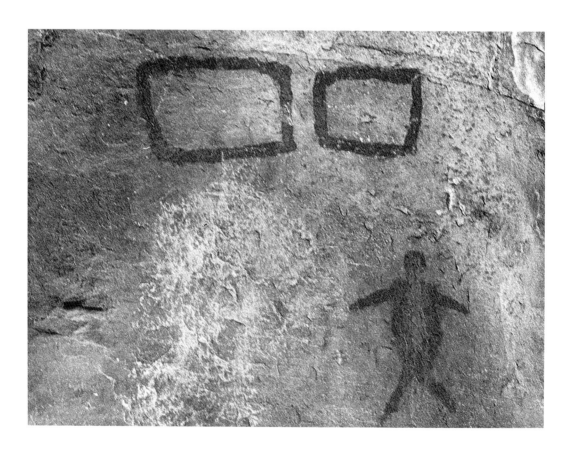

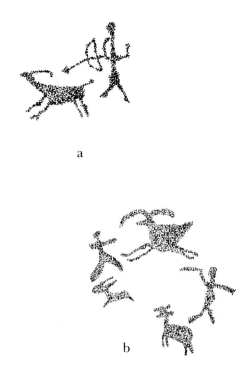

a

b

58. Hunting scenes involving spears (or possibly atlatl and dart) like that shown in b are older than bow and arrow scenes.

59. Horses and riders occur as Columbia River petroglyphs (a, c) and northern Oregon pictographs (b). One rider (a) shoots a gun.

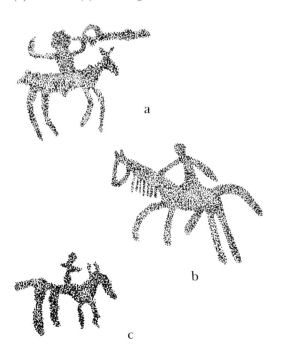

a

b

c

Stick figure and block-body humans usually have a dot or open circle for a head. Facial features are more common than in any other area of the Columbia Plateau. Three- or five-fingered hands appear on some designs, and phallic images identify some as males. One block-body figure possesses female genitalia. Humans do not usually figure in action scenes, but several hunting scenes show either archers or men with spears or atlatls (fig. 58). These scenes, primarily found at sites along the Columbia River, are similar to those throughout the rest of the Columbia Plateau. The numerous horse and rider drawings at eleven Columbia River sites (thirty mounted figures in all) may reflect the frequent visits of mounted traders coming from the eastern Columbia Plateau and northwestern Plains (fig. 59).

The close symbolic association between humans and animals that characterizes northern and western Columbia Plateau pictography is not as common in the lower Columbia area. Only a few examples depict humans and animals in this power relationship. Twin figures, like those found in the mid-Columbia area, occur at four sites. Near The Dalles, one site (fig. 49) has a panel of eight pairs of twins, six with rayed arcs (Woodward 1982). Certainly these stylized figures show a relationship between the rock art of the two areas.

Almost 30 percent of the stick figure humans at lower Columbia River sites have a rayed head or associated rayed arc. In a few cases an animal is painted under a rayed arc. These pictographs are identical to examples found as far north as central British Columbia. The stylistic consistency of this design throughout the western Columbia Plateau strongly suggests that it had inherent symbolic meaning for artists from all of the tribes living in this region.

Faces

Faces, or masks, are painted or carved at forty sites. More than half are formed by a rayed arc

that frames dots and lines representing eyes, nose, and mouth, characteristic of the Yakima polychrome style. These motifs, often red and white pictographs, are discussed separately. Other faces range from simple circles or ovals with facial features to elaborate, stylized, masklike designs that sometimes wear hats.

Some mask faces represent mythical beings; Tsagiglalal is a well-known example (fig. 60). Historic-period Indians sometimes called these water monsters, a generic term for a panoply of mythical beings prevalent in their religion, and wavy chin lines on one example may indicate water. Most of these particular mask faces belong to the Long Narrows style and show some relationship to Northwest Coast art, which commonly depicts faces. The only faces at northern Oregon sites are a single arc face and two simple, Long Narrows–style faces. All three appear to be southern extensions of the northern styles.

Mythical Beings

A wide variety of highly stylized anthropomorphic and zoomorphic figures does not seem to represent real people or animals (fig. 61). Some even mix human and animal traits in the same drawing. These bizarre, often abbreviated figures typically show ribs or other internal organs, facial features, and exaggerated appendages, and include Tsagiglalal and some of the other grotesque grinning mask designs, various water monsters, the Spedis Owls, and other half-man/half-bird creatures. Tsagiglalal and the Spedis Owls (a stylized bird motif first noted at Petroglyph Canyon, where Spedis Creek enters the Columbia River [fig. 62]) are each present at several sites in very similar form; others are individual, unique portrayals. These designs, probably denoting mythical beings, define and characterize the Long Narrows style. Various mythical beings occur at about twenty sites along the Columbia River, and a few more have been found in northern Oregon along the lower Deschutes and John Day rivers.

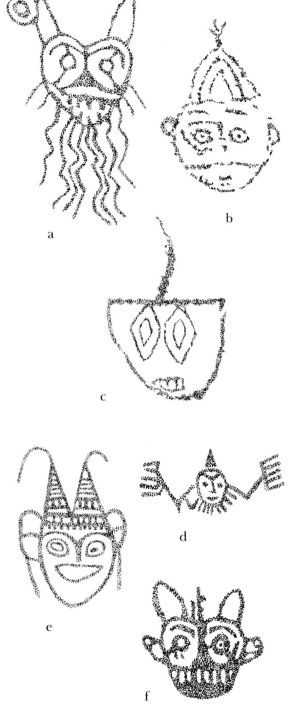

a b c d e f

60. Faces or masks are most common in the Long Narrows style in the lower Columbia region. Some of these (including Tsagiglalal [She Who Watches]) were intended to represent mythical beings: a, b, d–f, petroglyphs; c, pictograph. See also Tsagiglalal, fig. 71.

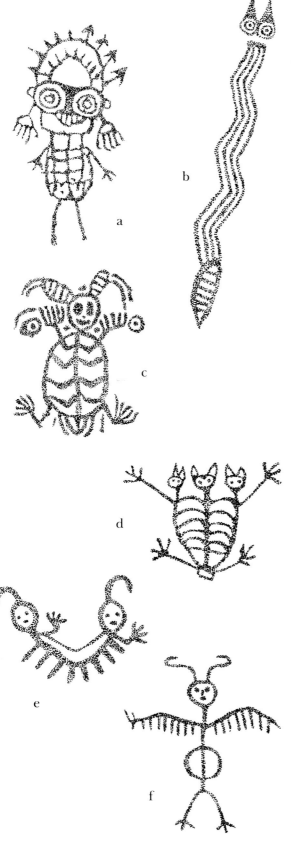

61. *A variety of lower Columbia anthropomorphs and zoomorphs represent mythical beings: a,c-f, petroglyphs; b, "snake" pictograph. These show exaggerated features (eyes, mouth, appendages), a combination of human and animal traits (c, f), and "skeletal" imagery showing internal structure or organs (a, c, d). Most mythical beings occur in the Long Narrows style. Note earrings (a) and compare with those on Tsagiglalal carvings in fig. 73.*

62. *Two Spedis Owls on a panel from Petroglyph Canyon. Note also mountain sheep (with variety of horn treatments) and two hoofprints to the left of the lower owl.*

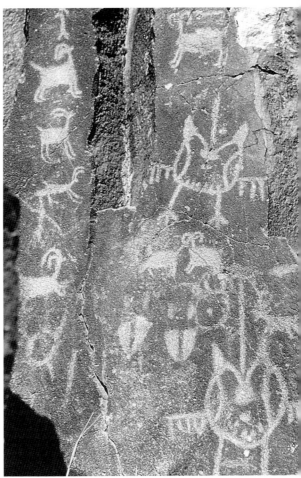

Animals

Pictured less frequently than humans, animals vary significantly in number among the four styles. Only 45 percent of recorded sites have

animals, although about 700 individual designs (excluding bear tracks) have been identified, more than 400 of them mountain sheep. Other animals include deer or elk, birds, fish, horses, lizards, dogs, insects, bison, a turtle, and a bear (fig. 63). Fewer than 100 figures have insufficient anatomical detail (or are too highly stylized) to permit specific identification.

The presence or absence of animal portrayals is another hallmark distinguishing the four lower Columbia styles. Most Yakima polychrome sites have no animal figures, though two lizards, one at a small site east of Yakima and the other, a red and white polychrome figure near The Dalles, may belong to this style. Animals are also painted infrequently at north Oregon rectilinear glyphs: fewer than 100 figures, mostly lizards and unidentifiable quadrupeds, are recorded at only 37 percent of sites. Mountain sheep and deer are rare.

However, along the Columbia River itself animal portrayals are far more common than elsewhere on the lower Columbia Plateau. More than 600 individual figures are painted or carved at more than 50 sites, in both the central Columbia Plateau and Long Narrows styles. Fewer than 75 animals cannot be assigned to a species. Mountain sheep or deer herds occur at a few Columbia River sites, and other hunting scenes show an individual bowman shooting a single animal.

Mountain sheep, identified by their characteristic horn shape, are the most common animal in lower Columbia rock art, followed by deer or elk (fig. 64). More than 400 mountain sheep exist, and herds are shown at several sites; Petroglyph Canyon had more than 200 individual sheep. At several sites, mountain sheep horns appear in front view, rather than in the more usual swept-back profile. Mountain sheep horns shown in front view also occur at some mid-Columbia sites and, more frequently, in the rock art of the Great Basin.

Their branching antlers identify deer or elk. Ten individuals are painted at northern Oregon sites; the remaining forty-six occur along the

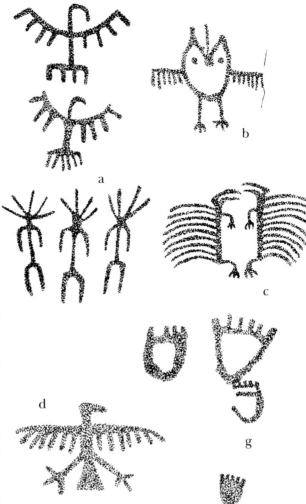

63. Identifiable animals in lower Columbia River rock art: a-d, birds; e, f, mountain sheep; g, bear tracks. Examples are: a, d, pictographs; b, c, e-g, petroglyphs.

 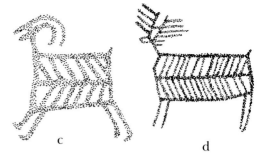

a　　　　　　　　　b　　　　　　　　c　　　　　　　　　d

64. Mountain sheep and deer or elk are the most frequent animal figures in lower Columbia rock art; a, c, d, petroglyphs; b, pictograph. Style showing ribs (c, d) is a late development in The Dalles–Deschutes area rock art.

Columbia River. The twelve recorded examples of dogs, more frequent in lower Columbia rock art than elsewhere on the Plateau, are all shown in hunting scenes chasing deer or mountain sheep. One site in northern Oregon (fig. 65) shows deer being driven toward a waiting hunter by dogs which are recognized by their open mouths and tails arching over their backs (Loring and Loring 1982).

Birds, fairly prevalent at sites along the Columbia River, include spread-eagled avians and stylized figures, such as the Spedis Owl (fig. 62)

that appear to represent mythical beings. Fish occur at seven sites, usually as single figures (fig. 66). One clearly represents a salmon or steelhead trout. The scarcity of fish portrayals in this region's rock art contrasts with their central position in the local tribes' subsistence economy and the fact that Long Narrows has been a major fishing station for eight thousand years. On the other hand, lizards are quite common, both at Columbia River and northern Oregon sites (fig. 67).

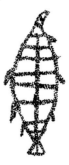

66. Despite the economic importance of salmon, this white pictograph near The Dalles is among very few rock art examples of salmon.

Bear Tracks

More than 200 bear paws, closed U or V shapes with claws at the wide end, are carved or painted at fifteen sites. However, this number is inflated by the approximately 180 pecked at the John Day Lock site and another 22 near Roosevelt. Otherwise, one site has only 3 bear-paw designs, and all the rest are single tracks. The reason why so many bear tracks were made at a single site is unknown, but similar clusters occur at Lake Pend Oreille on the central Columbia Plateau.

65. Dogs with open mouths and upraised tails drive deer toward a waiting human in this northern Oregon hunting scene pictograph.

a

b

c

d

67. Lizards or salamanders are more common in lower Columbia rock art than elsewhere on the Columbia Plateau: a–c, north Oregon rectilinear style pictographs; d, Columbia River petroglyph near Roosevelt, Washington.

Rayed Arcs and Circles

Arcs and circles with rays are the most common design element in lower Columbia rock art. Counting those linked with human figures and arc faces, more than 1,000 are painted or carved at more than 120 of the sites. These designs occur at all Yakima polychrome sites, more than 70 of the 88 Columbia River sites, and at 37 of the 62 northern Oregon sites. Many sites have between 20 and 50 examples, and often as several different forms in close proximity. Frequently a human figure has either a rayed arc above, or rays projecting directly from, its head (fig. 68). In a few cases animals also have a surmounting rayed arc. Sometimes double or triple rayed arcs nest one inside the other. Many rayed circles are complex concentric circle designs, while others have central dots. Either arcs or circles may be drawn in concentric series without rays.

The explicit meaning of these designs is unknown, but their number and consistency throughout the western Columbia Plateau indicates that they conveyed meaning to the artists who created them. While the specific meaning may have changed over time across the region throughout their history of use, it seems likely that many of the rayed arcs and circles were intended to symbolize the concept of supernatural power, which could be acquired by humans through the guardian spirit quest and similar rituals. This explanation fits comfortably with the direct association noted so often between the rayed symbols and humans or animals.

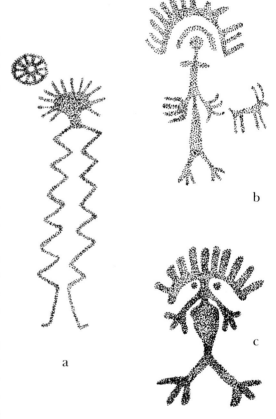

a

b

c

68. Rayed arcs and circles occur with a variety of human figures in the lower Columbia area: a, pictograph; b, c, petroglyphs.

Polychrome Rayed Figures

The Yakima polychrome style consists primarily of arc faces, rayed arcs, and concentric rayed circles found at forty-four sites. More than half of the figures are pictographs, and the great majority are polychrome red and white paintings. Often these polychromes, clustered at sites, present striking, multicolored panels of elaborate pictographs. Concentric arcs, or circles of alternating color with rays between them, form many of the rayed figures. The rays are often by turns red and white, and arc faces frequently alternate red and white rays on the arc that frames the facial features.

A few other painted figures at sites in The Dalles–Deschutes area seem to belong to the Yakima polychrome style. A polychrome lizard shows alternating red and white ribs, toes, and tail stripes. Several highly abstract human figures associated with rayed polychromes at the Tsagiglalal site have alternating red and white ribs and toes, or alternating red and white concentric circle eyes. All of these figures resemble the nearby rayed polychromes in color, style, and weathering.

Stars

Stylized, four-pointed stars, often with an open circular center, are found along the Columbia River at seventeen sites, each having from one to five examples, with a total of thirty-nine recorded. One star is painted, the rest are petroglyphs. A few have a dot in the open central circle. Often these stars occur at sites with arc faces or polychrome arcs and circles characteristic of the Yakima polychrome style, but four sites have stars without this style's motifs. I suspect that these stars are affiliated with the Yakima polychrome style (although evidence is not conclusive). If so, I cannot explain their absence from Yakima valley sites, but will note that Columbia River sites of this style are more complex overall.

Linear Geometric Figures

Many figures classified as linear geometrics are most common as pictographs at northern Oregon sites, where they compose more than 50 percent of the designs. They also occur in smaller numbers at many Columbia River sites as both pictographs and petroglyphs. Both curvilinear and rectilinear forms occur, but the latter predominate. Curvilinear designs include circles and ovals (often bisected by one or more lines), dot series, and a few abstract mazes. Rectilinear figures encompass squares, rectangles, grids, ladder-like forms, crosses, ribbed figures, rakes, chevrons, triangles, and zigzags. Frequently two or more of these elements will be combined into a single design, some of which become complex, mazelike grids. These mazes can be very large; at several sites on the upper Deschutes and John Day rivers they are more than three feet in maximum dimension, and the largest is nearly eight feet long.

The meaning of these figures is unknown, though their size, number, careful execution, and stylistic similarities across the northern Oregon area indicate that they are not merely doodles. Probably various figures had different significance to different artists. A few with projections having digits like the three-fingered hands of stickmen may represent highly abstract anthropomorphic figures, but most do not have any feature suggesting they represent abstract humans, animals, or spirit beings. Neither do they appear to represent maps or drawings of structures. These rectilinear geometric designs are more elaborate than drawings anywhere else on the Columbia Plateau, and they occur most frequently at the sites representing the north Oregon rectilinear style.

Tally Marks

Tally marks occur at thirty-two sites in the lower Columbia and are most common overall in northern Oregon, where they occur at

twenty-two sites. Except for a single pecked group of seven marks on the Columbia River and some groups incised at a petroglyph on the upper Deschutes River, they occur as pictographs. Most sites have more than a single group, and some north Oregon rectilinear sites have five to ten groups. Tally marks probably served as counts of objects or as memory aids to help recall rituals, and possibly some of the dot series also so common at these northern Oregon sites served a similar counting or mnemonic function. Though tally marks occur throughout the Columbia Plateau, they are found most often in the rock art of western Montana and northern Oregon.

Interpretation

Four distinct rock art styles, all part of the Columbia Plateau rock art tradition, flourished in the lower Columbia region. Each of these styles has its own characteristic motifs and expression, but does not necessarily represent only the art of one particular tribe, since motifs from two or three styles often occur at the same site. Furthermore, all of the styles share some general characteristics—stick figure humans predominate, and motifs such as the rayed arc, rayed circle, and tally marks are common—that make them more similar to rock art of the broader Columbia Plateau tradition than to the rock art of any surrounding area. A fifth style, called pit and groove, also occurs at a few sites throughout the Columbia Plateau, but most commonly along the lower Columbia and Snake rivers. This style appears to belong to the Great Basin rock art tradition, having come onto the Plateau from the south.

Yakima Polychrome Style

The Yakima polychrome style consists primarily of spectacular red and white pictographs and a few petroglyphs showing arc faces, rayed arcs, and concentric rayed circles. Associated with these motifs at a few sites are four-

pointed stars, pictograph stick figure humans with circular rayed heads, and polychrome paintings of triangles and abstract ribbed human and animal figures (fig. 69). These latter motifs suggest some relationship between the Yakima polychrome and the Long Narrows styles.

Forty-seven known sites contain Yakima polychrome rock art, in the Yakima valley, the Little Klickitat River valley, and along the Columbia River (map 5). Three sites containing characteristic Yakima polychrome motifs are found in the mid–Columbia River area, just east of the northern Yakima valley. The only site south of the Columbia River is one on the lower Deschutes River that has two painted arc faces. Sites along the Columbia River cluster near The Dalles and at the mouths of the Deschutes and John Day rivers.

69. Painted geometric patterns involving repeated diamonds, triangles, and zigzags occur occasionally in the lower Columbia area. They appear to be associated with the Yakima polychrome style. Hatchured areas are white pigment; stippling is red.

Often these polychrome paintings are quite large and clusters of them create very impressive panels. The most extensive, artistically complex murals are at sites near The Dalles and near Goldendale, in the Little Klickitat drainage. More than half of known Yakima polychrome style sites have these polychromes, and several also have all-white paintings. The use of pigment other than red is more common in this style than anywhere else on the Columbia Plateau, and at each of the three largest Yakima polychrome sites there are more true polychrome paintings than in all the rest of the region.

Yakima polychrome rock art in The Dalles–Deschutes area likely dates from the Late Riverine phase, between approximately two hundred and fifty and twelve hundred and fifty years ago. This suggestion arises from relative weathering and the dated occurrences of motifs such as the diamond, triangle, and ribbed human or animal figures made on portable art objects found in archaeological deposits (McClure 1984). The concentration of sites along the Columbia River between The Dalles and the mouth of the John Day River, coupled with the occurrence here of the more complex polychrome paintings, suggests that the style originated in this area and spread upriver as far as Umatilla, Oregon, and northward to the Yakima valley. The few motifs in this style near Priest Rapids and Vantage on the mid–Columbia River probably arrived there from the northern Yakima valley, since the characteristic designs are absent from the Snake River drainage, the Columbia River between Pasco and Priest Rapids, and the lower Yakima River.

Central Columbia Plateau Style

The central Columbia Plateau rock art along the lower Columbia is very similar in style to the rock art of the mid–Columbia River between Priest Rapids and Wenatchee. Characteristic motifs, in pictographs and, somewhat more frequently, as petroglyphs, are stickmen, often with rayed heads or rayed arc headdresses, mountain sheep and elk, spread-winged bird figures, and simple rayed arcs and rayed circles. Twin figures and hunters with bows and arrows are special human depictions in this style, and mountain sheep often congregate as herds in hunting scenes. Horses with riders occur as the most recent examples of this art style. Central Columbia Plateau style art is relatively evenly distributed along the lower Columbia River, where it has been recorded at more than fifty of the eighty-eight sites. The Sherar's Bridge site is one of the best known of the few sites in northern Oregon.

Rock art of the central Columbia Plateau style has endured a long time in the lower Columbia area, as it apparently has throughout the Plateau. Some scenes at Petroglyph Canyon show herds of mountain sheep and hunters using either atlatls or spears, but not bows and arrows (fig. 58). Quite probably these panels predate the arrival of the bow and arrow on the Plateau and are thus older than two thousand years. These sheep-hunting scenes appeared to be highly weathered and fully repatinated when they were photographed prior to their inundation, supporting the suggestion of great age (McClure 1984). Additional support for assigning some of these scenes considerable age comes from the excavation of prehistoric camps along the Columbia River, where mountain sheep bones were found in large quantities in levels that dated before one thousand years ago. Sheep-hunting scenes at other sites show the use of bows and arrows, and the portrayal of horses and riders and one mounted man with a gun indicates that the style continued to be used into the historic period. The relative scarcity of historic objects suggests that Indians discontinued use of the central Columbia Plateau style after A.D. 1840.

Long Narrows Style

The Long Narrows style, unique to the lower Columbia River, consists of bizarre, stylized anthropomorphic and zoomorphic figures, grotesque grinning mask faces, human face depictions, and elaborately conventionalized animal and human forms showing ribs and facial features. Some of the triangles, zigzags, and gridlike designs near The Dalles probably also belong to this style. The more elaborate anthropomorphic or zoomorphic figures may depict mythical beings and water monsters from the myths and legends of the Wishram Indians who lived in this area.

Long Narrows art occurs primarily at more than forty Columbia River sites between The Dalles and Boardman, Oregon; those closer to The Dalles seem to have the largest concentrations of Long Narrows motifs. The few examples occurring as far as 100 miles downstream from The Dalles include a Spedis Owl carved on a boulder near Skamania and two portable Tsagiglalal carvings of stone and antler found on Sauvie Island, near Portland. Occasional northern Oregon rock art sites, such as Jones Canyon on the lower Deschutes River and Butte Creek in the John Day drainage, also contain motifs typical of this style. The petroglyph farthest south is a circular face pecked along Willow Creek between Madras and Prineville, Oregon, but one antler carved as Tsagiglalal was found near Madras, and another by Summer Lake, more than 150 miles farther south. That portable figurines occur in a much broader area than the rock art almost certainly reflects the importance of trade in the economy of Indian groups living at The Dalles.

The elaborate, bizarre forms characteristic of the Long Narrows style are strikingly different from most of the art found elsewhere on the Columbia Plateau, and stylistic criteria show strong relationships to the conventionalized art of the Northwest Coast (fig. 70). Interestingly, the only comparable Columbia Plateau

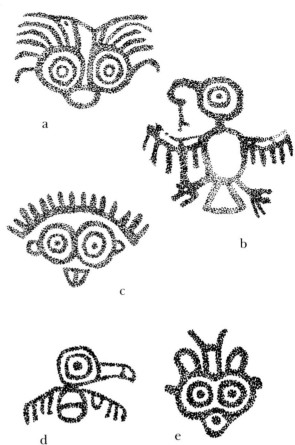

70. Curvilinear petroglyph figures emphasizing concentric circles show a relationship between the Long Narrows style and Northwest Coast rock art: a, b, c, Columbia Plateau figures; d, e, Northwest Coast figures (after Hill and Hill 1974).

drawings are the spirit beings of southern interior British Columbia. Though somewhat less conventionalized and bizarre than Long Narrows designs, these British Columbia figures were likely influenced by concepts from Northwest Coast art brought inland up the Fraser River. A relationship is also apparent between the Long Narrows style and the more abstract anthropomorphic figures of the Yakima polychrome style, found at two sites near The Dalles. It seems probable, however, that these elaborate polychrome paintings were late conventionalizations of the Yakima polychrome style, created in response to the

same influences that created the highly abstract figures of the Long Narrows style.

Long Narrows art is relatively recent. The earliest examples are simple face designs possibly carved as many as fifteen hundred years ago, but the bulk of the art dates from much later. Excavated examples of portable art indicate that most of the characteristic features of this style did not come into vogue until approximately twelve hundred years ago. These include the portrayal of ribs and teeth and the general stylization of facial features into masklike forms. Thus, the full elaboration of the Long Narrows style must have taken place within the past one thousand years. The culminating, most highly conventionalized forms, such as Tsagiglalal, Spedis Owl, and others, date within the past two hundred and fifty years. Bone and stone Tsagiglalal carvings recovered from cremation sites on the lower Columbia River were found in association with historic trade items of copper and iron, and thus date to the eighteenth century (Butler 1957; McClure 1979b). Based on his excavation of some of these sites and exhaustive study of the art objects, Butler (1957) has indicated that the grinning face motif is restricted to the period between approximately A.D. 1700 and A.D. 1840. In summary, then, Long Narrows style rock art apparently may have begun fifteen hundred years ago, but its most complex forms did not appear until the past two to five hundred years.

North Oregon Rectilinear Style

The north Oregon rectilinear style occurs primarily as pictographs at sites in the upper Deschutes and John Day watersheds. The stick figure humans, rayed arcs and circles, simple block-body animals, hunting scenes, and tally marks generally resemble those found elsewhere on the Columbia Plateau. However, designs in this style are sufficiently distinct from

the central Columbia Plateau style in their emphasis on abstract linear geometric figures and the depiction of so many lizards (fig. 67). Rectilinear and curvilinear motifs, frequently of considerable size, make up more than 50 percent of the designs at these sites. The largest paintings, found at several sites, range from three to eight feet across—the largest single pictographs on the Plateau. Lizards occur at fourteen sites, often with more than one per site. These creatures are clearly identifiable as lizards, in contrast to the amorphous forms in central and northern Columbia Plateau art that could represent lizards, insects, or something else entirely.

Significant evidence attests to relationships between the north Oregon rectilinear style and the art styles more common along the Columbia River. Several sites in the lower reaches of both the Deschutes and John Day rivers have motifs characteristic of both the Yakima polychrome and Long Narrows styles, mixed with typical north Oregon rectilinear paintings. Likewise, lizard designs are found at twelve sites along the lower Columbia River. We cannot determine whether these "mixed" sites result from the same artists drawing several styles of art, or different artists using the same sites, but certainly such stylistic coincidence shows that people living in the area knew of all these art styles.

The north Oregon rectilinear paintings probably span a long period of time. Some Columbia River petroglyphs of rayed arcs and stick figure humans are heavily repatinated, suggesting considerable age. A few superimpositions at sites near The Dalles show stickmen or rayed arcs underneath later designs of the Long Narrows and Yakima polychrome styles, further supporting the suggestion that the earlier designs may predate the Christian era. Extensive research led McClure (1984) to suggest that both the rayed arc and stick figure motifs were made between thirty-five hundred and one hundred years ago. Conversely, a white lizard at the Jones Canyon site is painted on an

abstract Long Narrows style human figure, and a few north Oregon rectilinear sites show hunters with bows and arrows, which postdate two thousand years ago, and horsemen that must date to the historic period. In sum, these clues suggest that the north Oregon rectilinear style originated prior to two thousand years ago and lasted until historic times.

Pit and Groove Style

As in other areas of the Columbia Plateau, a few pit and groove petroglyphs occur in the lower Columbia area. Approximately a dozen sites contain panels composed only of cupules and abstract curvilinear designs. Similar rock art is found on the Columbia Plateau along the Fraser River in British Columbia, at Kettle Falls, and in Hells Canyon. To the south, pit and groove art is a major component of many Great Basin petroglyphs, yet its function is unknown. In the Great Basin, pit and groove panels were carved for more than seven thousand years. Some of the lower Columbia sites are the most heavily repatinated petroglyphs in the area, suggesting that they too may be of considerable antiquity.

Cultural Perspectives on Lower Columbia Rock Art

Most lower Columbia rock art appears to have functioned in the realm of shamanism. Many designs in the central Columbia Plateau and north Oregon rectilinear styles are humans with rayed arcs, rayed arcs and rayed circles depicted by themselves, and hunting scenes. These motifs appear to be primarily "documentary," in the sense that they demonstrate the possession and use (through successful hunts) of personal power rather than its acquisition through the vision quest ordeal. That Indians, including shamans, obtained their power by vision questing is documented ethnographically, but, in contrast to artists on the

northern and eastern Columbia Plateau (see pages 35–46 and 49–60), the people of the lower Columbia did not frequently paint the symbolism of this ritualized acquisition. Excluding one or two examples, the scenes associating men, animals, sun symbols and circles, which symbolize a person's quest for his or her own power, are not found.

Instead, individual figures showing mythical beings and humans with rayed arcs predominate. These rayed designs probably symbolize the concept of supernatural power, especially when they surmount humans, lizards, and occasionally deer and mountain sheep as an aura possessed by the living being. The overall feeling imparted by the majority of these carvings and paintings is that they are "advertising" a person's possession of power, rather than recording what it is or how it was obtained. The rayed arc faces and rayed circles of the Yakima polychrome style epitomize this idea of a person's aura of power. In these paintings, the image of the person is reduced to nothing more than a simple face of dots and lines, but the aura is a striking arc or circle of alternating red and white rays.

The mythical beings characteristic of Long Narrows art also fit the interpretation of shamanic activities. Quite likely many of these figures represent beings from the rich oral tradition of myths and legends documented for the Wishram and other lower Columbia River tribes. Among these peoples, folk tales told of mythical beings such as the fiendish, child-stealing, cannibal woman; a half-man, half-fish water monster; a land monster who lived in deep caves and ate people who ventured near, and many others. Indians described a child-stealing ogress as having an ugly face and big eyes and ears; an owl was her husband. The land monster was a lizard with a rattlesnake tail who left an enormous track as it crawled along. Other mythical beings protected humans. Various water monsters living in eddies and whirlpools of the Columbia River guarded fishermen and saved people from drowning.

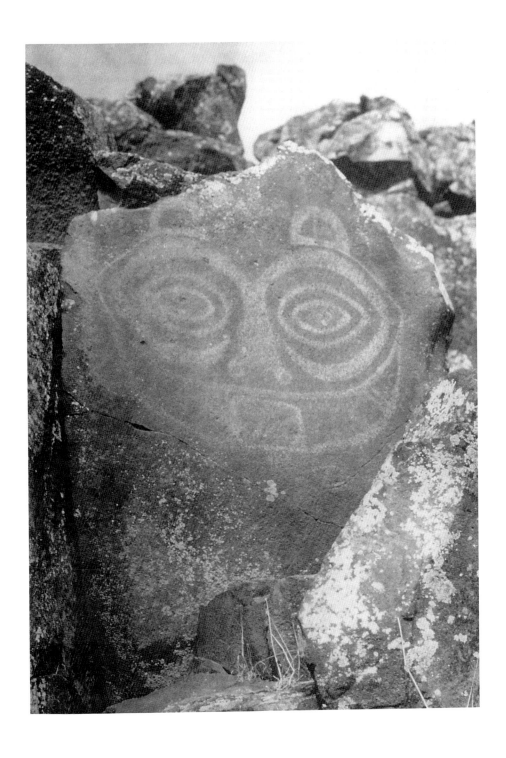

71. Tsagiglalal petroglyph near The Dalles.

vance of the Europeans pushing westward. Calendric records of Missouri River village tribes document six major epidemics between A.D. 1725 and A.D. 1802. Similar plagues swept before the Spanish who were settling California and the Russians who established their fur trading colonies on the Alaskan coast.

These epidemics killed hundreds of thousands of Indians, who had no immunity to the foreign diseases. Populations living in large communal villages, where people crowded into close contact in unsanitary conditions, would have been especially susceptible. Travelers from long distance would have brought infections from many different sources and left them to flare up among the inhabitants of these towns. The tribes living at The Dalles experienced just such horrendous plagues, which started with no apparent reason and were almost impossible to survive. The Wishram are known to have suffered two major smallpox epidemics and bouts of various other European diseases. Thousands of crema-

tion burials along the lower Columbia River attest to the severity of these episodes, and by 1840 as much as 90 percent of the Indian population previously living in this area had been wiped out.

Among these people, medicine and curing were the province of shamans. Evil spirits that invaded a person's body caused disease. Shamans cured because they had stronger guardian spirits, which could drive out the evil. We can only speculate, but even the shamans must have felt nearly helpless in the face of unknown diseases that responded to none of their traditional cures.

Given this combination of circumstances, it is easy to understand why these people had a fascination with death and thus developed a death cult and a special guardian spirit to deal with its terrible constant presence and their own vulnerability. On the cliffs above their ancient villages, Tsagiglalal still watches— mute testimony to the agony of a vanished people.

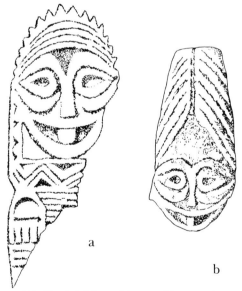
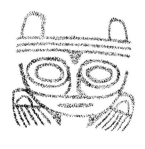
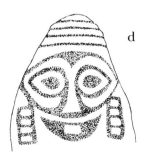

73. *The Tsagiglalal motif in portable art: a, b, carved antler objects, and c, incised stone bowl, from near The Dalles; d, incised stone found on Sauvie Island near Portland, Oregon. These items are sometimes found as grave goods in cremation burials.*

The Southeastern Columbia Plateau:
Hells Canyon and Central Idaho

THE EXTREME SOUTHEAST-ern portion of the Columbia Plateau consists of the Salmon River drainage of central Idaho and the Hells Canyon portion of the Snake River, between Hells Canyon Dam and Lewiston, Idaho, which forms the border between Idaho, Oregon, and Washington for almost 150 miles. Overall, this is a rugged region, dissected by steep, narrow river canyons separating heavily forested mountain ranges. To the north, near Lewiston, the mountains give way to the fissured basalt plateau that extends far to the west along the lower Snake and lower Columbia rivers. The most spectacular of the river gorges typifying this area is Hells Canyon, which reaches an average depth of more than six thousand feet southwest of Grangeville, Idaho. Major wilderness areas, including the Selway-Bitterroot, Gospel Hump, Frank Church–River of No Return, and Hells Canyon wildernesses, which together contain hundreds of thousands of acres, attest to the region's extreme ruggedness.

The higher plateaus are heavily forested with stands of pine, and some of the higher peaks even extend above the timber line. The area was unglaciated during the Pleistocene epoch, except for small, isolated mountain glaciers, so valleys carved by streams and rivers are steep and V-shaped. Hells Canyon and lower Snake River topography resulted primarily from large-scale scouring by the floods from glacial Lake Bonneville, which drained in the late Pleistocene about twenty thousand years ago.

Despite its large rivers and rushing mountain streams, much of the southeastern Columbia Plateau is quite dry. Some of the river bottoms are so arid that they support only short-grass prairie with sagebrush and prickly pear cactus. The aptly named Hells Canyon is desertlike during the summer months when temperatures rise to more than ninety degrees Fahrenheit for weeks at a time. The lower Salmon River and the terrain around Lewiston are also very arid.

Much of the rock art of the southeastern Plateau is still undescribed, despite increased interest in the subject throughout the region during the past decade. Richard Erwin (1930) compiled data on the numerous locations in Idaho known to contain pictographs or petroglyphs. Since then, only three studies have been completed: one focused on the rock art in the vicinity of Buffalo Eddy, near Lewiston; another on the lower Salmon River; and the most recent, a rock art survey in Hells Canyon sponsored by the U.S. Forest Service, that located and recorded more than 175 sites between Hells Canyon Dam and Buffalo Eddy (Leen 1988). The first two projects (Nesbitt 1968; Boreson 1976, 1984) each recorded fewer than 10 sites and provided only minimal interpretation and analysis (although Keo Boreson has recently documented more than 30 additional sites farther upstream on the Salmon River, these have yet to be described in detail). Fortunately, the recent publication of Leen's work in Hells Canyon has greatly increased our knowledge of rock art in this area.

The Rock Art

We know of more than 200 rock art sites in the southeastern Columbia Plateau, and results of recent inventories on the Salmon River and in Hells Canyon indicate that many more await discovery. The majority of the known sites are pictographs, but major petroglyph sites occur at Buffalo Eddy, Dug Bar, and Pittsburg Landing. Most sites are small panels of red pictographs painted on stream-side cliffs of basalt or metamorphic rock. Some sites are found in small overhangs and rock shelters. Yellow, black, white, and even blue-green pigments were occasionally used, but never for more than a few figures at any given site. True polychrome paintings are very rare. Petroglyphs are primarily pecked figures, some like those found on the middle and lower Columbia River, but at several sites others are either pit and groove glyphs or lines, circles, and ovals of the Great Basin abstract style. Very faint scratches found superimposed on pictographs at several Hells Canyon sites appear to represent a distinct style, but the recency of this discovery means that it has yet to be evaluated.

Nearly all pictograph sites are small groups of fewer than 50, and in many cases fewer than 10, paintings. The overall feeling conveyed by many of these panels is that they are each the product of a single artist, or at most two or three painters. These sites are smaller on average than those anywhere else on the Columbia Plateau, except for ones in the Similkameen valley of southern British Columbia. The largest sites are petroglyphs at Pittsburg Landing and Buffalo Eddy, and pictographs at Granite Rapids (Nesbitt 1968; Leen 1988). Buffalo Eddy, with panels of figures situated on both sides of the Snake River, contains more than 500 separate petroglyphs and a few pictographs. At Pittsburg Landing a total of nearly thirty boulders are covered with petroglyphs at two separate sites. At Granite Rapids, Daniel Leen recorded more than 55 panels of red,

white, black, and green pictographs showing animals, humans, and geometric designs.

Sites in Hells Canyon and in central Idaho are relatively well preserved, thanks to their remoteness and the fact that the area has been spared the dam building that impounded the lower Snake and Columbia rivers. Some sites were undoubtedly drowned by Lower Granite and Hells Canyon dams, and road and trail construction damaged or destroyed a few, especially near Asotin, Washington. Although most sites remain relatively free of modern graffiti, several Hells Canyon sites were extensively overpainted with white pigment before 1950, apparently by an overzealous photographer. In 1983, a part of one panel at Buffalo Eddy was pried off with an iron bar and stolen (fig. 74).

Motifs characteristic of Hells Canyon and central Idaho rock art include human and animal figures, tally marks, and geometric forms (fig. 75).

Human Figures

Humans appear at more than 50 percent of the sites in this region. Most are typical Columbia Plateau style stick figures, depicted in front view with spread legs and extended arms. Heads are dots lacking facial detail; hands and feet only rarely show digits. Commonly these human figures are phallic, but very few are shown with rayed heads or rayed arcs. At Buffalo Eddy, a distinctive triangular body with horned headdress, often holding aloft a "barbell," occurs in the petroglyphs on both sides of the river (fig. 76). No similar figures, either petroglyphs or pictographs, are yet known elsewhere on the Columbia Plateau, but they resemble human figures farther southeast, in the northeastern Great Basin area of southern Idaho and Utah.

Human hand prints occur occasionally as pictographs in this region (fig. 77). One Hells Canyon site has similar-sized left and right hand prints. Both lack pigment in the palm

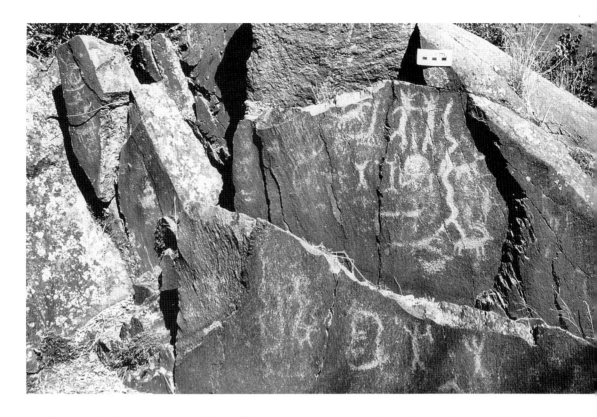

74. *Thieves stole the upper portion of this Buffalo Eddy site panel after prying it loose with an iron bar. Such "thieves of time" destroy hundreds of sites each year, but law enforcement efforts to prosecute these people provide hope that some of the destruction can be halted.*

75. *Percentages of motifs in southeastern Columbia Plateau rock art.*

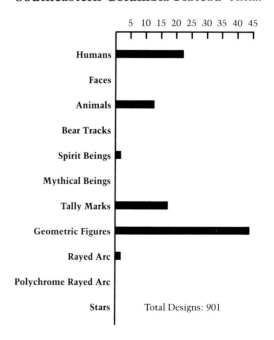

Southeastern Columbia Plateau Percent

and under the knuckles, indicating that the artist smeared his hands with red paint and then pressed them lightly against the cliff to make the imprints.

Humans mounted on horseback are shown more often in this area's rock art than elsewhere on the Columbia Plateau. Riders are painted at more than a dozen sites along the Salmon River and in Hells Canyon. Near Buffalo Eddy two mounted men chase three bison in a hunting scene. Farther upstream in Hells Canyon a mounted rider kills a buffalo (fig.78). The horse-using Nez Perce and Cayuse tribes occupied this area during the historic period; its location just west of the rich buffalo-hunting grounds in the Beaverhead and Big Hole

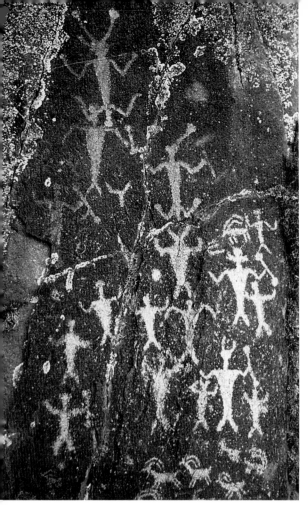

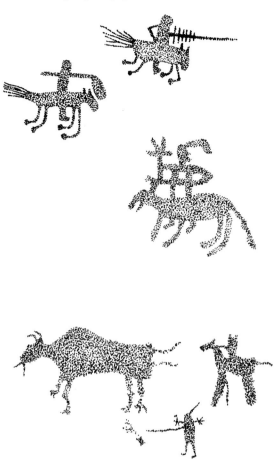

78. Horses and hunting are common themes in Hells Canyon pictographs.

76. Triangular body humans are characteristic of the petroglyphs at Buffalo Eddy on the Snake River. Some of them hold aloft a "barbell" whose symbolism is unexplained.

77. The hand print is a universal rock art symbol that is found only occasionally in Columbia Plateau rock art. At one Hells Canyon pictograph site two hands are paired with animals and a cross.

valleys of Montana probably accounts for the numerous horse-and-rider pictographs.

Animals

The rock art of the southeastern Columbia Plateau depicts animals more frequently than humans. Most are simply drawn, block-body figures with minimal anatomical detail, making species recognition difficult. Identifiable figures include deer or elk, mountain sheep, bison, dogs, horses, birds, and lizards (fig. 79).

Mountain sheep are most common; more than seventy individuals are pecked at Buffalo

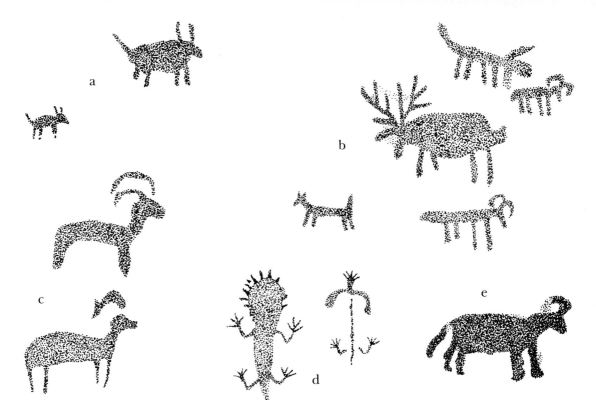

79. *Southeastern Columbia Plateau animal pictographs include: b, c, e, mountain sheep; b, deer or elk; d, lizards; and a, unidentifiable quadrupeds.*

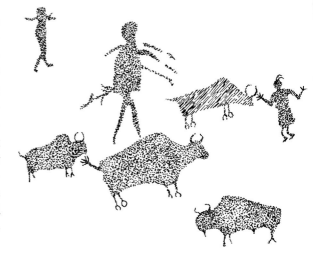

80. *Buffalo Eddy takes its name from this panel (below) of red and yellow pictographs. Yellow pigment is indicated by hatchured figure.*

Eddy. Elsewhere, one or two figures occur at a few sites. Throughout the southeastern Plateau, these animals are shown with the swept-back horns and elongated, boat-shaped body characteristic of mountain sheep pecked at sites on the Columbia River. Deer or elk appear as pictographs at several sites in the region, and a few, identified by their branching antlers, are pecked at Buffalo Eddy. Both deer and mountain sheep are painted at the Lightning Creek site in the Imnaha River drainage just west of Hells Canyon, and at the Stoddard Creek site in the upper Salmon River watershed.

Bison occur at several sites as horned, humpbacked quadrupeds, usually in hunting scenes. Sites near Buffalo Eddy show herds of three and four animals (fig. 80). Although one researcher has identified a bison at Buffalo Eddy as a longhorn steer, it differs little from nearby bison and undoubtedly represents that animal instead. Horses, signified by riders at more than a dozen sites, are not as detailed nor as stylized as the horses so common in northwestern Plains rock art, but their number clearly indicates the importance of this animal to historic period tribes in this part of the Plateau.

Dogs, birds, and lizards are also found occasionally in this area's rock art. Dogs appear in one hunting scene at Stoddard Creek and another near Birch Creek, just east of the Salmon River's headwaters. Lizards occur as pictographs at a few sites. Spread-winged birds are painted at sites in Hells Canyon, the lower Salmon River, Stoddard Creek, and near Kamiah on the Lochsa River north of Grangeville.

Tally Marks

Tally marks are quite common at central Idaho pictographs and in those along the Snake River in Hells Canyon. Tallies, usually short, evenly spaced, vertical lines arranged in horizontally oriented series, appear at a few sites as horizontal marks in vertically oriented rows, resembling rungs in a ladder without side bars. Tally marks occur in series of 3 to as many as 30 marks, and sites often have more than one series. Some sites have more than 100 marks in total. Although marks may vary in length, width, and spacing, all of those in any one series are usually very uniform in these attributes.

Geometric Abstracts

A large group of nonrepresentational designs is best described as geometric. These figures include dots (often arranged in groups or clusters), circles, triangles, rectangles, ribbed figures, zigzags, crosses, chevrons, rayed circles, and complex rectilinear and curvilinear abstracts. Geometric designs occur both as pictographs and petroglyphs, and one petroglyph style consists of little other than these elements.

Dots (sometimes called cupules when petroglyphs) and circles are most common, often arranged in groups containing from 5 to 50. One composition at Buffalo Eddy (fig. 81) has at least 150 dots, a dozen circles, and a large series of five concentric circles all organized in a

structured composition (Nesbitt 1968). Sites at Pittsburg Landing and Dug Bar consist almost entirely of shallow cupules pecked on boulders (Leen 1988). Sometimes these are arranged in rows and groups, but usually they seem randomly scattered across a boulder. Several of the biggest boulders each have more than 100 cupules. At several sites, such as Lightning Creek, dots are also painted in groups similar to those found as petroglyphs. At a site on the upper Salmon River, painted circles are linked into "chains" (fig. 82). Ribbed figures, rakes, zigzags, triangles, and other forms, although not as common as dots, occur at many sites.

Many sites include rectilinear abstract figures, sometimes with associated humans but not always. Generally these are complex, well-drawn designs rather than merely doodles. Their careful execution suggests that they likely had symbolic meaning to the artists. Although somewhat similar to the complex geometric abstracts in northern Oregon sites to the west, these motifs occur in significantly smaller proportions at southeastern Columbia Plateau sites.

Interpretation

Based on the very limited data currently available, it appears that three broadly defined rock art styles prevailed on the southeastern Columbia Plateau (Leen 1988). The most common, a naturalistic pictograph style, shows animals, stick figure humans, tally marks, and various geometric designs, typically grouped on small panels, sometimes forming compositions. Hunting scenes and horseback riders occur at several sites, and humans are drawn as part of complex geometric abstracts at others (fig. 83). Compositions characteristic of vision questing—humans associated with animals or abstract symbols—characterize some pictographs, although not quite as frequently as in the rock art of western Montana. Pictographs of this style occur in both the Salmon and Snake river basins, and fit comfortably with

81. *Abstract petroglyphs along the Snake River at Buffalo Eddy, near Lewiston, Idaho.*

82. *Abstract designs at this upper Salmon River pictograph are more like the Great Basin abstract style art found to the south.*

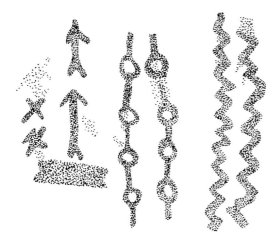

those in western Montana in what McClure (1980) has named the eastern Columbia Plateau style zone.

A second style, found as petroglyphs at Buffalo Eddy, Pittsburg Landing, and Dug Bar and as pictographs at a few other sites, has been called different names by different investigators. Some have termed it pit and groove, others Great Basin curvilinear, and Nesbitt called it the graphic style in his work with the Buffalo Eddy sites (1968). Though data from these sites are incomplete, I believe that this rock art contains elements of both the pit and groove and Great Basin abstract styles. Regardless of the name, typical motifs include dots, circles, and various rectilinear or curvilinear figures. Dots are often arranged in groups, occasionally in structured compositions; circles frequently are connected in chains. At some sites, lines meander across the panel, connecting various designs to one another or separating them. Occa-

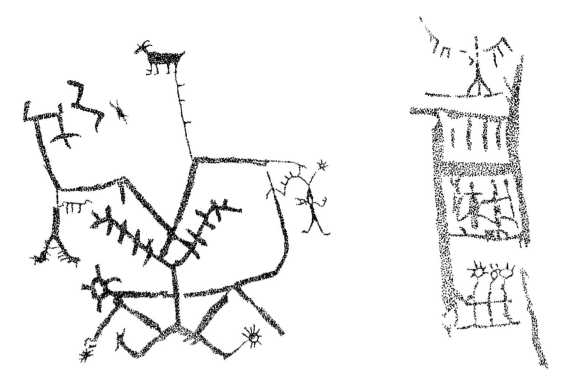

83. *Complex pictographs along the lower Salmon River show combinations of human, animal, and geometric elements.*

84. *Petroglyphs of humans (below) characterize this Snake River site near Buffalo Eddy, south of Lewiston, Idaho.*

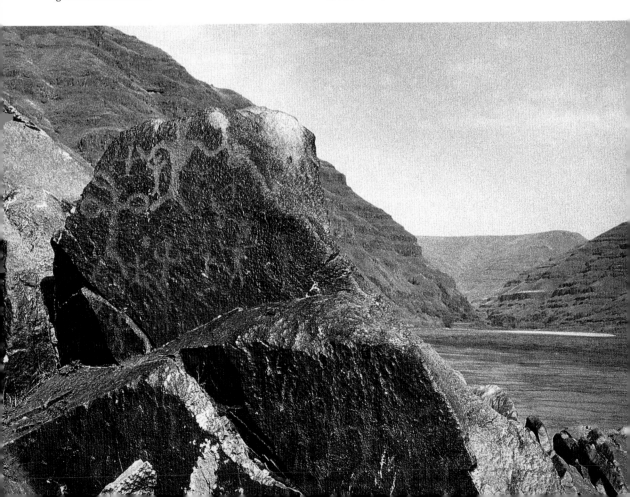

sionally human and animal figures occur in this style, but these are somewhat abbreviated forms. Simple lizards and mountain sheep occur at sites downstream on the Snake River from Lewiston.

A third art style, at Buffalo Eddy on both sides of the river, consists almost exclusively of pecked mountain sheep, deer, and triangular body humans (fig. 84). These figures occur in large groups, including apparent hunting scenes. On one panel hunters use what may be atlatls, but no human in drawings of this style uses a bow and arrow. Many of these petroglyphs are repatinated, in contrast to the later dots, circles, and triangles of Nesbitt's graphic style. In subject matter, style, and apparent age these petroglyphs resemble some of the hunting scenes found at mid- and lower Columbia River sites such as Vantage and Petroglyph Canyon. The only basic differences are the triangular human bodies and the posture of many of the humans, who hold aloft an object like a barbell. Neither of these elements is found commonly elsewhere in Columbia Plateau style rock art.

Recent work in Hells Canyon suggests the presence of a fourth art style composed of finely scratched petroglyphs. In some instances these may be random scratched lines; others form rectilinear or curvilinear figures. Although most of the currently known examples of these scratched petroglyphs are found at pictograph sites (and many are actually superimposed on the earlier pictographs), this apparent association may be partly due to the difficulty of finding the scratches in the absence of the more visible rock art. By themselves, these lightly scratched figures are very difficult to see, and nearly all recorded examples would likely have been missed had it not been for the close examination of the rock surface during the recording of pictographs and deeper petroglyphs.

There is some limited evidence indicating that the scratched petroglyphs also occur apart from earlier pictographs. At many Hells Canyon sites there are scratched figures that are not superimposed on pictographs, and Boreson (1984) reports scratches at a lower Salmon River site that do not superimpose a pictograph, but she did not have enough examples to document that the scratches formed a distinct rock art style. In the summer of 1991, Daniel Leen recorded a site in Hells Canyon where a large panel of these lightly scratched petroglyphs occur by themselves. The glyphs form a number of rectilinear designs, including several that appear to be highly stylized anthropomorphs (fig. 85). Boreson and Leen's combined evidence suggests that these scratches do form a distinct rock art style in this area. Finding additional sites and further analyzing the known examples should provide important information about this style in the future.

We have more difficulty inferring the function of southeastern Columbia Plateau rock art than we do for rock art found elsewhere in the region, primarily because we lack both complete records for so many sites outside of Hells Canyon and detailed comparative analyses for sites or areas. The Hells Canyon rock art project (Leen 1988) provides some significant clues for this task and should be a solid foundation for further study of this issue.

Certainly some of the red pictographs, which show humans associated with animals or geometric abstracts, are vision quest records like similar paintings to the north and northeast in the central Columbia Plateau and western Montana (fig. 87). Typical scenes of humans apparently receiving spirit power occur at a few Hells Canyon sites and some of those along the Salmon River. Others of these pictographs are hunting scenes, made either to document successful hunts or as offerings to the spirit world to insure future success. Some of these scenes probably record hunting trips across the Rocky Mountains to the buffalo country of south-central Montana. The Nez Perce and the Cayuse annually undertook such trips after they acquired horses.

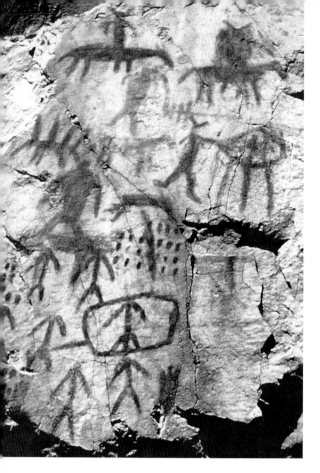

88. Stickmen, horses, and tally marks are painted on this pictograph panel at Stoddard Creek in the Salmon River drainage. Superimpositions and different shades of pigment indicate three separate episodes of painting.

rock art in this part of the Columbia Plateau. The oldest art appears to be the pictograph fragments recovered during the excavation of Bernard Creek Rockshelter (Randolph and Dahlstrom 1977) and the highly patinated humans and mountain sheep at Buffalo Eddy. At Bernard Creek Rockshelter in upper Hells Canyon, excavators found small wall or roof spalls covered with red paint in a level that dated between six and eight thousand years ago. Although these fragments could not be fitted to any of the currently surviving pictographs in the rock shelter, they demonstrate considerable age for the practice of rock painting in Hells Canyon. Excavations there also yielded bird-bone-tube paint applicators whose inte-

rior surfaces were coated with red pigment.

None of the exposed rock art at any southeastern plateau site can be proven to be as old as these early fragments from Bernard Creek, but the repatinated petroglyphs at Buffalo Eddy appear to predate the bow and arrow, which was introduced into this region between two and three thousand years ago. A hunting scene at Buffalo Eddy shows men using possible atlatls, and none of the hunters uses a bow and arrow (Leen 1988). In combination with their heavy repatination, this suggests that the petroglyphs are at least as old as the Early Riverine phase, before the introduction of the bow to Columbia Plateau tribes. Thus, they are at least two thousand years old and could be considerably older.

The abstract petroglyphs postdate the mountain sheep hunting scenes at Buffalo Eddy: designs are lightly pecked on the same surfaces as the mountain sheep, but are not repatinated. Nesbitt (1968) even reports one case where abstract glyphs are superimposed on earlier naturalistic ones. At Pittsburg Landing the abstract petroglyphs are also not repatinated. Unfortunately, we do not know how much younger these designs are than the naturalistic sheep carvings, since no diagnostic items such as bows and arrows are shown. The absence of horses suggests that these petroglyphs predate the historic period.

Although some pictographs may be as old as the fragments recovered from Bernard Creek Rockshelter, most are considerably younger. Some show bows and arrows and many depict horses with riders. The bows and arrows date those sites to the last two thousand years and the horses must have been painted after about A.D. 1720. The weathering evident on many sites indicates that most of these paintings were made in the last five hundred to one thousand years. Finally, the scratched petroglyphs in Hells Canyon are younger than the red paintings upon which they were superimposed, suggesting that they were made in the last two to five hundred years.

The Horse Brings a New Way of Life

PLAINS INDIANS CALLED the first horses they saw "elk dog," a graphic description combining the size of this strange new beast with its utility as a pack animal. Even more amazing, a man could ride one and outrace the wind!

For more than ten thousand years, Indians had lived on the Plains and Columbia Plateau of northwestern North America with only the dog domesticated to help in the hunt and to carry packs or drag travois. About A.D. 1600, Spanish colonists brought horses to New Mexico rancherias and taught the local Indians to ride. During the next one hundred years runaways and stolen animals were traded northward by Ute and Shoshone middlemen to tribes living in the rich grasslands of the northern Plains and southern Columbia Plateau. By A.D. 1700 Shoshones on the Snake River of southern Idaho were the focal point for horse trade throughout the Pacific Northwest, and by A.D. 1720 the Nez Perce, Cayuse, Umatilla, Sanpoil, and Flathead on the Columbia Plateau, and the Crow, Cheyenne, Shoshone, and Blackfeet on the northern Plains to the east, possessed horses (Haines 1938).

These tribes' adoption of the horse rapidly changed almost every aspect of their life style. With just one of these animals, a family could transport many times what it had been able to carry with all of its dogs, and suddenly the Plains buffalo country was within easy reach. Now every summer promised the Nez Perce, Cayuse, and Flathead all the bison they could kill and pack home (fig. 89). Very rapidly a man's wealth and social position became measured in how many horses he owned, for with them he could buy a bride and kill enough buffalo to feed a larger family and get hides for a bigger tipi.

But danger came with this new-found wealth. The Crow, Shoshone, and Blackfeet defended their buffalo hunting grounds and killed trespassers. Horse stealing soon became the easiest way to add to a herd, and the horse-rich Nez Perce and Cayuse found themselves easy prey for the Blackfeet and Crow. These eastern Columbia Plateau groups rapidly became locked into the Plains warfare pattern, and military conflict quickly changed from an

89. Horseback buffalo hunters painted near Buffalo Eddy, Snake River, Idaho.

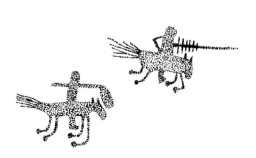

occasional battle to a continual series of war parties vying to steal horses or to avenge another group's raids. Status came to be defined by deeds of bravery—called coups—that were carried out on such raids, and young men were eager to make war so they could accumulate these honors.

On the Columbia Plateau, these changes in traditional culture made the life style of the Flathead, Nez Perce, and Cayuse resemble that of the northern Plains tribes in many respects. Unlike most of their Columbia Plateau relatives, these groups adopted Plains-style clothing and feathered headdresses, lived in large tipis, and transported their goods in parfleches packed on horse-drawn travois. Dances and rituals were borrowed from Plains culture, and coup counting and the size of his horse herd measured a man's status and wealth.

These dramatic cultural changes are clearly captured in the rock art of the Columbia Plateau, primarily as pictures of horses and riders (fig. 90). In the central and southern Plateau, horses and riders are painted or carved at more than twenty sites scattered from The Dalles to Spokane. Some horsemen along the lower Columbia River probably represent mounted traders who came to The Dalles from as far away as what is now North Dakota . One rider at Petroglyph Canyon

shoots a gun. In the Flathead country of western Montana, horses appear at two sites, and one panel with a horse and bison almost certainly records a hunting trip to Blackfeet territory in north-central Montana.

The most graphic records, however, are found in the southeastern plateau homeland of the Nez Perce and Cayuse. At two sites along the Snake River and at another south of Baker, Oregon, mounted hunters pursue bison, and mounted men and pedestrian warriors at Stoddard Creek and other sites in the upper Salmon River basin appear to be records of war parties crossing the Rocky Mountains (fig. 88). In the late historic period, Nez Perce and Cayuse warriors even kept ledger books in which they recorded their coups and horse-stealing exploits. These scenes paint a graphic picture of the unforeseen changes brought to these people by the introduction of the "elk dog."

90. Some Columbia Plateau horses (a, Chief Joseph Dam, Columbia River, central Washington) are quite well drawn. Others (b, Kila, western Montana) have features like the mane and hook-shaped hooves that appear more like northwestern Plains examples. Sometimes the rider is made with more attention to detail than the horse (c, lower Columbia petroglyph; d, Hells Canyon).

a

b

c

d

Rock Art Sites Developed for the Public

PROTECTION AND CONSERvation are vitally important to maintaining the prehistoric art heritage of the Columbia Plateau. Clearly, many sites that once existed in the region have been lost to dam building and road construction, and others are still being damaged today by the thoughtless actions of "spray-can vandals." With the increasing popularity of river rafting, hiking, and offroad vehicles, the remaining sites are becoming increasingly accessible, and, as they become known, more and more people want to see them firsthand. Every year rock art sites at Pittsburg Landing, Long Lake, Stehekin, Vantage, and Horsethief Lake State Park receive thousands of visitors, and other sites are not far behind.

State and federal agencies charged with managing these sites have a dilemma: how to protect the often fragile rock art while maintaining adequate public access. Fortunately, several significant sites in the region have been developed for visitation so that the interested public can enjoy them. In this chapter, I identify seventeen sites where rock art can be viewed in a protected setting. The best are natural sites protected by fences or security patrols; the others include rock art that was moved prior to destruction or inundation of its original location.

Where to See Columbia Plateau Rock Art

Horsethief Lake State Park

Located on the north shore of the Columbia River just upstream from The Dalles Dam, Horsethief Lake State Park contains one of the Columbia Plateau's largest concentrations of rock art still existing in a natural setting. Both pictographs and petroglyphs, including the famous Tsagiglalal site, are found within the park.

The rock art at Horsethief Lake is most easily reached by crossing the Columbia River at The Dalles and proceeding to the junction of highways 197 and 14. Travel east on Highway 14 from this intersection approximately two miles to the park entrance on the south side of the road. Within the park, a road leads south past the administrative office toward the reservoir, where it ends at a gravel parking area adjacent to the Burlington Northern railroad tracks that parallel the shoreline. From this parking lot, a developed walking trail leads west below a rimrock of low basalt cliffs. Scattered along these cliffs for more than one-half mile are various pictographs and petroglyphs. Park personnel patrol the area, but guided tours of the site are not yet available.

Cowiche Creek

The Cowiche Creek site, just northeast of Yakima, is one of the better examples of

Yakima polychrome pictographs in south-central Washington. Access to this developed site is easy. From Interstate 82, just north of Yakima, take the Naches exit. Proceed west on Highway 12 for almost four miles to Ackley Road. Turn south on Ackley Road and almost immediately intersect Powerhouse Road, which approximately parallels Highway 12 at this point. Travel west on Powerhouse Road for less than one-half mile to the large Washington State Parks and Recreation Commission interpretive sign. This marks a pathway to the paintings at the base of the columnar basalt cliff south of the road. This site was cleaned, restored, and developed for public use by state parks staff in 1972, after the polychrome paintings had suffered decades of abuse. This development has been successful in limiting additional graffiti and vandalism.

Ginkgo Petrified Forest State Park

Petroglyphs from three large Columbia River sites were salvaged prior to the shutting of Wanapum Dam and set in cement just outside the museum at Ginkgo Petrified Forest State Park at Vantage, Washington. Situated to simulate the columnar basalt cliffs on which they were originally carved, these petroglyphs are easily reached by turning north off Interstate 90 at Vantage (approximately thirty miles east of Ellensburg) and driving to the museum, less than one mile north of the service stations at the highway exit. The petroglyphs here include fine renderings of deer, mountain sheep, hunters with bows and arrows, and one pair of twins. These can be easily photographed from the walkway built for viewing the display. The museum, with its displays of fossils and natural history, is an added attraction.

Long Lake and Little Spokane Pictographs

On the Spokane River, approximately thirty miles northwest of the city of Spokane, are the Long Lake Pictographs—another development by the Washington State Parks and Recreation Commission for public visitation. This site is found most easily by following Highway 291 from Spokane to milepost 28, almost exactly six miles past the town of Tumtum. Here a parking area on the north side of the road has an interpretive sign and developed paths leading to two separate pictograph areas. In the late 1970s, the pictographs here were cleaned and restored after an episode of spray-paint vandalism. Consequently, the figures are distinct and provide a good opportunity to see paintings in their natural setting. Fences now protect the art from any further damage.

A second developed rock art site in this area is found along the Little Spokane River, just off of Rutter Parkway a few miles north of Spokane. Rutter Parkway extends from Nine Mile Falls on the Spokane River to Whitworth College on Highway 395 north of Spokane. The small park here has a parking area, interpretive sign, and a grate that protects the pictographs.

Kila, Montana

Approximately twelve miles west of Kalispell, Montana, are the Kila pictographs—two sites protected by fences built by the Montana State Highway Department many years ago. The sites, situated about one-half mile apart, are almost three miles west of the town of Kila. They are painted just north of Highway 2 on high cliffs that border the Ashley Creek valley. The easternmost site is located almost exactly at milepost 108, two miles west of the turnoff to Kila. Here a turnout on the north side of the road provides limited parking for visitors, who walk slightly uphill to the protective fence in

front of the pictographs. The second site, close to one-half mile to the west, is located at the foot of a slight grade where the highway begins to ascend a long slope out of the valley bottom. Here one finds a small gravel parking area. The pictographs, protected by a chain link fence, are screened from the parking area by a row of evergreen trees. The pictographs at both sites are in excellent condition, thanks to the protective fencing. Of special interest here are paintings of bison, animals, and men in canoes.

Other Sites

Throughout the region, a few places display rock art that was salvaged prior to site destruction. Unlike the previously mentioned sites, these displays make no attempt to show the rock art in its natural setting, and thus some interpretive value is lost, though the art can still be viewed and appreciated. These locations include:

1. Fort Okanogan State Park Visitor Center, at the confluence of the Okanogan and Columbia rivers, five miles east of Brewster, Washington;

2. Wells Dam Overlook, on the Columbia River ten miles north of Chelan, Washington;

3. Rocky Reach Dam Museum, on the Columbia River north of Wenatchee, Washington;

4. North Central Washington Museum, Wenatchee, Washington (some petroglyph boulders are also displayed in a nearby city park);

5. Priest Rapids Dam—petroglyph boulders are displayed at the dam's picnic area on the east side of the Columbia River about twenty miles south of the Interstate 90 bridge at Vantage, Washington;

6. Ice Harbor Dam Overlook, on the Snake River approximately twelve miles east of Pasco, Washington;

7. Prosser City Park, in Prosser, Washington, approximately thirty miles west of Richland, Washington;

8. Roosevelt Park, on Washington Highway 14, one mile east of Roosevelt, Washington;

9. Maryhill Museum, on Washington Highway 14, approximately four miles west of Maryhill, Washington; and

10. Stanley Park—the Lone Cabin Creek petroglyph boulder was moved in the 1920s from the Fraser River to Stanley Park in Vancouver, British Columbia (figs. 30, 31).

A Cautionary Note About Site Conservation

Despite the fact that Columbia Plateau rock art sites have survived the forces of nature for hundreds of years, many of these sites are very fragile. Anyone viewing the damage done by vandals who paint or scratch names, dates, and other graffiti across these art treasures is justifiably angry at the defacers' thoughtlessness. Even more disturbing is the theft of rock art by thieves who chip off designs or steal small petroglyph boulders (fig. 74). Both vandalism and theft of rock art violate state, provincial, and federal laws. Anyone witnessing or knowing of these acts should contact appropriate agencies, including the pertinent state or provincial parks department or state historic preservation office, the U.S. Forest Service, U.S. Bureau of Land Management, or U.S. Army Corps of Engineers. Since the majority of these sites occur on public lands, public effort can be expended to preserve them and prosecute those who damage or steal them.

What many people do not realize, however, is that all direct contact with rock art can damage both its aesthetic and scientific value. Occasionally, well-meaning but uninformed photographers highlight designs with chalk, crayon, and even paint, and some persons have tried to make block prints directly from petroglyphs. These things should never be done! Applying any foreign substance to rock art and then attempting to remove it can cause serious damage to both pictographs and petroglyphs.

Often the surface cannot ever be completely cleaned, ruining the appearance of the panel forever.

Viewers should also take care not to touch rock art surfaces, and making rubbings or casts of petroglyphs is not advisable without professional assistance. Many sites have been accidentally damaged by contact from well-intentioned visitors.

Since the rock art is so fragile, how does one capture its beauty? My advice to those who wish to record these paintings and carvings is to photograph them. From nearly twenty years of research at hundreds of sites, I have found that both color and black-and-white photographs provide the best means of reproducing their art value. One need not be an expert photographer: I am not, and my equipment is simple, but I have taken many fine rock-art pictures.

A few techniques will greatly improve your chances of getting a good photograph. Visiting a site at several different hours of the day provides various lighting effects that can be used to enhance even faint images. Adjusting films and filters is also sometimes necessary, and a tripod is invaluable. Finally, careful composition improves the artistic elements of the picture. Certainly all these procedures mean that time must be spent to acquire an excellent photograph, but I have found that the results more than make up for the effort expended.

Conclusions

The columbia plateau is a region rich in prehistoric Indian rock art. More than 750 sites—petroglyphs and pictographs—are currently known, scattered from The Dalles to the Rocky Mountains and from the Fraser River to Hells Canyon. Undoubtedly many more sites await discovery and description.

The rock art across this broad region shows a remarkable homogeneity of form and function combined with a basic simplicity of style. As such, it is more like the rock art of the Canadian Shield region in the eastern woodlands than that anywhere else in North America. Throughout the Columbia Plateau, one can find red paintings of stickmen and simple block-body animal figures associated with tally marks, rayed arcs, geometric forms, and sun symbols, and even casual observation shows notable similarities between paintings hundreds of miles apart, as the drawings in this book attest.

However, careful study has shown that, in several subareas of the region, the frequency of various designs, coupled with the artists' preference for certain combinations of motifs, has created distinctive patterns—each with its own "feel"—within the basic Columbia Plateau style. Based on these patterns, I define five slightly different regional variants of the basic Plateau rock art style (map 6, fig. 92). These correspond more or less to the book's geographic regions.

Eastern Columbia Plateau rock art occurs primarily in the Kootenai, Flathead, and Clark Fork watersheds of western Montana and southeastern British Columbia. A few sites are scattered in the Rocky Mountain foothills just east of the continental divide, and farther west a few more are found in north Idaho and near Spokane, Washington. Vision quest pictographs and tally marks characterize these small, simple sites. Petroglyphs are very rare. Southeastern Columbia Plateau rock art is found in Hells Canyon and the Salmon River drainage of central Idaho and at a few upper Bitterroot valley sites in southwestern Montana. Horsemen, bison, hunting scenes, and a preponderance of animal figures are painted at small sites or pecked at a few large petroglyphs. Together, the rock art of the eastern and southeastern Columbia Plateau makes up what McClure (1980) has called the eastern Columbia Plateau style zone.

McClure's corresponding western Columbia Plateau style zone also has northern and southern subdivisions. In the north, Western British Columbia rock art occurs in the basins of the upper Columbia, Okanogan, Thompson, and Fraser rivers in interior British Columbia and north-central Washington. Characterized by rayed arcs, spirit beings, bird figures, fir branches, and hunting scenes, this art commonly occurs at large, complex, lakeshore pictographs in south-central British Columbia and at smaller, somewhat simpler sites along the Columbia, Similkameen, and lower Okanogan rivers in southern British Columbia and northern Washington. Farther south, along the middle and lower Columbia River, is the central Columbia Plateau art style. Composed primarily of petroglyphs showing mountain sheep and deer, hunting scenes, horsemen, and humans with rayed arcs, this art has a distinctly

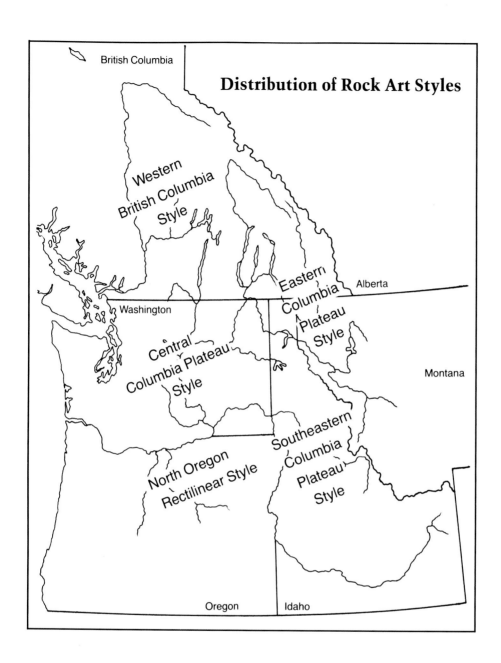

Distribution of Rock Art Styles

British Columbia

Western British Columbia Style

Eastern Columbia Plateau Style

Alberta

Washington

Central Columbia Plateau Style

Montana

North Oregon Rectilinear Style

Southeastern Columbia Plateau Style

Oregon

Idaho

Map 6. Distribution of rock art styles on the Columbia Plateau.

more descriptive feel than the symbolic art characteristic of sites farther north. The twins motif is restricted to this area, with only two exceptions. Large petroglyph sites, many of which contain hundreds of motifs, are usual. Pictographs occur in much smaller numbers.

South of the Columbia River, in the Deschutes and John Day river basins, are sites of the north Oregon rectilinear style. Primarily red pictographs of stickmen, lizards, and rectilinear geometric abstracts, this art is stylistically more like other Plateau art than like the Great Basin petroglyphs to the south. Although McClure did not include this style in either of his two zones, it is unquestionably more closely affiliated with Columbia Plateau rock art than with that of any other region. My analysis suggests, however, that it is significantly distinct from the art characteristic of either broad style zone, and thus merits its own stylistic identity.

Despite these regional variants, however, rock art is generally very similar across the breadth of the Columbia Plateau. Hunting scenes, vision quest compositions, and horsemen are stylistically the same throughout the region, and tally marks are found in all areas. Nearly identical rayed-arc motifs occur throughout the western Plateau, from Picture Gorge in the upper John Day River valley of north-central Oregon to Pavilion Lake in south-central British Columbia—a distance of nearly 450 miles! Anyone pursuing even superficial study becomes rapidly convinced of the art's stylistic unity across this broad region.

Spicing what might otherwise seem to be the region's stylistic monotony are the two distinctly different art styles near The Dalles on the Columbia River in the southwestern corner of the Plateau. The Yakima polychrome style is characterized by striking red and white polychrome arcs and circles that make typical sites a profusion of color not found elsewhere in the region. The Long Narrows style is a series of highly conventionalized petroglyphs characterized by grotesquely grinning faces

and bizarre, elaborately stylized figures representing mythical beings. Their curvilinear quality and focus on concentric circle designs show a definite relationship between Long Narrows motifs and Northwest Coast art. However, despite their differences from the simple red pictographs typical throughout most of the region, that both styles also include plenty of such standard Plateau motifs as faces, rayed arcs, and stickmen defines them as basically just highly elaborated versions of the broader Columbia Plateau rock art tradition.

The age of Columbia Plateau rock art supports the unity of all the region's styles. A painted spall excavated from Bernard Creek Rockshelter in Hells Canyon indicates that rock painting began at least seven thousand years ago in the region, but the recovered fragment is too small to determine stylistic affinity and no other surviving pictograph or petroglyph can be confidently dated to more than a few thousand years old. Nevertheless, dating clues from several sites indicate that the basic Columbia Plateau style began at least three thousand years ago and remained relatively unchanged into the late 1800s, when Indians abandoned the production of rock art.

In contrast to this long history of stylistic continuity, both the Yakima polychrome and Long Narrows styles are relatively recent. Neither can be older than about twelve hundred years, and both apparently reached their peak of popularity after approximately A.D. 1500. This coincides with the overall elaboration of Columbia Plateau culture, the upriver migration of Chinookian-speaking Wasco and Wishram Indians into The Dalles area, and the rise of The Dalles to its height as a trading center for all Pacific Northwest tribes. Concurrent with this increased cultural flowering, these newer art styles developed from the earlier style, helped along by increased contact with Northwest Coast cultures.

Like its basic form, the function and meaning of Columbia Plateau rock art is also relatively homogeneous throughout the region.

Despite fanciful reports in the 1920s that identified some of these paintings and carvings as the chronicles of Vikings or pre-Columbian Chinese explorers (Boreson 1976), solid ethnographic evidence demonstrates that this rock art was made by Columbia Plateau Indians as part of their religious ceremonies.

In the eastern half of the region, from Kootenay Lake south through Idaho and western Montana to Hells Canyon, the most common symbolism shows a human figure associated with an animal or a geometric abstract such as dots, a circle, or a sun symbol. These compositions were painted to represent a person's acquisition of supernatural power in the guise of a guardian spirit. Such spirits appeared to a worthy supplicant during the vision quest, a strenuous ordeal several days long involving isolation, fasting, prayers, and other rituals. Different animals personified different powers: coyote was cunning, deer gave success in love or gambling, bear provided bravery and hunting prowess. The sun and other natural phenomena also were powerful guardians. The guardian spirit quest was centrally important to the religion of Columbia Plateau tribes, and painting these pictographs to commemorate a successful vision was one way of ensuring the transfer of supernatural power from the natural world to a worthy person.

Farther west in the region, along the main stem of the Columbia River and in the Okanagan and Fraser river watersheds of British Columbia, these images of power acquisition through vision quests are not as common. Like their eastern cousins, tribes here practiced the vision quest and painted or carved rock art in commemoration. However, more often than do eastern panels, their art shows an elaborate, highly conventionalized, supernatural being that apparently represents the individual artist's conceptual image of his guardian spirit. Paintings in the Similkameen and Thompson river valleys almost certainly represent young women secluded in lodges specially constructed for the vision quest ritual. The women are accompanied by painted fir branches, crossed trails, and basketry—all symbols of the female vision quest.

More often, however, rock art in the western half of the Columbia Plateau centers on depictions of people associated with rayed arcs or rayed headdresses. Rather than depicting the ritual acquisition of spirit power, these pictures appear to demonstrate a person's possession and use of such power. Twins, thought to be especially potent, are usually displayed with rayed arcs, and this symbol likewise surmounts some bowmen shooting game animals. Other drawings show elaborate rayed arcs or rayed circles displayed almost like a coat of arms. Such paintings, designed almost to advertise a person's power, seem likely to have been associated with shamans, the religious specialists called on to insure hunting success, predict the future, ward off evil spirits, cure illness, or cast spells. In their rituals, shamans used various carved and painted objects, and likely much of western Columbia Plateau rock art was made for such purposes.

Many of the mythical beings characteristic of the Long Narrows petroglyphs on the lower Columbia River were almost certainly made for shamanistic purposes. Tsagiglalal was a death-cult guardian spirit used by shamans near The Dalles in their largely futile attempts to cure the epidemics of smallpox and other diseases that killed most of the resident Indian population between A.D. 1700 and A.D. 1840. Carved-antler Tsagiglalal amulets from cremation burials document the use of this motif in shamanistic curing ceremonies, and probably the Tsagiglalal petroglyphs above nearby cemeteries served the same function.

Throughout the Columbia Plateau, rock art also functioned as hunting magic. Scenes in all areas show people killing big-game animals—deer, elk, moose, mountain sheep, bear, mountain goats, and bison—and even sturgeon. Often an individual hunter shoots or spears a single animal, but several scenes show complex communal hunts involving herds, dogs,

"drivers," and even constructed fences.

Hunting was crucial to the subsistence economy of Columbia Plateau tribes. Unlike salmon fishing, however, which was seasonally dependable and involved large returns for a relatively predictable effort, hunting was somewhat risky. Game herds dispersed if forage or weather conditions were unfavorable, and even a hunter's slightest mistake could cause an animal to bolt or an arrow to fly wide of its target. Given hunting's chancy nature, Columbia Plateau tribesmen designed a variety of rituals to guarantee hunting success. Before the chase, hunters engaged in ritual purification and prayed to the animal spirits to cooperate by allowing themselves to be harvested. After a successful hunt, offerings to the spirits expressed the Indians' thanks and good will. These activities, both pre- and posthunt, were so important that they were usually assigned to a specially designated hunt chief, who had both expert knowledge of animal behavior and appropriate guardian spirits to provide assistance in finding and controlling the animals. As part of their preparatory rituals, and to offer thanks for the harvest, hunt chiefs and individual hunters painted and carved these rock art hunting scenes.

In summary, Columbia Plateau rock art was one aspect of a complex religious system designed to help Indians order their world and thereby increase their chance for survival and success. The beauty and artistic quality of these drawings was probably not intended, but was instead a by-product of heartfelt appeals to the supernatural world for the assistance of a guardian spirit or of thanksgiving for a bountiful harvest. Regardless of their prehistoric purpose, many panels are works of art, made only more impressive when one understands the reasons why ancient artists created such rich and expressive designs.

Columbia Plateau Rock Art Tradition

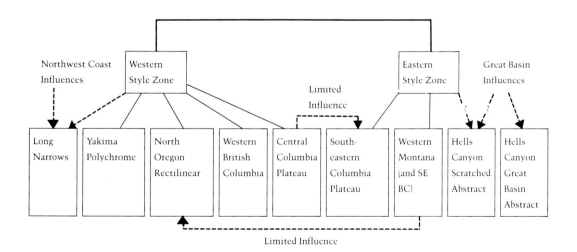

92. Dendrogram of stylistic relationships for Columbia Plateau rock art.

Of Irish Monks and Ancient Astronauts

ETWEEN 1919 AND 1927, a heated debate appeared in the pages of the *Spokane Chronicle* and *Spokesman Review* newspapers concerning the origin of Columbia Plateau rock art. No fewer than two dozen published articles expounded the views of Professor Oluf Opsjon, who argued vigorously that the carvings and paintings were runes documenting the exploration and colonization of the Plateau by Vikings at about A.D. 1000. Still other "experts" claimed that the art was made by pre-Columbian Oriental explorers as lunar records (Boreson 1976). Some people, more perspicacious than the rest, even attributed the paintings to American Indians!

Fanciful theories like these, for the origin of rock art, are still with us. A few years ago some African pictographs were identified as graffiti from ancient space travelers who visited earth and left their mark thousands of years ago. Another author argued that western United States rock art was an ancient code showing the locations of secret water holes and trails. Recently it has become fashionable among pseudoscientific organizations, such as the Epigraphic Society, to see rock art all over North America as the work of pre-Columbian Irish monks or Scandinavian kings writing a script called "Ogam" to document their explorations of the New World (Fell 1982). Even some of my own work has been used by Fell (1982) to "prove" this nonsense.

In the words of Campbell Grant, a nationally renowned American rock art scholar, all of these flights of fancy have one thing in common: they are investigations conducted in re-

verse (Grant 1967). Propounders of these imaginary explanations develop a pet theory and then selectively gather evidence to support it. Facts that do not conform to the theory are ignored, or more often, changed to fit preconceived ideas. I have seen illustrations of well-known pictographs and petroglyphs so different from the originals that I had difficulty recognizing them, yet the authors insisted that minor details of these "exact copies" verified that Irish monks drew the figures or that the designs were a coded message revealing secret information. One petroglyph I recorded more than ten years ago has since been "proven" by one author to be the work of Celtic farmers and, by another, the drawings of ancient Chinese explorers! That petroglyph has an identity crisis!

Unfortunately for these "experts," their theories cannot survive even simple scientific scrutiny. There are no authentic Viking runes in North America. The only Viking settlement on this continent was a short-lived colony on the coast of Newfoundland, whose settlers were driven away by Indian attacks after less than three years. This discovery of America almost five hundred years before Columbus is an amazing story, but it has nothing to do with Columbia Plateau rock art. Likewise, no acceptable evidence of Irish monks has been found in North America. Books discussing "American Ogam" are dismissed by reputable British scholars (who seriously study this script with all its associated cultural manifestations) as ramblings of a "looney left" knowing little or nothing about real Ogam, a Celtic script developed in southern England

Columbia Plateau. A cultural area encompassing the interior portion of northwestern North America. It includes the watersheds of the Fraser and Columbia rivers (excluding the upper Snake River in southern Idaho) and extends from central British Columbia to central Oregon and from the Rocky Mountains to the Cascades.

Conventionalized. Rock art designs drawn or painted in a non-naturalistic manner according to patterns understood by the artists responsible for the rock art style.

Coup. A deed of bravery, part of Plains Indian warfare. Usually coups involved stealing horses or touching an enemy.

Cupule. Shallow circular pit pecked in a rock or cliff surface. Often these occur in great numbers at a site, with some or all arranged in patterns.

Early Riverine phase. The cultural period following the Cold Springs phase and dating from approximately thirty-five hundred to two thousand years ago. This period saw the beginnings of portable art on the Columbia Plateau.

Ethnography (ethnographic). The writings of an ethnologist. *Ethnographic* is used to describe cultures as they were when first recorded by ethnologists.

Ethnology (ethnologist). The study of preliterate peoples. An ethnologist is an anthropologist who studies groups such as the various American Indian tribes.

Glacial Lake Bonneville. A Pleistocene lake that flooded the northeastern Great Basin in Utah and southern Idaho. It emptied about twenty thousand years ago in a series of cataclysmic floods that sculpted much of Hells Canyon. Great Salt Lake is a remnant of glacial Lake Bonneville.

Glacial Lake Missoula. A Pleistocene lake that flooded the river valleys of western Montana. It emptied with great force between twelve and fifteen thousand years

ago, creating the channeled scablands of central Washington.

Great Basin. The interior drainage basin of western North America. This region includes most of Nevada, western Utah, southern Idaho, and southeastern Oregon. The region is characterized by basin and range topography and a dry arid climate. As a cultural area, the Great Basin is typified by simple hunting and gathering tribes adapted to the region's deserts and large shallow lakes.

Guardian spirit (spirit helper). A supernatural force acquired by a person through the vision quest. Both men and women obtained guardian spirits to aid them in their lives (see also **Vision Quest**).

Kutenai. A Columbia Plateau Indian tribe living in northwestern Montana and southeastern British Columbia. Their language is spoken by no other Indian group.

Late Riverine phase. The last prehistoric culture period on the Columbia Plateau, dating from approximately two thousand years ago to A.D. 1720 when historic trade goods came into the area. This period represents the material culture and life style of the ethnographically known Columbia Plateau Indians before they were changed by European influences.

Mount Mazama eruption. An enormous volcanic eruption dated to approximately sixty-seven hundred years ago. The explosion deposited a layer of ash and pumice over much of the Columbia Plateau and resulted in the formation of Crater Lake.

Naturalistic. Rock art designs drawn in a realistic or natural manner so that they resemble the real-life objects they represent.

Nephrite. A hard, jadelike stone used for making woodworking tools such as axe and adze heads. Nephrite is found in British Columbia.

Northwest Coast. A cultural area extending from the southern Oregon coast to the

southern Alaskan coast. Tribes in this area have complex social systems and elaborate material culture, including a very stylized art.

Northwestern Plains. A cultural area just east of the continental divide extending from southern Alberta to northern Colorado, and as far east as the middle Missouri River in North and South Dakota. Tribes in this area changed rapidly from pedestrian bison-hunting groups to equestrian nomads with the arrival of the horse in the 1700s.

Obsidian. A shiny, black, brittle stone of volcanic origin found primarily in central and southern Oregon. Obsidian was commonly used for projectile points, knives, and other chipped-stone tools, and was widely traded throughout the Columbia Plateau.

Patina (patinated). The chemically altered surface of stone such as basalt. Patina darkens the surface, and many petroglyphs are pecked through this crust to expose the lighter interior stone. Repatination of basalt surfaces is one relative dating clue for rock art.

Petroglyph. A carving on a nonportable stone. Petroglyphs are made by pecking, abrading, and scratching or incising (see also **Pictograph**).

Pictograph. A painting on a nonportable stone. Pictographs can be painted with the fingers or brushes, or drawn with raw pigment or greasepaint "crayons." In Columbia Plateau rock art, mineral pigments included the colors red, white, yellow, black, and blue-green.

Pit and groove. Rock art style predominant in the Great Basin area of Nevada and eastern California, consisting of cupules (pits) and line abstracts (grooves). Often these form complex patterns including spirals, grids, "chains" of circles or diamonds, bisected circles, and others.

Pleistocene. This period includes several ice ages, the most recent ending about eleven thousand years ago. During the height of the Pleistocene, much of northern North America was covered with continental and montane glaciers, and the United States had many large glacial lakes (see **Glacial Lake Bonneville** and **Glacial Lake Missoula**). Humans entered North America at the end of the Pleistocene by crossing the Bering land bridge from Siberia.

Rancheria. A small ranch of the early Spanish settlers in the Southwest United States (from west Texas to California). Rancherias had Indians as slaves and employees. Through history, many rancherias developed into predominantly Indian villages and today several have the same status as Indian reservations. The first horses traded to the Pacific Northwest were stolen by Indians from the Spanish rancherias in the late 1600s.

Sahaptian. A language family common to the tribes of the southern and southeastern Columbia Plateau. Principal Sahaptian-speaking groups include the Nez Perce, Umatilla, Cayuse, Tenino, and Yakima.

Salish (Salishan). A language family common to the tribes of the northern and central Columbia Plateau. Principal Salishan-speaking groups include the Flathead, Spokane, Sanpoil, Lakes, Shuswap, Colville, Okanagan, Coeur d'Alene, Thompson, and Wenatchee.

Sedentism. The condition of living in one location as a more or less permanent habitation site. This occurs in pre-agricultural societies in areas where sufficient resources exist to support the resident group year round. In the Columbia Plateau the co-occurrence of anadromous fish runs and bountiful root crops (e.g, camas, yampah) enabled the development of sedentism at places like The Dalles and Kettle falls.

Style (rock art). A group of recurring motifs or designs portrayed in a typical form, which produces basic recognizable groups of figures and an overall distinctness of expression. A style is geographically localized. See **Tradition (rock art).**

Stylized. Rock art designs with some attributes depicted in a conventionalized, non-realistic manner. Often these attributes include facial features or headdresses on humans, and body parts such as ribs or appendages on animal figures.

Tradition (rock art). Two or more rock art styles that are more similar to each other than to any neighboring style. A rock art tradition extends through time and across a defined geographic area, and has a group of characteristic motifs and expressions that differentiate it from any other tradition.

Vision quest. Ritual isolation, fasting, and prayer undertaken to acquire a guardian spirit helper. The vision quest was central to the religion of Columbia Plateau tribes (see **Guardian spirit**).

Vulvaform. A stylized representation of the female genitalia. These forms are not common in Columbia Plateau rock art but they do occur as scratched petroglyphs in the Hells Canyon area.

Windust. A cultural period (and its characteristic long-stemmed, leaf-shaped spearpoint) that follows the Clovis period on the Columbia Plateau. The Windust period dates between ten and eight thousand years ago.

Zoomorph. A rock art figure with animal characteristics portrayed in such highly stylized or abstract fashion that it does not appear to represent an actual animal.

Bibliography

Baravalle, V. E. Richard
 1981 *Final Report on a Survey of Kootenay Lake Pictograph Sites*. Victoria, British Columbia: British Columbia Heritage Conservation Branch.

Bell, Joy
 1979 "The Pictographs of Slocan Lake." *Heritage Record* 8:23–47. Victoria, British Columbia: British Columbia Provincial Museum.

Bettis, Greg
 1986 *Indian Rock Art of the Lower Deschutes River*. Portland, Oreg.: Rock Art Research.

Boreson, Keo
 1976 "Rock Art of the Pacific Northwest." *Northwest Anthropological Research Notes* 10 (no. 1): 90–122.
 1984 *The Rock Art of the Lower Salmon River*. Cheney, Wash.: Eastern Washington University, Archaeological and Historical Services.
 1985 *The Petroglyphs at Lake Pend Oreille, Bonner County, Northern Idaho*. Seattle, Wash.: U.S. Army Corps of Engineers.

Butler, B. Robert
 1957 "Art of the Lower Columbia Valley." *Archaeology* 10 (no. 3): 158–65.

Cain, H. Thomas
 1950 *Petroglyphs of Central Washington*. Seattle, Wash.: University of Washington Press.

Cannon, William J., and Ricks, Mary J.
 1986 *The Lake County, Oregon, Rock Art Inventory: Implications for Prehistoric Settlement and Land Use Patterns*. Contributions to the Archaeology of Oregon, no. 3. Portland, Oreg.: Association of Oregon Archaeologists.

Cline, W.; Commons, R. S.; Mandelbaum, M.; Post, R. H.; and Walters, L. V. W.
 1938 *The Sinkaietk or Southern Okanogan of Washington*. General Series in Anthropology, no. 6. Menasha, Wis.

Copp, Stan
 1980 "A Dated Pictograph from the South Okanagan Valley of British Columbia." *Canadian Rock Art Research Associates Newsletter* 14:44–48.

Corner, John
 1968 *Pictographs in the Interior of British Columbia*. Vernon, British Columbia: Wayside Press.

Cornford, Jackie, and Cassidy, Steve
 1980 Cranbrook Petroglyphs. *Datum: Heritage Conservation Branch Newsletter* 5 (no. 2): 7–9. Victoria, British Columbia.

Dewdney, Selwyn
 1964 "Writings on Stone along the Milk River." *The Beaver*, Spring.

Dewdney, Selwyn, and Kidd, Kenneth E.
 1967 *Indian Rock Paintings of the Great Lakes*. Toronto, Ontario: University of Toronto Press.

Elrod, John Morton
 1908 "Pictured Rocks: Indian Writings on the Rock Cliffs of Flathead Lake, Montana." *Bulletin of the University of Montana*, no. 46. Missoula, Mont.

Erwin, Richard P.
 1930 *Indian Rock Writing in Idaho*. Annual Report no. 12. Boise, Idaho: Idaho Historical Society.

Fell, Barry.
 1982 *Bronze Age America*. Boston Mass.: Little Brown and Co.

Grant, Campbell
 1967 *Rock Art of the American Indian*. New York: Thomas Y. Crowell.
 1983 *The Rock Art of the North American Indians*. Cambridge, Eng.: Cambridge University Press.

Haines, Francis
 1938 "The Northward Spread of Horses among the Plains Indians." *American Anthropologist* 40:429–37.

Hill, Beth, and Hill, Ray
 1974 *Indian Petroglyphs of the Pacific Northwest*. Seattle, Wash.: University of Washington Press.

Joyer, Janet
 1990 Interpretive Text for Daphne Grove Petroglyphs. Grants Pass, Oreg.: U.S. Forest Service, Siskiyou National Forest.

Keyser, James D.
 1977 "Writing-On-Stone: Rock Art on the Northwestern Plains." *Canadian Journal of Archaeology* 1:15–80.
 1978 *The Zephyr Creek Pictographs: Columbia Plateau Rock Art on the Periphery of the Northwestern Plains*. Occasional Paper 5. Edmonton, Alta.: Archaeological Survey of Alberta.
 1979 "The Central Montana Rock Art Style." *Heritage Record* 8:153–77. Victoria, British Columbia: British Columbia Provincial Museum.
 1981 "Pictographs at the DesRosier Rockshelter." *Plains Anthropologist* 26 (no. 94): 271–76.
 1990 "Tsagiglalal—She Who Watches: Rock Art as an Interpretable Phenomenon." *Journal of Interpretation* 14 (no. 2): S1–S4.

Keyser, James D., and Knight, George C.
 1976 "The Rock Art of Western Montana." *Plains Anthropologist* 21 (no. 71): 1–12.

Leen, Daniel G.
 1984 "Rock Art Sites." In *Final Report, Archaeological Investigations at Nonhabitation and Burial Sites, Chief Joseph Dam Project, Washington*. Seattle, Wash.: U.S. Army Corps of Engineers.
 1988 *An Inventory of Hells Canyon Rock Art*. Enterprise, Oreg.: U.S. Forest Service, Hells Canyon National Recreation Area.

Loring, J. Malcolm, and Loring, Louise
 1982 *Pictographs and Petroglyphs of the Oregon Country. Part 1: Columbia River and Northern Oregon*. Los Angeles: University of California Press.

Lundy, Doris
 1974 "The Rock Art of the Northwest Coast." Master's thesis, Simon Fraser University.
 1979 "The Petroglyphs of the British Columbia Interior." *Heritage Record* 8:49–69. Victoria, British Columbia: British Columbia Provincial Museum.

Malouf, Carling I., and White, Thain
 1952 *Recollections of Lasso Stasso*. Anthropology and Sociology Papers, no. 12. Missoula: Montana State University.
 1953 *The Origin of Pictographs*. Anthropology and Sociology Papers, no. 14. Missoula, Mont.: Montana State University.

McClure, Richard H., Jr.
 1978 *An Archaeological Survey of Petroglyph and Pictograph Sites in the State of Washington*. Olympia, Wash.: Evergreen State College.
 1979a "Dating Petroglyphs and Pictographs in Washington." *The Washington Archaeologist* 23 (no. 2–3): 1–24.
 1979b "The Tsagiglalal Motif in Rock Art of the Lower Columbia River." *American Indian Rock Art* 5:173–89.
 1980 "Anthropomorphic Motifs and Style in Plateau Rock Art." Paper presented at the 33rd Northwest Anthropological Conference, Bellingham, Washington.
 1981 "Paired Anthropomorphs of Central

Washington." *American Indian Rock Art* 6:36–47.

1984 "Rock Art of The Dalles-Deschutes Region: A Chronological Perspective." Master's thesis, Washington State University.

Nesbitt, Paul Edward

1968 *Stylistic Locales and Ethnographic Groups: Petroglyphs of the Lower Snake River.* Occasional Papers, no. 23. Pocatello, Idaho: Idaho State University Museum.

Randolph, Joseph E., and Dahlstrom, Max

1977 *Archaeological Test Excavations at Bernard Creek Rockshelter.* Anthropological Research Manuscript Series, no. 42. Moscow, Idaho: University of Idaho.

Ray, Verne F.

1939 *Cultural Relations in the Plateau of Northwestern America.* Fredrick Webb Hodge Anniversary Publication Fund, Publication no. 3.

Richards, Thomas H.

1981 "A Pictograph Survey of Southeast Stuart Lake, British Columbia." *Annual Research Report* 1:133–65. Victoria, British Columbia: British Columbia Heritage Conservation Branch.

Taylor, J. M.; Myers, R. M.; and Wainwright, I. N. M.

1974 "Scientific Studies of Indian Rock Paintings in Canada." *Bulletin of the American Institute for Conservation* 14 (no. 2): 28–43.

1975 *An Investigation of the Natural Deterioration of Rock Paintings in Canada.* Conservation in Archaeology and the Applied Arts. London, Eng.: International Institute for Conservation of Historic and Artistic Works.

Teit, James A.

1928 *The Salishan Tribes of the Western Plateau.* Annual Report, no. 45. Washington, D.C.: U.S. Bureau of American Ethnology.

U.S. Geological Survey

1973 *The Channeled Scablands of Eastern Washington: The Geologic Story of the Spokane Flood.* Washington, D.C.: U.S. Government Printing Office.

Wellman, Klaus P.

1979 *A Survey of North American Indian Rock Art.* Graz, Austria: Akademische Druck und Verlagsanstalt.

Woodward, John A.

1982 *The Ancient Painted Images of the Columbia Gorge.* Ramona, Calif.: Acoma Books.

Index

Magic. *See under* Hunting magic
Mineral deposits, 15
Mountain goats: in rock art, 52, 54–55, 80
Mountain sheep: in rock art, 38, 39, 54–55,
67–69, 87, 89–91, 95, 106–7, 110, 113

Nez Perce Indians: participation in Plains
culture and warfare system, 21, 28, 33, 105–6,
111–12, 115–16; ledger drawings of, 21, 116
North Oregon rectilinear style, 83, 93, 97–98, 123

Okanagan Indians, 32
Old Cordilleran culture. *See* Cascade phase

Patina: defined, 14; role in dating, 19–20, 111,
114
Petroglyph: defined, 14
Pictograph: defined, 14–15. *See also* Pigments;
Weathering
Pigments, 14, 15, 50
Pit and groove style, 17, 94, 98, 104, 109–12;
evidence of age, 20. *See also* Cupules
Polychrome painting, 37, 50, 61, 65, 82–83, 90,
93, 104, 123. *See also* Yakima polychrome style

Rayed arc, 51, 57, 59, 61–62, 67, 68, 71, 77, 83,
87, 92–93
Rock art: attributed to non-Indian authorship,
13, 21, 124, 127–28; first noticed in Pacific
Northwest, 13, 64, 81; defined, 14–16; earliest
scientific interest in, 35, 64, 81–82, 103; efforts
of amateurs to record sites, 35, 49, 64, 82;
stylistic similarities across Columbia Plateau,
43–44, 121–25; stylistic differences with
northwestern Plains styles, 44–45; destruction
of sites, 63, 65–66, 81, 84, 104, 117, 119. *See
also* Interpretation of rock art, *and specific
named styles of rock art*

Salmon, 91. *See also* First salmon ceremonies
Shamanism: role in Columbia Plateau culture,
33, 75; association with rock art, 75, 98–100,
112, 124
"She Who Watches." *See* Tsagiglalal
Shield. *See* Warrior, shield-bearing
Similkameen Valley pictograph sites, 50, 121, 124
Spedis owl, 89, 90, 91, 96, 99–100
Style, rock art: definition of concept, 16–17;
zones, 57–58, 72, 108–9, 121–23. *See also*
Central Columbia Plateau style; Great Basin
abstract style; Hells Canyon scratched style;
Long Narrows style; North Oregon rectilinear
style; Pit and groove style; Yakima
polychrome style

Tally marks, 38, 39, 41, 47, 57, 71, 80, 93–94,
108; defined, 43
Teit, James: ethnographic references to rock art,
13, 49, 60
Tracks: in rock art, 58–59, 65, 69, 89, 90
Tsagiglalal, 88, 99–100, 124; dating of portable
examples, 18, 97, 101; association with Long
Narrows style, 83, 88, 96–97, 98–99
Twins: in rock art, 66, 77–78, 87, 95

Vandalism of rock art, 13, 66, 84, 104, 105, 119
Viking runes, 127
Vision quest: association with rock art, 21, 34,
45, 47–48, 51, 59, 67, 74, 98, 108, 111, 121; role
in Columbia Plateau culture, 33–34, 57, 124

Warrior, shield-bearing, 37, 38, 43, 44
Weathering of rock art, 15, 20, 46, 60

Yakima polychrome style, 16–17, 82, 83, 93,
94–95, 98, 123

Zoomorph: defined, 15

About the Author

JAMES D. KEYSER IS PACIFIC Northwest Regional Archaeologist for the U.S. Forest Service and he lives in Portland, Oregon. His first visit to rock paintings at an early age kindled a lifelong interest that has been both a career and an avocation.